W9-CDD-526

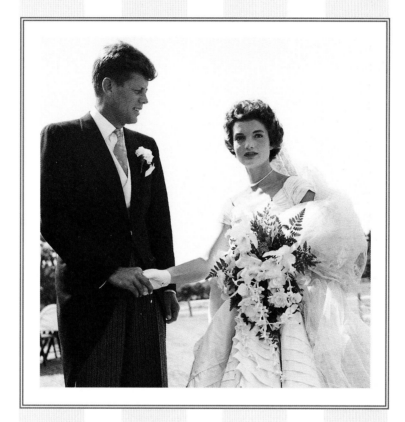

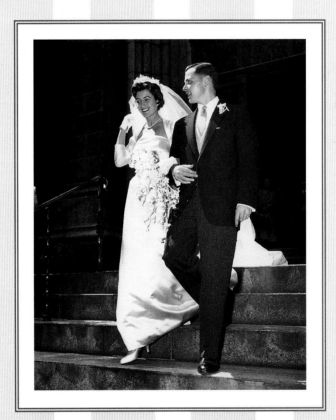

KENNEDY WEDDINGS

A Family Album

JAY MULVANEY

WITH A FOREWORD BY

DORIS KEARNS GOODWIN

ST. MARTIN'S PRESS NEW YORK

TO TWO EXTRAORDINARY FRIENDS—

KATHRIN SEITZ, WHO FIRST ENCOURAGED ME TO WRITE,

AND GERRY LAYBOURNE, WHO GAVE ME MY FIRST ASSIGNMENT

Book design and composition by Gretchen Achilles

Library of Congress Cataloging-in-Publication Data
Mulvaney, Jay.
 Kennedy weddings: a family album / Jay Mulvaney. — 1st ed.
 p. cm.
 Includes bibliographical references and index.
 ISBN 0-312-24208-5
 1. Kennedy family Pictorial works. 2. Kennedy family Miscellanea. 3. Kennedy, John F. (John Fitzgerald), 1917–1963—Marriage Pictorial works. 4. Kennedy, John F. (John Fitzgerald), 1917–1963—Marriage Miscellanea. 5. Weddings—United States Pictorial works. 6. Weddings—United States Miscellanea. I. Title.
E843.M85 1999
973.922'0922—dc21 99-15917
[B] CIP

10 9 8 7 6 5 4 3 2

CONTENTS

ACKNOWLEDGMENTS

*M*any members of the Kennedy family have helped me with the preparations for this book. I have been the grateful recipient of photographs, memories, and memorabilia. Any book, or magazine article, or newspaper story—even a favorable one—is an intrusion into their lives, and I am thankful for their generosity and goodwill, and honored by their trust.

SENATOR AND MRS. EDWARD M. KENNEDY

MRS. ROBERT F. KENNEDY

AMBASSADOR AND MRS. SARGENT SHRIVER

CAROLINE KENNEDY AND EDWIN SCHLOSSBERG

JOHN AND CAROLYN BESSETTE KENNEDY

JOE AND BETH KENNEDY

LT. GOVERNOR AND MR. DAVID TOWNSEND

ROBERT F. KENNEDY JR. AND MARY RICHARDSON

PAUL AND COURTNEY KENNEDY HILL

VICTORIA GIFFORD KENNEDY

SECRETARY AND MRS. ANDREW CUOMO

CHRISTOPHER AND SHEILA KENNEDY

MAX AND VICKI KENNEDY

MARIA SHRIVER AND ARNOLD SCHWARZENEGGER

MARK AND JEANNIE SHRIVER

ANTHONY AND ALINA SHRIVER

CHRISTOPHER AND JEANNIE LAWFORD

PETER AND SYDNEY LAWFORD MCKELVY

MICHAEL AND KARA KENNEDY ALLEN

First thanks go to Jeff Steele. Like Thor, the Norse God of Thunder—Jeff made the electric connection that gave birth to this book.

And in a quick second breath, my heartfelt thanks go to Melody Miller from the office of Senator Edward Kennedy. From the first day we spoke of this project, she has been supportive, helpful beyond words, a sympathetic ear, and a wise sounding board. She deftly weaves honesty and tact, compassion and common sense. To paraphrase Shakespeare (clumsily), my gratitude to her is as boundless as the sea and my thanks as deep.

The search for photographs was an amazing journey. The first step was the archives of the John F. Kennedy Library and the

capable stewardship of Alan Goodrich. The depth of his knowledge about the pictures in his care is amazing. Working with him is like taking a seminar, and I am the beneficiary of his critical eye and indefatigable spirit. His associate Jim Hill was also a source of great help, as were curators Frank Rigg and Jim Wagner, librarians June Payne and Rosie Atherton, and, at the JFK Library Foundation, Keyna Samuel and Kim Dietel.

At *The Boston Herald,* John Cronin was both generous and hospitable. At *The Cape Cod Times,* Arnold Miller and Steve Heaslip were equally so. I also want to single out Jorge Jaramillo of AP/Wide World Photos, Norman Currie of Corbis/Bettman, Beverly Brannon at the Library of Congress, Mrs. Beaula Harris, Carol Moore from ASU, Jean Shriner of *The Boston Globe,* John Dorsey at the Boston Public Library, Ken Regan of Camera Five, Sylvia Franco from Denis Reggie Photography, Ann Garside of the Peabody Institute, and Kathrin Klippinger at the JFK Birthplace.

In London my thanks go to: Lady Elizabeth Cavendish, Lady Anne Tree, Jean Lady Lloyd, Jane Stephenson, Patrick Hambilton, Stephen Hatton, and Aileen McEuan. At Chatsworth, Charles Noble, Helen Marchant, and their graces the duke and duchess of Devonshire.

Special thanks to Yusha Auchincloss, Katel La Bourhis, Marc Bohan, Danielle Charron, Lynn Delaney, Jean Fleishman, Pat Hackett, Josefina Harvin, Sally Kilbridge, Harold Koda, Joanna Mannino, Muffie Potter Astin, Catherine Olim, Mary Beth Postman, Amy Sigenthaller, Amy Simmons, Roger Souto, and Lynn Wooten.

A measure of gratitude to Denis Reggie, along with a request that he write his own book sometime in the future. As his photographs show, he is the "Lord Snowden" of the Kennedy family, and I appreciate his magnanimity.

I want to especially thank the following: Doris Kearns Goodwin for her generosity and goodwill. Dick Duane and Bob Thixton for their help and guidance. Larry Kammerman for his advice and counsel. Linda Ellerbee and Rolfe Tessem for taking this to another medium. David Chalfont for his early advice. Caroline Gervasi for her inscrutable support. Kathie Berlin for her energetic support and advice in the midst of her work on *Life Is Beautiful.* Marjorie Kaplan for her gracious support and flexibility.

Thanks to Meghan Cashin, Colleen Cashin, and Kevin Cashin, whose love I treasure.

At St. Martin's, first thanks go to Gretchen Achilles, who designed this book. Her creativity, aesthetic sense, collaborative nature, and natural enthusiasm have made this book a visual delight. Thanks, too, to the rest of the team at St. Martin's, including Dorsey Mills, Joe Cleeman, Valari Barocas, Jamie Brickhouse, Susan Dabol, Rebecca Oliver, Patty Rosati, Kim Whalen, Laura Wyss, and, especially, Meg Drislane.

Of course, the best is saved till last—deepest appreciation to Charles Spicer, my editor, who with graceful hand guided this process, and in turn was encouraging, supportive, helpful, and complimentary—with thanks and memories of summer swims at York Lake and the Salisbury Grove.

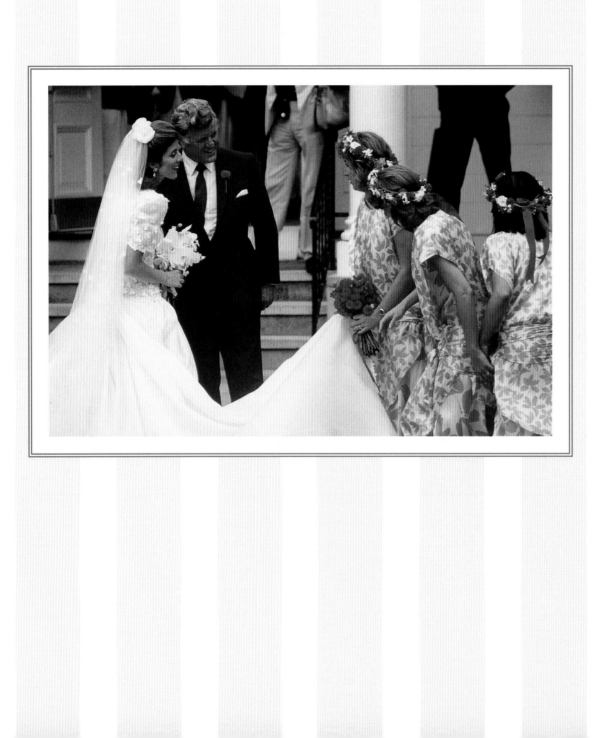

FOREWORD

by Doris Kearns Goodwin

Perhaps no other American family—with the possible exception of the Adams family—has had a more vivid and powerful impact on the life of their times. But the Kennedy tale—the spiritual compound of glory, achievement, and almost mythical tragedy—exerts a fascination upon us that goes beyond their public achievements, for it is in the end the tale of a family that has managed to retain its bonds despite all the disintegrating forces of twentieth-century life.

The close structure of the Kennedy family has a special appeal to the imagination. For every story that was written about John Kennedy during his political rise in the 1950s, there were twice as many about the Kennedy family. For nearly three quarters of a century, ever since Joseph Kennedy became a source of public interest, reporters have invariably focused attention on the esprit de corps of the Kennedy family as a whole, projecting an affirmative image of kindred loyalties and commitment that seemed strangely and appealingly anachronistic in the modern world.

In a sense, the American people were right to be fascinated with the idea of the Kennedys. Whereas the typical American family was nuclear in structure, with each individual finding his own way, the Kennedys had done some basic thinking about themselves as a family, and that thinking had produced a series of rituals and mechanisms that kept them together. In the early days, these mechanisms had taken the form of religious ceremonies, obligatory mealtimes, discussions, and shared vacations. Later,

politics would become the arena whose mastery transformed the Kennedys from successful Americans, fortunate inheritors of the American dream, to subjects of the interest and passions of the entire world. And as the family expanded and accepted new members, there was no ritual stronger than a wedding to reiterate the bonds of family, loyalty, and faith.

On the night before Caroline's wedding to Ed Schlossberg, there was a bridal dinner. At the dinner John Kennedy Jr. stood up and gave this remarkable toast in which he said that all of his life there had just been the three of them, Caroline, he, and his mother, and when he first met Ed, he was wondering what it would do to their triumvirate. But he had become so close to his new brother-in-law-to-be that he had been asked to be best man at the wedding. So then he said, "I now welcome my brother-in-law-to-be to our family." I turned to Jackie afterwards, and I said, "You must be so proud that those kids feel so close to each other," and she looked me straight in the eye and said, "It's the best thing I've ever done."

Jackie's successor as First Lady wrote after the wedding of her elder daughter, "My heart was a roaring tumult of pride, of desire to wring from this wonderful time every second of pleasure, living to the fullest this milestone of their lives." In *Kennedy Weddings*, the reader is given the occasion to examine these milestones, these wonderful times in the lives of a family whose fabric is interwoven with the chronicle of twentieth-century America.

*G*rowing up Irish Catholic in Watertown, Massachusetts, in the 1960s, as I did, made you a Kennedy fan. Just as Friday lunch inevitably brought a heaping plate of macaroni and cheese to the table, the activities and achievements of the clan Kennedy were set before us to be savored, endorsed, and admired. Their model served as our example, their success shaped our aspirations. They were a fact of our lives. Not that Watertown had much else going for it in those days. Nestled on the banks of the Charles River, seven miles from Boston (and five miles from the Beal Street birthplace of JFK in Brookline), by the sixties it had been reduced to a sleepy factory town with no factories left open for business. But Watertown was rich in history, celebrating WASP accomplishment all over the place, from Saltonstall Park at one end of town, to the Lowell and Hosmer Schools, all the way over to the granite tablet set at the foot of Winsor Ave. commemorating the delivery route of some cannons needed by General Washington—the ultimate in WASPy Presidents.

But the Kennedys were ours. They were Catholic, they were Irish, and they were heroes. Our heroes. How could they not be, when everything they did was inspiring—sending men up in space, staring down the Russians, creating the Special Olympics, making us, all of us, proud of our history and letting us point a hopeful finger toward the future. But the sixties were also a tumultuous decade, and seared in our memory are events that transformed the Kennedys from mere heroes into icons.

And icons need images. Close your eyes, say the words *Kennedy* and *wedding*, and what images spring to mind? A handsome couple, standing in a field overlooking Narragansett Bay, her lace veil billowing in the wind? Another handsome couple, walking down the steps of a cathedral, engulfed in the cheers of their family and friends? Another couple, handsomer still, standing at the front of a small wooden chapel, the young man gallantly kissing the hand of his new bride?

In his musical play *Company*, Stephen Sondheim asks and answers the question "Wedding, what's a wedding? It's a prehistoric ritual." True, yes, but a wedding is also life at its most hopeful—full of promise and happiness and love. It is the ritual forging of an alliance, but also a moment of intimacy, shared with family and friends. It is also a communal milestone—experienced by the great and the humble, celebrated by all faiths and in all cultures. And a Kennedy wedding is a fusion of ritual and iconography. Caroline Kennedy once said so herself, that the images from her parents' wedding are so memorable they are indelibly etched into our cultural consciousness, resonating through our senses of history and culture.

But why is that so? Maybe Oliver Stone got it right. In his film *Nixon*, there's a moment when Anthony Hopkins looks at the Aaron Shikler portrait of JFK and says, "When they look at you, they see what they want to be..." Is that the secret of the Kennedys' hold on us? Do we do that; do we see ourselves in this family who have been so much a part of our consciousness? We tend to objectify people in public life, turning them into what we see as the better parts of ourselves, portraying our dreams and fantasies into our perception of their reality. Is that fair? Can we expect any person, let alone an extended family, to live up to those great expectations?

The Kennedys are, after all, only human, and though unified by a strong familial bond, the descendants of Rose Fitzgerald and Joseph P. Kennedy are seven families in the second generation and twenty-eight in the third. They are individuals as much as they are "Kennedys." Their lives, like ours, are a tapestry fash-

ioned from many threads—beautiful and harsh, loving and sad, generous and unassuming. There have been divorces and remarriages, lives lost in war, to illness, to violence. There have been public mistakes, yes, and many private acts of philanthropy. They have been made larger than life and have generally assumed that role with grace, humor, and responsibility. Watching them as we all grow older, one is left, over time, with an appreciation of the good that they represent in all of us—a loyalty to family, a sustaining faith in God, patriotism measured in altruistic service to our country, and a dedication to finding a better life for those less fortunate. Is there any better definition of "family values" around?

Tucked away in the archives of the John F. Kennedy Library is a scrapbook, its handwritten cover inscribed "I MARRIED A SENATOR ON MY SUMMER VACATION by Jacqueline Bouvier Kennedy." Such homemade books were an inveterate part of Jacqueline Kennedy's life; from childhood she was encouraged by her mother to keep them. This one, created in the summer and early fall of 1953, is filled with clippings and photographs of her engagement, wedding, and honeymoon. Each clipping is hand-tipped into the book, and many are annotated in her whimsical script. Newspapers and magazines from around the country, from New York to St. Louis and back again, announced her engagement and reported on her wedding in enthusiastic detail. The photographs from her wedding day are carefully pasted into place, and one can even find her first press interview, with *The Boston Traveler*, in which she describes her plans for her upcoming nuptials: "It will have to be small. If it were large, it would have to be very large. And we wouldn't want it that way." Well, as someone said (fifty yards of silk taffeta and twelve hundred guests later), you can't always get what you want.

Think of *Kennedy Weddings* as a scrapbook, like one of Jackie's, a collection of images and thoughts, some fleeting, others lingering for a moment longer, photographs (many published here for the first time) and words illustrating thirty-one weddings over a span of eighty-four years. It's meant to be an affectionate divertissement in the Kennedy canon. A family's history, yes, but also a centenary's worth of social mores, evolving fashions, a cultural retrospective, and a small but legitimate piece of the twentieth-century American narrative.

So much time has passed since those hero-worshiping days of the 1960s. The Watertown of my youth is gone—discovered by the upwardly mobile, it's called "D'eauville" now in mock honor of its newfound chic. Gone, too, is the notion of hero-worship, and that's a sad thing—a casualty of childhood perhaps, or part and parcel of the natural skepticism that comes with maturity.

With maturity, too, comes a delight in attempting to capture evanescent memories and those fleeting moments of bliss. It says something, in this day and age of unquenchable thirst for celebrity, that so many members of the Kennedy family have been able to create these very private moments within their very public lives. And it says something else that they have been willing here to share some of those moments with us. Enjoy!

KENNEDY FAMILY TREE

Joseph Patrick Kennedy (1888–1969) m. 1914 Rose Elizabeth Fitzgerald (1890–1995)

Joseph P. Kennedy Jr. (1915–1944)

John Fitzgerald Kennedy (1917–1963) m. 1953 Jacqueline Bouvier (1929–1994)

Rosemary Kennedy (b. 1918)

Kathleen Agnes Kennedy (1920–1948) m. 1944 William Cavendish, Marquess of Hartington (1917–1944)

Eunice Mary Kennedy (b. 1921) m. 1953 Robert Sargent Shriver Jr. (b. 1915)

Patricia Kennedy (b. 1924) m. 1954 Peter Lawford (1923–1984)

Robert Francis Kennedy (1925–1968) m. 1950 Ethel Skakel (b. 1928)

Caroline Bouvier Kennedy (b. 1957) m. 1986 Edwin Schlossberg (b. 1945)

John Fitzgerald Kennedy Jr. (1960–1999) m. 1996 Carolyn Bessette (1966–1999)

Patrick Bouvier Kennedy (1963–1963)

R. Sargent Shriver III (b. 1954)

Maria Owings Shriver (b. 1955) m. 1986 Arnold Schwarzenegger (b. 1948)

Timothy Perry Shriver (b. 1959) m. 1986 Linda Potter (b. 1956)

Mark Kennedy Shriver (b. 1964) m. 1992 Jeanne Ripp (b. 1964)

Anthony Paul Kennedy Shriver (b. 1965) m. 1993 Alina Mojica (b. 1965)

Christopher Lawford (b. 1955) m. 1984 Jeannie Olsson (b. 1955)

Sydney Lawford (b. 1956) m. 1983 Peter McKelvy (b. 1956)

Victoria Lawford (b. 1958) m. 1987 Robert Pender (b. 1953)

Kathleen Kennedy (b. 1951) m. 1973 David Townsend (b. 1947)

Joseph P. Kennedy II (b. 1952) m. 1979, div. 1990 Sheila Rauch (b. 1949)

m. 1993 Beth Kelly (b. 1957)

Rose (b. 1988), Tatiana (b. 1990), John (b. 1993)

Katherine (b. 1990), Christina (b. 1991), Patrick (b. 1993)

Rose (b. 1987), Timothy (b. 1988), Samuel (b. 1992), Kathleen (b. 1994)

Teddy (b. 1988), Eunice (b. 1994), Francesca (b. 1994)

David (b. 1987), Savannah (b. 1990), Matthew (b. 1995)

James (b. 1985), Christopher (b. 1987), Patrick (b. 1989), Anthony (b. 1992)

Alexandra (b. 1988), Caroline (b. 1990), Victoria (b. 1993)

Meaghan (b. 1977), Maeve (b. 1979), Rose (b. 1983), Kerry (b. 1992)

Joseph P. III (b. 1980), Matthew (b. 1980), twins

Jean Ann
Kennedy
(b. 1928)
m.
1956
Stephen
Edward
Smith
(1927–1990)

Edward
Moore
Kennedy
(b. 1932)
m.
1958,
div. 1982
Virginia Joan
Bennett
(b. 1936)

m.
1992
Victoria
Ann
Reggie
(b. 1954)

Robert F.
Kennedy Jr.
(b. 1954)
m.
1982,
div.
1994
Emily
Black
(b. 1957)

David
Anthony
Kennedy
(1955–1984)

Mary
Courtney
Kennedy
(b. 1956)
m.
1980,
div.
1990
Jeffrey
Ruhe
(b. 1952)

m.
1993
Paul
Hill
(b. 1954)

Michael
LeMoyne
Kennedy
(1958–1997)
m.
1983
Victoria
Gifford
(b. 1957)

Mary
Kerry
Kennedy
(b. 1959)
m.
1990
Andrew
Cuomo
(b. 1957)

Christopher
George
Kennedy
(b. 1963)
m.
1987
Sheila
Berner
(b. 1962)

Matthew
Maxwell
Taylor
Kennedy
(b. 1965)
m.
1991
Victoria
Strauss
(b. 1964)

Douglas
Harriman
Kennedy
(b. 1967)
m.
1998
Molly
Stark
(b. 1967)

Rory
Elizabeth
Katherine
Kennedy
(b. 1968)

Stephen
Edward
Smith Jr.
(b. 1957)

Amanda
Mary
Smith
(b. 1967)

Kara
Ann
Kennedy
(b. 1960)
m.
1990
Michael
Allen
(b. 1958)

Edward
Moore
Kennedy Jr.
(b. 1961)
m.
1993
Katherine
Gershman
(b. 1959)

Patrick
Joseph
Kennedy
(b. 1967)

William
Kennedy
Smith Jr.
(b. 1960)

Kym
Maria
Smith
(b. 1972)

Robert F. III
(b. 1985),
Kathleen
(b. 1988)

Conor
(b. 1994),
Kyra
(b. 1995),
Finbar
(b. 1997)

Saoirse
Roisin
(b. 1997)

Michael
(b. 1983),
Kyle
(b. 1984),
Rory
(b. 1987)

Cara
(b. 1995),
Mariah
(b. 1995),
twins

Katherine
(b. 1990),
Christopher Jr.
(b. 1992),
Sarah
(b. 1995)

Matthew Jr.
(b. 1993),
Caroline
(b. 1994)

Grace
(b. 1994),
Max
(b. 1996)

Kiley
(b. 1994)

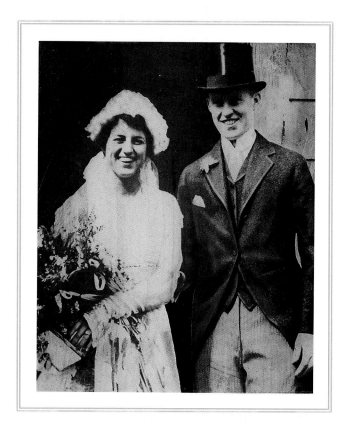

THE FIRST GENERATION
1914

For unto whomsoever much is given,
of him shall be much required;
And to whom men have committed much,
of him they will ask the more.

LUKE 12:48

JOSEPH PATRICK KENNEDY AND ROSE ELIZABETH FITZGERALD

October 7, 1914
Boston, Massachusetts

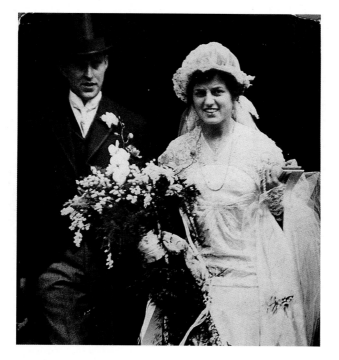

The genesis of the Kennedy Dynasty was a sunny Wednesday morning in the first week of October 1914. Woodrow Wilson was President and World War I was less than three months old when Joseph Patrick Kennedy took Rose Elizabeth Fitzgerald to be his wife, for better or worse, for richer or poorer, in sickness and in health, until parted by his death in 1969. The family they created would contribute immeasurably to the welfare of the country, and at times even inspire the whole world, in the decades to come.

Joe and Rose were married after a nine A.M. Mass in the private chapel of Boston's William Cardinal O'Connell in a ceremony witnessed by only their closest family. Her sister Agnes was her maid of honor, and his Harvard friend Joe Donovan was best man. Afterward they traveled— "by automobile," news reports noted—to the home of her parents for a wedding breakfast, where they were joined by more family and close friends.

In her autobiography, *Times to Remember*, Rose Kennedy says little of her wedding, except to note that "neither of us wanted a public fiesta." She does recall being "a bit stunned by what I saw" when she opened a box containing the two-carat flawless white-diamond engagement ring in the early spring of 1914. It was matched by Joe's wedding gift to her—a splendid diamond-encrusted pendant. Their three-week honeymoon, at the luxurious Greenbrier Hotel in White Sulphur Springs, West Virginia, was the start of a marriage that lasted fifty-five years.

She was born in the shadow of Boston's Old North Church, its towering spire made famous by Longfellow's poem "Paul Revere's Ride." She had been the "first daughter" of the city during the mayoral reign of her father, the legendary "Honey Fitz," John Francis Fitzgerald. At twenty-four, Rose Fitzgerald had traveled extensively, been educated abroad, and was lauded in the contemporary press as "one of the most talented young women in the city," praised not only for her charm but also for her charitable and educational work.

She loved American history, having been reared in the cradle of it, in Boston and Concord, and her marriage to Joseph Patrick Kennedy would ensure her place in the history of twentieth-century America.

She didn't know that, though, the morning she posed for this formal wedding portrait in her gown of duchess satin and rose point lace. She was a young woman in love and had chosen an elegant dress in which to become Mrs. Joseph P. Kennedy. Her winsomely pretty face was framed by a Normandie cap of lace and a veil of white tulle. The train was fashioned of white brocaded satin with trimmings of silver and pearl. She carried a shower bouquet of lilies of the valley, sweet peas, and rosebuds.

TOP LEFT AND RIGHT These engraved announcements, rather than invitations, were sent to family and friends to commemorate the marriage of the attractive young couple. Fewer than two dozen people—almost all of them family—attended the wedding ceremony in the cardinal's private chapel, and only fifty more were invited to the wedding breakfast.

BOTTOM This photograph was last published at the time of the wedding and shows Rose with her father, "Honey Fitz," and her sister Agnes Fitzgerald, who was maid of honor. Though they would seem to have been photographed en route to the ceremony, the picture was actually taken afterward, with Mrs. Joseph P. Kennedy's husband nowhere in sight! Such was the public interest in the former mayor and his family. Newspaper reports described Agnes as "charming, in a costume of rose pink velvet with silver trimmings and hat of tete de negre trimmed with brown marten and roses. She carried a bouquet of Ward roses."

Mr. and Mrs. John Francis Fitzgerald
announce the marriage of their daughter
Rose Elizabeth
to
Mr. Joseph Patrick Kennedy
on Wednesday the seventh of October
one thousand nine hundred and fourteen
Boston Massachusetts

At Home
Second and fourth Tuesdays in January
at Eighty-three Beals Street
Brookline Massachusetts

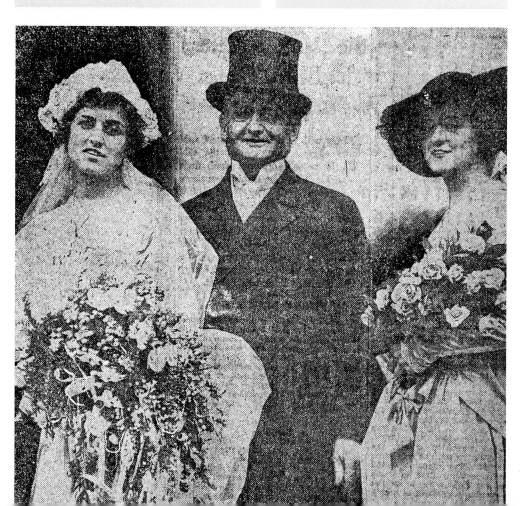

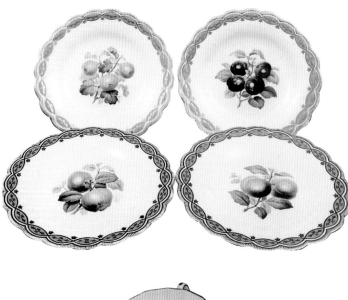

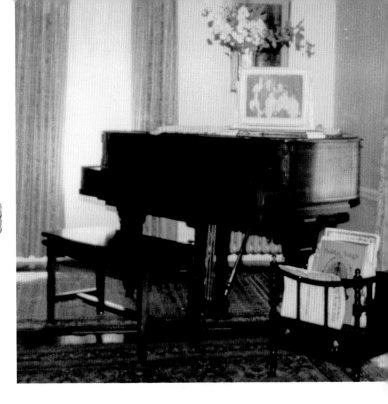

ABOVE LEFT The designs on these dinner plates were hand-painted by Joe Kennedy's sister Margaret Kennedy Burke as a wedding gift to the young couple.

ABOVE RIGHT This Ivers and Pond grand piano was a wedding present from two of Rose's Fitzgerald uncles. It stands in the living room of the JFK birthplace.

MIDDLE LEFT Sir Thomas Lipton, the tea magnate, gave Rose and Joe a set of teacups decorated with flags and shamrocks, similar to the ones he used on his sailing yacht, *Shamrock.*

BELOW LEFT The monogrammed silver and Limoges dinner service were also wedding presents. Rose Kennedy remembered that "a little wine or champagne was served at weddings or christenings."

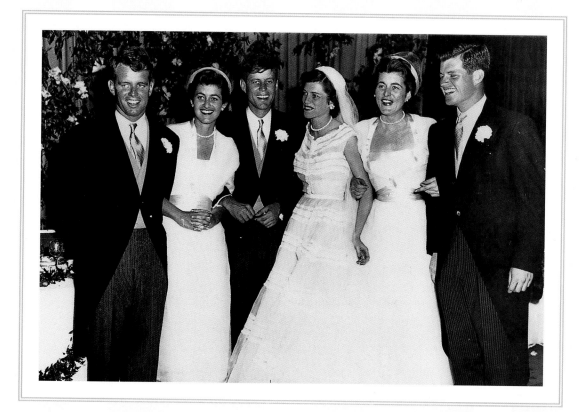

PART II

THE SECOND GENERATION
1944–1992

There's Bobby and Jackie and Jack.

And myriads more in the back:

There's Ethel and Teddy and Pat alone,

Plus Eunice and Peter and Jean and Joan.

And what's his name—? Stephen.

And hold the phone—

The one in the army—

One in the army?

Captain . . . Major?

Sargent!

That's it!

STEPHEN SONDHEIM, *MERRILY WE ROLL ALONG*

KATHLEEN AGNES KENNEDY AND WILLIAM JOHN ROBERT CAVENDISH, MARQUESS OF HARTINGTON

May 6, 1944
London

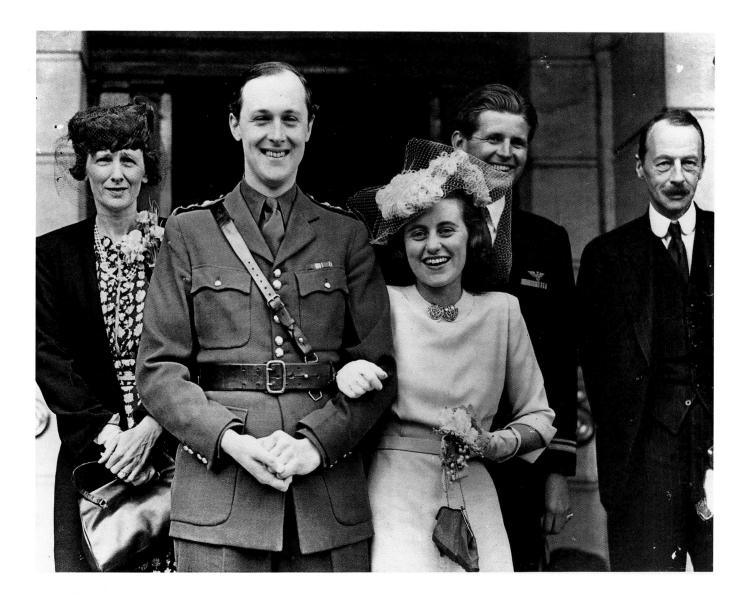

*K*athleen was the first in the second generation of the Kennedy family to marry, and the story of her marriage to Billy Hartington is riveting for its romance, drama, and ultimately tragic end. As Rose describes it in her memoirs, *Times to Remember,* "The two young people were much in love. Joe and I and the duke and duchess were friends. We were very fond of Billy. They were equally fond of Kick. This would have been 'a marriage made in Heaven' except for the special and ironic circumstances of religious loyalties."

In the summer of 1938 at a garden party at Buckingham Palace, "Kick" Kennedy was introduced to Billy Hartington. She was the captivating daughter of the American ambassador. He was the scion of one of the noblest families in Great Britain. "Kick was an absolute star," recalled Lady Anne Tree, Billy's youngest sister. "She was quite unlike any English girl. . . . She was a shining light of gaiety and pleasure and enthusiasm." Her romance with Billy blossomed over the course of six years, two continents, and a world war. Kathleen had gone home to the United States at the beginning of the war but had returned to London in 1943, to work with the Red Cross. Their love affair would have, indeed, been "a marriage made in heaven," except for the difficulties that their religious differences caused.

"It's hard to understand these days what all the fuss and bother was about," said Lady Elizabeth Cavendish, Billy's sister and Kick's closest friend in the Devonshire family. "It was a question of patronage. At that time, as heir, it would have become Billy's responsibility to appoint the clergy in all the parishes [of the High Church of England] on the estates. This was a grave responsibility and one Billy felt keenly that he couldn't honor if he were to change his religion." On the other hand, Kathleen was a member of one of the most prominent Catholic families in America; the Kennedys had represented President Roosevelt at the coronation of Pope Pius XII. Given the rigid stricture of the times, it was impossible for Kick to marry outside the faith and remain within the Church. This dilemma was cause for much debate, soul searching, and prayer. Though all parties tried, no acceptable compromise emerged, and so Kick and Billy married in a civil ceremony in the Chelsea Registry Office.

There, shortly before noon on Saturday, May 6, 1944, Kick and Billy recited the declaratory ("I do solemnly swear that I know not of any lawful impediment why I, Kathleen, may not be joined in matrimony to William") and contracting ("I call upon these persons here present to witness that I, William, do take thee, Kathleen, to be my lawful wedded wife") words of the civil marriage contract. Once declared husband and wife, the new marquess and marchioness, Lord and Lady Hartington, left the building to a shower of rose petals (it was wartime and rice was too valuable a commodity to be thrown away) and posed for photographers with the duke and duchess and Joe Kennedy Jr.

A few days after the wedding, Kick received a telegram from her father: WITH YOUR FAITH IN GOD, YOU CAN'T MAKE A MISTAKE. REMEMBER YOU ARE STILL AND ALWAYS WILL BE TOPS WITH ME. She was much comforted by her father's words. Kick and Billy had a week's honeymoon and a mere five weeks together ("the most perfect month," Billy wrote in his wife's diary) before his regiment was called away to fight in the invasion of Europe.

It was only a few weeks later, in the summer of 1944, when fate intervened in a tragic way. On August 12, Joe Jr. died in a dangerous bombing mission. Kick left London to mourn with her family, and less than a month later, on September 10, her beloved Billy was killed by a sniper in Belgium.

"I guess God has taken care of the matter in His own way, hasn't He?" Kathleen later wrote to a friend. She was to continue living in England—"She was very much part of our family," remembered Elizabeth Cavendish fondly—until her own tragic death in a plane crash in May 1948.

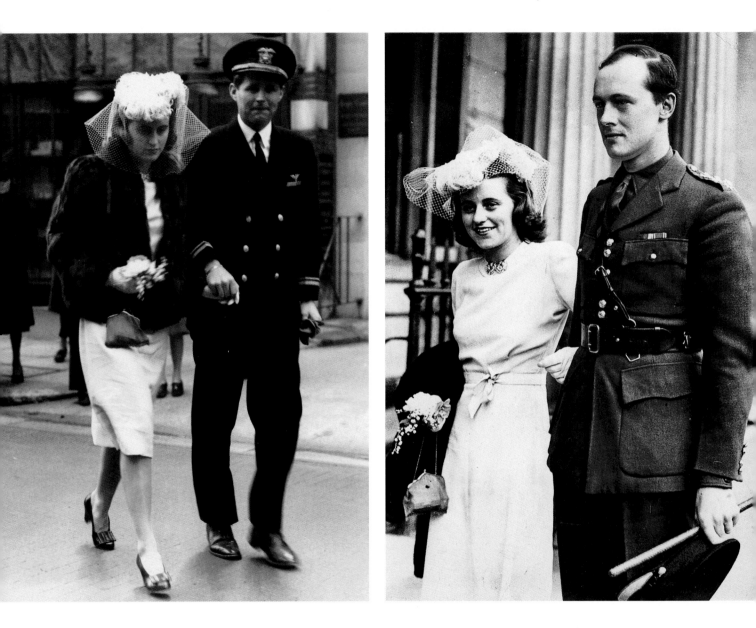

"But never did anyone have such a pillar of strength as I had in Joe in those difficult days before my marriage. From the beginning he gave me wise, helpful advice. When he felt I had made up my mind, he stood by me always. He constantly reassured me and gave me renewed confidence in my own decision. He could not have been more helpful and in every way he was the perfect brother doing, according to his own light, the best for his sister with the hope that in the end it would be the best for the family. How right he was!" Kathleen wrote these words about her brother for a private memoir, compiled and published after Joe's death by his brother Jack.

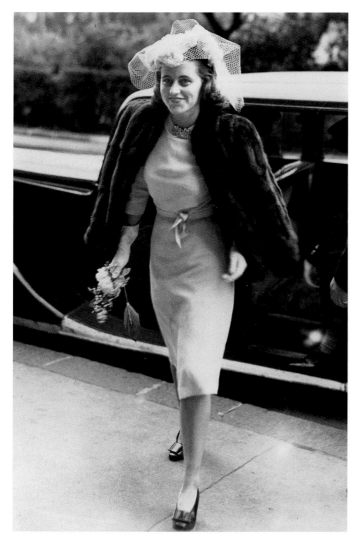

TOP Kathleen's dress was a pale pink crepe—made just the day before the wedding. With it, she wore a small hat made of pink ostrich feathers and veiling, and a brown mink jacket. Marie Bruce, a great friend of Rose Kennedy's, took charge of the arrangements. She recounts, in *Times to Remember*, that the "best fitter in London, Miss Jarvis, sat up all night to make the dress. There was no time for fittings, so she copied one of Kick's American dresses. We did not have enough coupons for material, so the milkman gave us his.... She carried my gold mesh bag with sapphires and diamonds, which I gave her for 'something old and something new' and a new posy of pink camellias I made for her.... She looked enchanting. Charles Rutland (Duke of Rutland) was the best man. Only others at marriage in the Registry were Devonshires, Anne, Elizabeth, Lady Salisbury [Billy's aunt], Lady Astor, young Joe, and me.... Eddie and Moucher [Billy's parents, the duke and duchess] gave her a diamond bracelet.... Reception was held at Lord Hambleden's house in Eaton Square. I gave five pounds to the head waiter at Claridge's and had a chocolate cake made for us."

More than two hundred people attended the wedding reception, including many of Kathleen's coworkers from the Red Cross. One of them, an American sergeant, pulled Billy aside and told him, "You've got the best damn girl that America could produce."

BOTTOM Stationed in London, Joe was the only member of the family able to attend the hastily arranged wartime nuptials. Here he stands with Lady Virginia Sykes at the wedding reception, which was held in the Eaton Square home of Billy's aunt Ester, Lady Hambleden—as a bomb had badly damaged the duke and duchess's house in Carlton House Terrace.

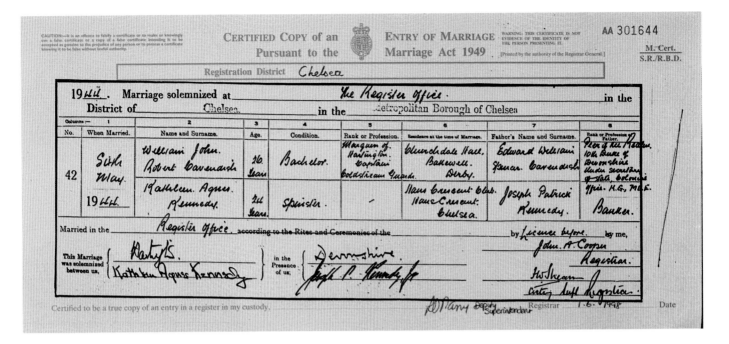

A simple municipal license, but oh, the history that surrounds it, as one of Britain's most revered and historical families married its heir to the young daughter of a family that would become one of the most influential of the twentieth century.

With its quaint and somewhat antiquated language, "bachelor" William John Robert Cavendish, twenty-six, married "spinster" Kathleen Agnes Kennedy, twenty-four, in the simplicity of a registry office in the London borough of Chelsea—the equivalent of going to a justice of the peace. The starkness of the room was relieved by vases of pink camellias that the groom's father had had sent down from eighteenth-century hothouses at Chatsworth, the family's magnificent seat in Derbyshire.

Look at the section requesting the "rank or profession of father." The first peals off the tongue in full British glory—

"Edward William Spencer Cavendish, Peer of the Realm, 10th Duke of Devonshire, Under Secretary of State, Colonial Office, K.G. [Knight of the Garter, Britain's oldest order of chivalry], M.B.E. [Member of the British Empire]."

The second is listed simply as "banker," but Joseph P. Kennedy was much more than that. Widely unpopular in Britain at the time, seen as a defeatist and isolationist before the United States' entry into the war, Joe Kennedy was something new, and perhaps frightening, to the British aristocracy. He was a leading member of the "meritocracy"—the new elite of the twentieth century whose power was not inherited but earned. In some ways, this marriage is a metaphor for the complex balancing act of the transfer of power in modern times.

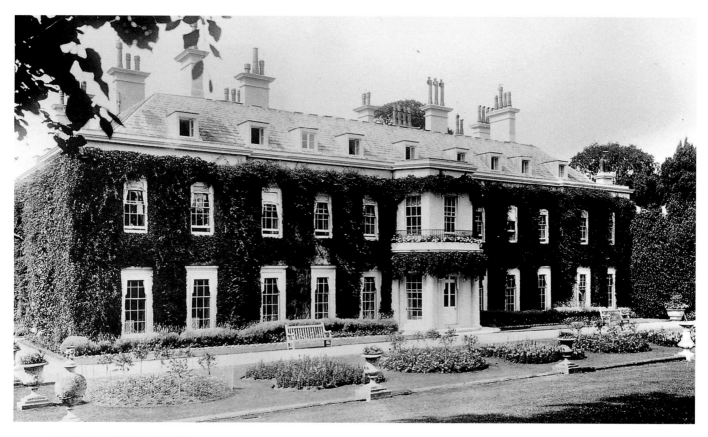

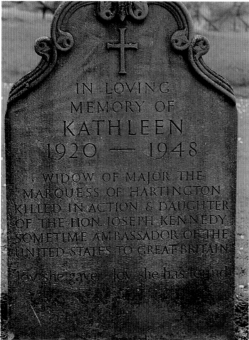

IN LOVING
MEMORY OF
KATHLEEN
1920 — 1948

WIDOW OF MAJOR THE
MARQUESS OF HARTINGTON
KILLED IN ACTION & DAUGHTER
OF THE HON. JOSEPH KENNEDY
SOMETIME AMBASSADOR OF THE
UNITED STATES TO GREAT BRITAIN

Joy she gave—Joy she has found

ABOVE After the wedding reception, Kick and Billy took a train to Eastbourne and walked half a mile from the station to Compton Place, one of the Devonshire family estates, where they spent a week on honeymoon. After the wedding Lord Hartington told a reporter, "We thought no one knew where we were going. . . . No arrangements have been made for a church service." Nonetheless, the couple did receive a blessing by an Anglican priest in a private ceremony on the estate.

LEFT Kathleen lies buried in a tiny village churchyard, a stone's throw from Chatsworth, the Devonshire family seat, Billy having been interred with his fallen comrades in Belgium. Deep in the moss and the shade stands her gravestone, with an epitaph chosen by her mother-in-law, the duchess of Devonshire: *Joy she gave—Joy she has found.*

President Kennedy made a brief visit to Kathleen's grave in June 1963, during his last trip to Europe. The public triumph of his "Ich bin ein Berliner" speech was matched here with a private moment of remembrance and love.

ROBERT FRANCIS KENNEDY AND ETHEL SKAKEL

June 17, 1950
Greenwich, Connecticut

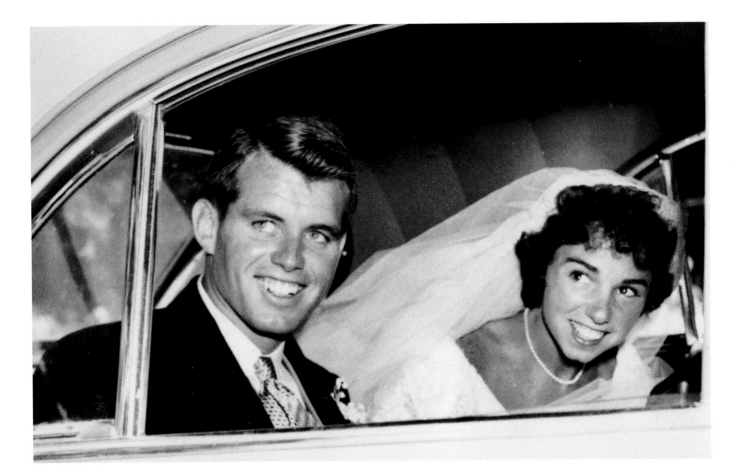

With bright smiles and a brighter look in their eyes, the newly wed Mr. and Mrs. Robert Francis Kennedy drive off on a life's journey unique in the history of twentieth-century America. Their eighteen-year partnership is, of course, famous for their eleven children. But their legacy also includes service to the country, most notably in the U.S. Senate and as Attorney General, and a run for the 1968 Democratic Presidential nomination. Their work inspired promise to people whose lives were filled with broken dreams, bestowed hope in the hearts of people devoid of hope, and touched the imagination of a generation. In the years since her husband's untimely death in 1968, Ethel Kennedy has continued their commitment to human rights through the work of the Robert F. Kennedy Memorial.

Ethel Skakel had been Jean Kennedy's roommate at Manhattanville College and met her brother Bob four years before they were married. The gown she wore was made of white satin and is described as having a fitted bodice and a bateau neckline trimmed with beaded pointe de Venise lace and panels of pearls. She also wore satin mitts embroidered with pearls. Her double-tulle veil was attached to a lace cap trimmed with orange blossoms. She carried lilies of the valley, stephanotis, and eucharis lilies.

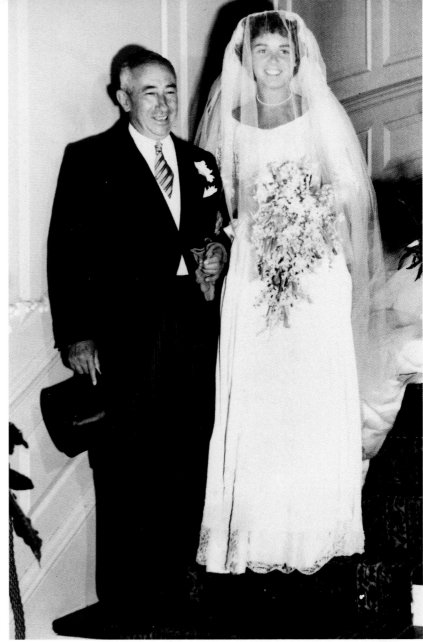

RIGHT Posing with her father, Ethel absolutely glows with happiness. A few minutes earlier, George Skakel had knocked on his daughter's door. "Let's get going," he advised her. "It's almost eleven."

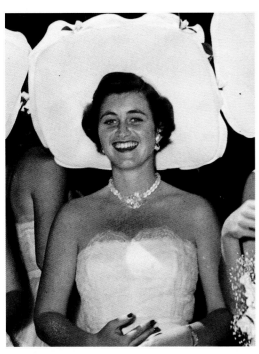

LEFT This was Jean Kennedy's debut as a family bridesmaid, and she put the experience to good use, attending the brides Eunice, Jackie, Pat (as maid of honor), Joan, and, in the next generation, her goddaughter Kathleen (as matron of honor).

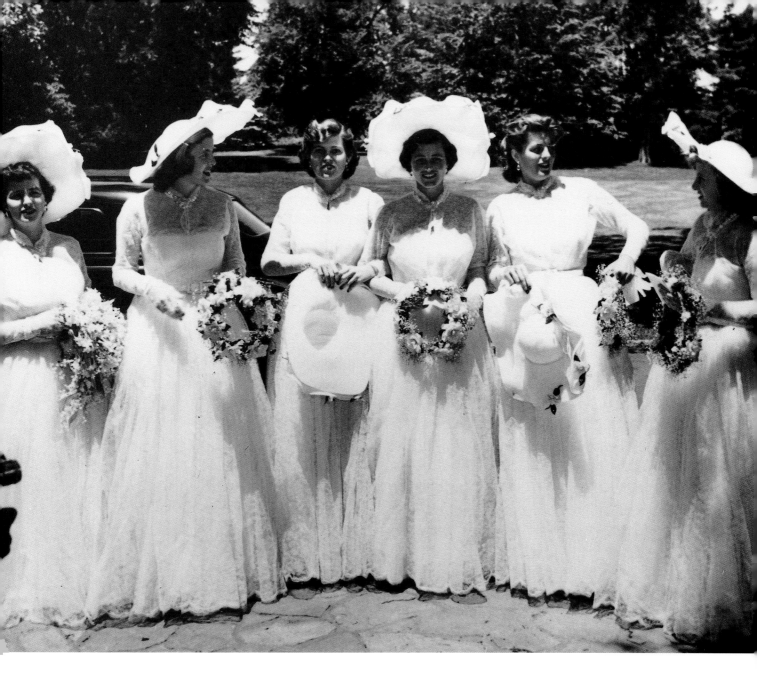

Ethel's three sisters, a sister-in-law, a cousin, and all three Kennedy girls were attendants. The six bridesmaids wore white taffeta dresses with bouffant skirts and an overdress of double Chantilly lace and matching jackets. Their square-brimmed hats were edged with five layers of white organza and decorated with pink gardenias and baby's breath. Instead of bouquets, they carried wreaths of pink gardenias, baby's breath, and lilies.

REMINDERS

Bachelor Dinner
1. Mr. Kennedy & Mr. Skakel should be invited - though probably won't accept.
2. Ushers presents from groom are given at dinner
3. Best man present from groom given at this dinner.
4. Ushers present to groom given at this dinner.
5. One point in dinner - groom Toasts bride & makes speech.

OVER →

REMINDERS

Groom
cutaway
dark gray striped Trousers
double breasted gray waistcoat
white shirt - with french cuffs
detachable stiff Turned-down collar
striped four-in-hand
Black highly polished calf shoes
Black silk socks & garters
gray gloves
garters

Best Man
Same clothes as groom
Tie identical to groom's

Ushers
Same clothes as groom
Tie different than "
But all ushers wear identical ties

INSET Ethel sent several reminders to her future brother-in-law Jack, arranging every last detail of the wedding, including the protocol for the bachelor's dinner ("Mr. Kennedy and Mr. Skakel should be invited—though probably won't accept") and the proper dress of the ushers ("Let's skip the spats . . . black silk socks—all black, no clocks").

RIGHT John F. Kennedy, then a second-term Congressman, invested time and energy fulfilling his duties as best man. A simple note concerning arrangements for the ushers' clothing requirements underwent style and content revisions in his own hand.

He also arranged all the plans for the bachelor's dinner at the Harvard Club in New York (selecting a $4.50-per-head menu of roast beef and stuffed chicken rather than a $7 choice of lobster and filet mignon).

In addition to the gentlemen in the wedding party, many of Bob Kennedy's Harvard football teammates were among the guests. The party got a little rambunctious—in JFK's words, "a couple of young men . . . got out of hand"—prompting a letter of apology and a check for more than a thousand dollars for damages incurred.

TO BRIDAL PARTY:-

Enclosed is the schedule of activities for June 14th to 17th, inclusive. If it is not possible for you to attend any of the functions, it is requested that you kindly inform Miss Ethel Skakel.

Would you also kindly advise Miss Skakel regarding the date of your expected arrival at Greenwich and the length of your stay there. Accommodations for all, including wives and husbands of the married bridesmaids and ushers, will be provided.

Ushers are requested to furnish me their glove sizes.

Ushers who do not own a morning suit are requested to forward their sizes to me and arrangements will be made for their rental, suite in Greenwich. Fittings can be made after ushers' arrival in Greenwich. This is necessary in order to assure a uniformity of style and color in the bridal party. Arrangements must be made beforehand due to the number of weddings in Greenwich in June.

Schedule for cars to and from Church will be posted on a bulletin board in the Skakel home, and we ask that each one read this bulletin board.

John F. Kennedy

NOTE--Miss Davis: Miss Ethel Skakel wondered whether the ushers should reply to her or to Jack regarding paragraphs three and four above. If Jack is going to handle it, memo will remain as is; if he wants her to handle it, paragraph three would say: Ushers are requested to furnish Miss Skakel, etc.

K.D.

May 12, 1950

Congressman John F. Kennedy
Congress of the United States
House of Representatives
Washington, D. C.

Dear Jack:

Thank you very much for the very boring letter. If your
letters to your constituents are as boring as the one I just
received, it is a great wonder to me how you have stayed in
Congress as long as you have.

I think a cigarette box is an excellent idea, particularly
when neither Bobby nor Ethel smokes, and I can't feature Bobby
purchasing cigarettes to fill it for other people to smoke. I
might suggest a silver cocktail shaker with which I am sure your
pappy would be very much in accord. However, you might find out
which is less expensive and give him that.

Although your dull letter did not indicate any interest as to the
time I am arriving, I plan to fly up to New York Friday night,
June 9, and will be up on the Cape Saturday, to be completely on
your hands until after the wedding.

I am attaching my impressive signature as you requested. See you
soon.

 Best,

 GENERAL SHOE CORPORATION

 Kirk

 Kirk L. Billings
 Advertising Manager

KLB:ml

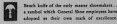

Bench knife of the early master shoemakers ..
a symbol which General Shoe employees have
adopted as their own mark of excellence.

LEFT JFK also organized the ushers' gift for the couple—a silver cigarette box with all their signatures engraved on it (at a per man cost of $11.25). His form letter to the ushers informing them of this spurred this letter back from his close friend and prep school roommate Lem Billings. The letter is a delicious example of the teasing and goading that peppered their friendship.

BELOW Best man John F. Kennedy shakes hands with a priest as he and the groom enter the church from a side door.

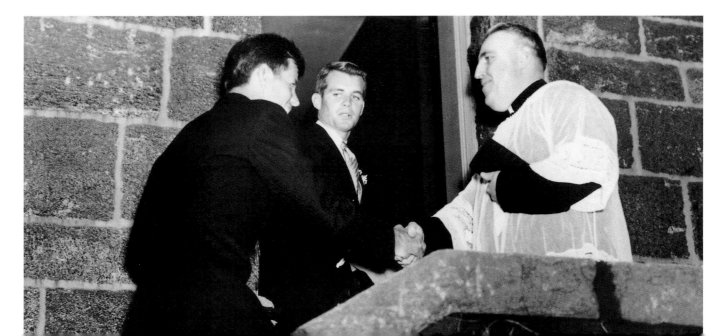

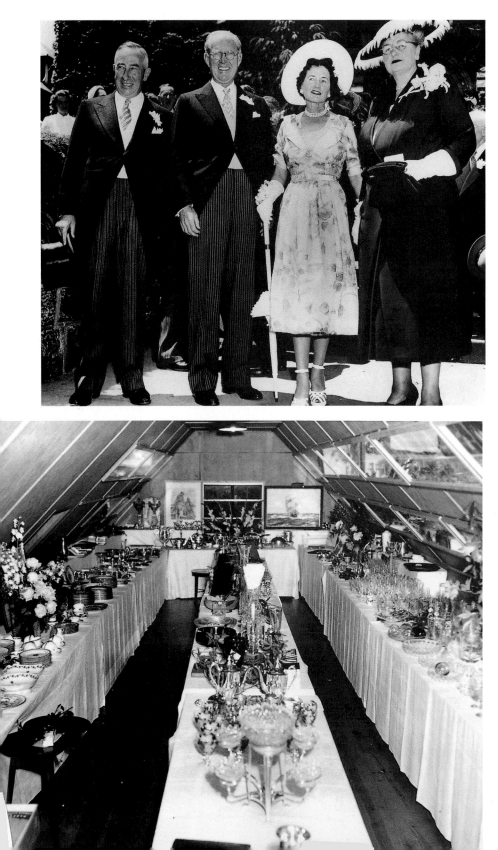

TOP The Skakels and the Kennedys share many similarities—both families are influential, wealthy, and strongly opinionated. But George and Ann Skakel and Joseph and Rose Kennedy shared something more important—a legacy of eleven grandchildren whose ranks include a U.S. Congressman, a Lieutenant Governor, a pair of human-rights activists, an environmental activist, a documentary filmmaker, an educator, a journalist, and innovative business leaders.

BOTTOM A custom of the times was to display the wedding gifts during the reception. Who would be surprised to learn that the couple was showered with lavish gifts?

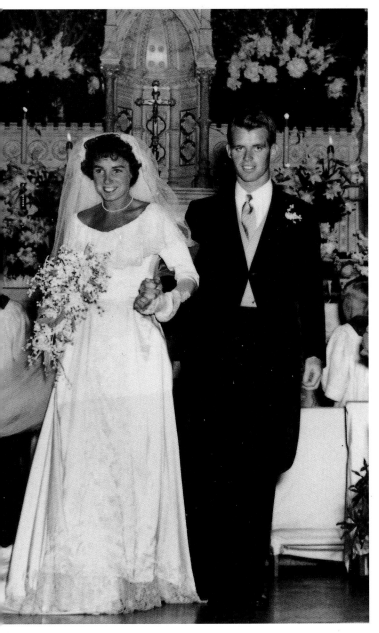

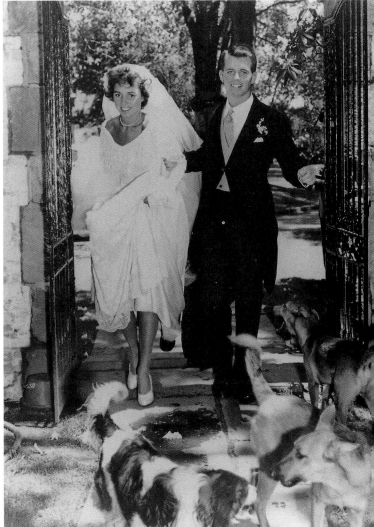

LEFT Now husband and wife, Ethel and Bob stand before the ornate main altar at St. Mary's Church in Greenwich, Connecticut. The church was banked with white peonies, regal lilies, and flowering dogwood. The Reverend Terence Connolly of Boston College celebrated the wedding and also delivered the papal blessing. The tenor voice of Michael O'Higgins, from the Royal Irish Academy of Music, sang the nuptial Mass.

RIGHT Ethel once recalled the beginning of her relationship with Bob Kennedy. "He was momentarily mad about me—for two weeks. Then he took out my older sister, Pat, for two years. She was much prettier and intellectual." Eventually, though, fate intervened.

Ethel takes a private moment to tuck into her wedding breakfast, which offered a tasty menu of "decorated Puerto Rican pineapple filled with fresh fruit Parisienne; roast filet of beef, mushroom, small Bermuda potatoes, jumbo asparagus and amber pudding with rum sauce."

Wedding Breakfast
in honour of
Mr. and Mrs. Robert F. Kennedy

Menu

June 17, 1950

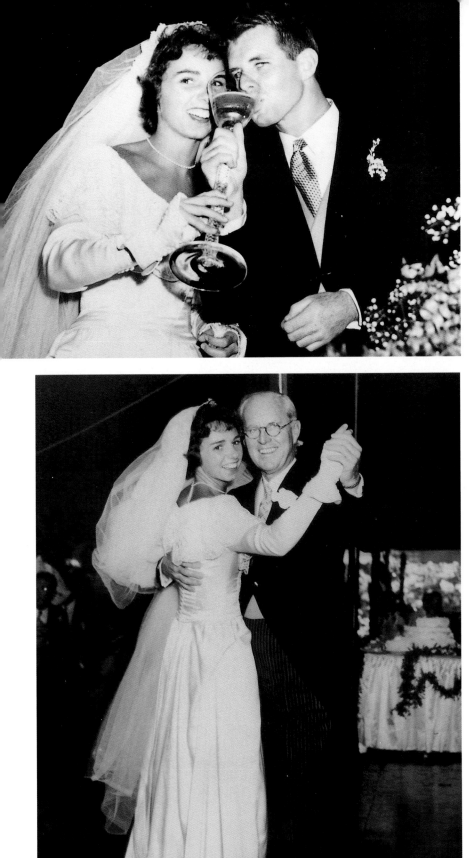

TOP The newlyweds sip from a Steuben loving cup. A cherished family heirloom, it was used a generation later in several of the couple's children's weddings.

Family friend Lem Billings, at a party before the wedding, offered a jocular toast: "Let me remind you that marriage is final. Bobby's trouble is heartfelt; Jack's is only spinal."

BOTTOM Joe Kennedy welcomes his first daughter-in-law into the family. Ethel's assimilation into the tight-knit family seemed effortless—in her enthusiasms, energies, and religious commitment, she shared many of the same values as her new family.

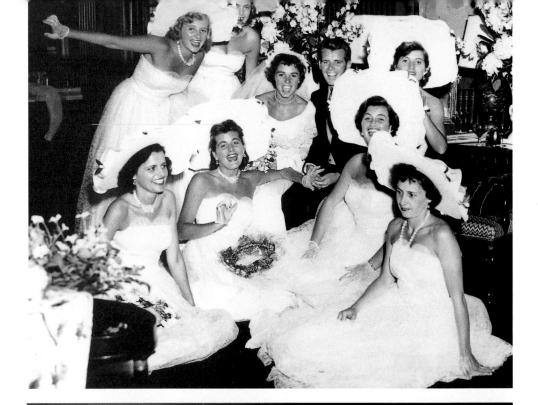

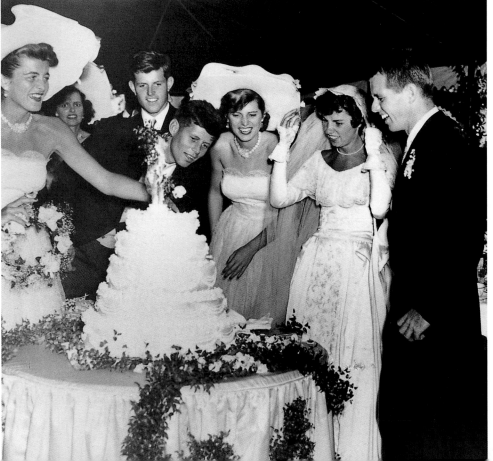

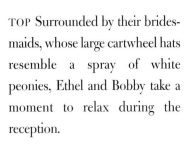

TOP Surrounded by their brides-maids, whose large cartwheel hats resemble a spray of white peonies, Ethel and Bobby take a moment to relax during the reception.

BOTTOM Something about the wedding cake is interesting enough to have caught the atten-tion of a sextet of Kennedys—Pat, Ted, Jack, Eunice, Ethel, and Bob. What it was remains hidden in the annals of history.

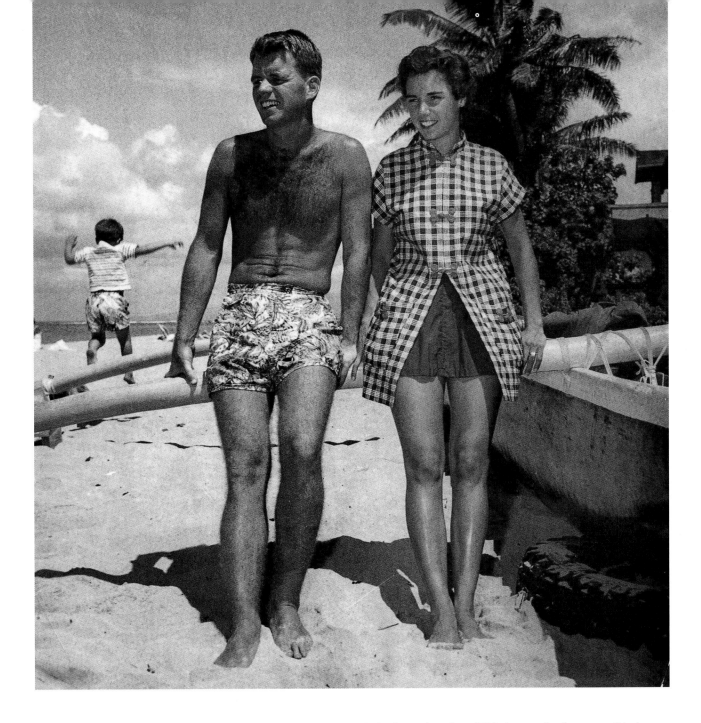

Pictured here on the beach outside Honolulu's Halekulani Hotel, Bob and Ethel spent the first part of their honeymoon in Hawaii, then flew back to Los Angeles and, borrowing his sister Pat's convertible, spent a leisurely three months driving across the country.

EUNICE MARY KENNEDY AND ROBERT SARGENT SHRIVER JR.

May 23, 1953
New York City

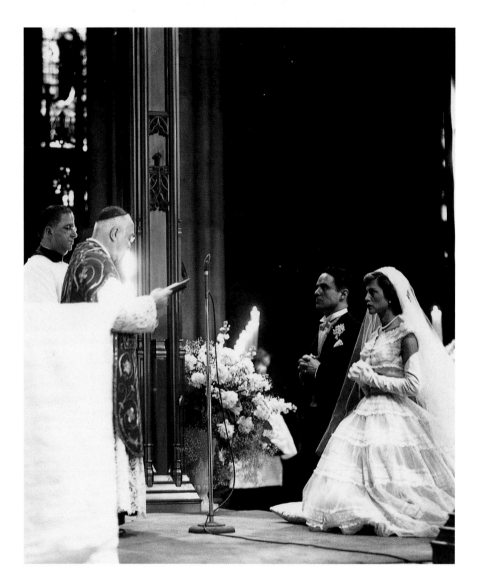

*S*argent Shriver and Eunice Kennedy kneel before Francis Cardinal Spellman at St. Patrick's main altar and receive a papal blessing. It was the first wedding and nuptial Mass that the cardinal had celebrated, outside of his family, since his elevation to the cardinalate in 1946.

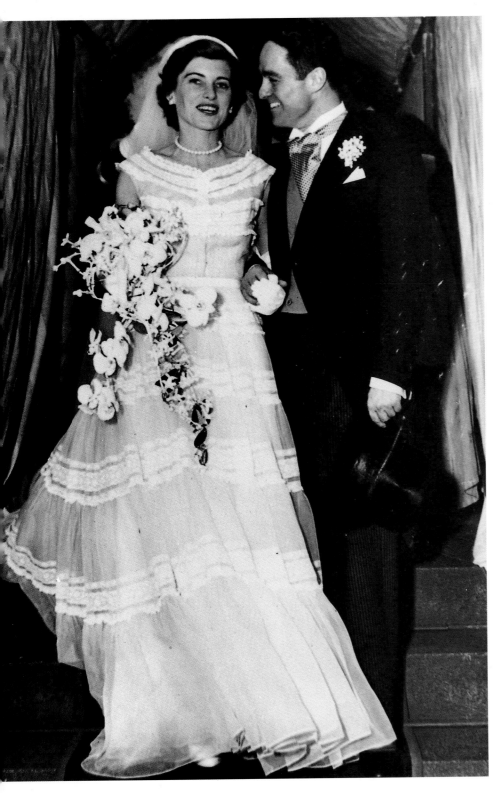

Eunice and Sarge met in 1946 at a party in New York. His seven-year pursuit of Miss Kennedy was described as "fantastically dogged" by journalist Charles Bartlett, a family friend, who said, "Sarge was in love with Eunice" from the instant they met. Though she remembers finding him "very attractive," he had his work cut out for him.

Lady Elizabeth Cavendish remembered a 1947 visit to the Georgetown house that Eunice shared with then-Congressman John F. Kennedy. She spoke of Sarge's steadfastness: "After we all had gone to bed, I remember Sarge would come and toss little stones up to Eunice's bedroom window so they could court. So charming."

"Eunice wasn't the sort of girl you could sweep off her feet," Sarge recalled. "When I first met her, she was being pursued by men on both sides of the Atlantic, all of them more or less eligible and some of them titled. She took her time. For one thing, of course, she looked on marriage as for keeps. Naturally she didn't want to make a mistake."

Eventually his persistence won and he was able to slip a diamond-and-sapphire ring on her finger, and on March 15, 1953, their engagement was announced. Their marriage has lasted the longest in their generation of the family, and they have been blessed with five children: sons Robert, Timothy, Mark, and Anthony, and daughter Maria.

EUNICE MARY KENNEDY AND ROBERT SARGENT SHRIVER JR.

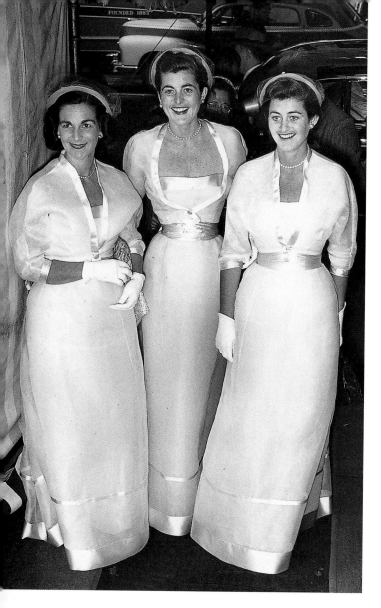

LEFT Pat and Jean Kennedy stand with Mrs. Robert Coleman at the Fifth Avenue entrance to the church. Like her sister-in-law Ethel, Eunice dressed her bridesmaids in white. Their gowns were made of organdy, with matching bolero jackets that could be removed once the reception started. The strapless bodice and the hem of the full skirt were banded in white satin, and there was a waist sash that tied in a bow in the back and had long streamers that fell to the floor. The bridesmaids wore caps of basket-weave satin and carried nosegays of garnet-colored roses and stephanotis. This gown would make a subsequent appearance a few years later at another Kennedy wedding.

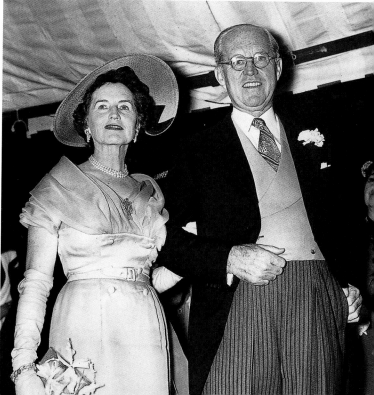

RIGHT Eunice was the middle child, the fifth of Joe and Rose's nine offspring. She inherited the best characteristics of both—a commitment to excellence, compassion, drive, and faith. Her mother was named a papal countess by Pope Pius XII, but it is the world's respect and admiration for her groundbreaking work with the mentally challenged that has ennobled Eunice Kennedy Shriver.

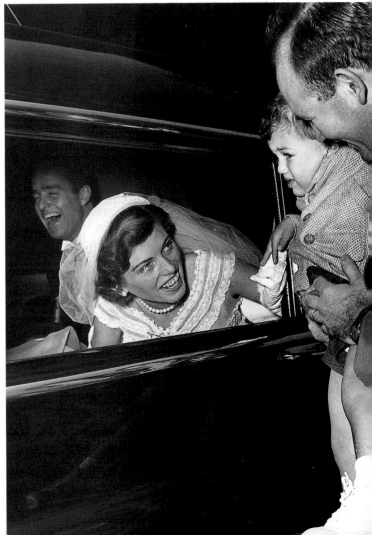

BELOW At two years of age, little Richard Snyder most likely doesn't understand what all the fuss is about when the pretty lady leans out of her car to shake his hand. Richard and his father, Aaron, were among the hundreds of spectators who crowded around the cathedral to watch the wedding activities.

ABOVE Sarge's mother, Mrs. Robert S. Shriver, is escorted from the church by her nephew William Shriver. Sarge's father, a banker, had died when he was a young man. The Shriver family played an eminent role in the history of the United States. One ancestor, David Shriver, was a signer of the Stamp Act and the Bill of Rights; another, Robert Owings, held the original land grant from Lord Baltimore for the larger part of what is now Maryland; yet another, General T. Herbert Shriver, was for many years adjutant general of Maryland. Sargent Shriver added further distinction to his family's annals, founding the Peace Corps during the Kennedy Administration, serving as U.S. Ambassador to France in the late 1960s, and becoming the Democratic candidate for Vice President in 1972.

In a tribute to the two most important men in her life, Eunice toasted her new husband: "I searched all my life for someone like my father, and Sarge came closest." Here she dances with Joe Kennedy while youngest brother Ted looks on.

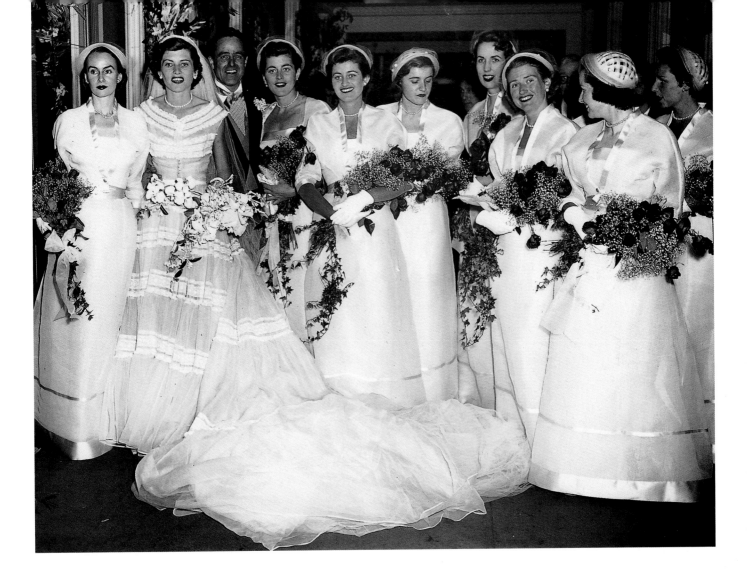

I want a wedding in a big church with bridesmaids and flower girls,
A lot of ushers in tailcoats, reporters and photographers . . .
A big reception at the Waldorf with champagne and caviar . . .

Irving Berlin wrote these lyrics for a song he added to a revival of *Annie Get Your Gun* in 1966. A good friend of the Kennedy family, he was a wedding guest at St. Patrick's, a very "big church," and at the "reception at the Waldorf [Astoria Hotel]." Did the famed Broadway composer immortalize the Shrivers' wedding in a song written for the clarion voice of Ethel Merman? Seems so.

With a look of sheer determination, Eunice makes the first cut in the eight-tiered wedding cake as her new husband offers stalwart support. Thirty-three years later, their daughter, Maria, had the cake duplicated for her wedding to Arnold Schwarzenegger.

JOHN FITZGERALD KENNEDY AND JACQUELINE LEE BOUVIER

September 12, 1953
Newport, Rhode Island

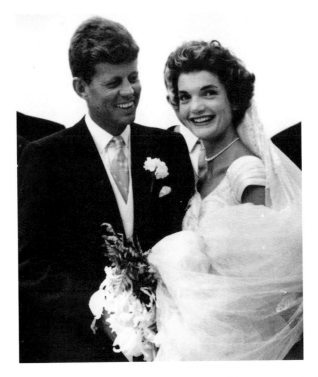

Was there ever a more glamorous couple? Or a more glorious wedding? Nearly fifty years after that September afternoon in Newport, the images from this wedding still captivate us. The sheer numbers from the day are staggering: seven hundred guests at the church, an additional five hundred attending the reception, two dozen wedding attendants, fifty yards of silk taffeta for her gown, scores of bottles of vintage champagne.

The marriage of Jacqueline Lee Bouvier and John F. Kennedy was, above all, a love match of two intriguing and intelligent personalities. Their relationship was complex, as Jackie herself once spoke of: "Since Jack is such a violently independent person, and I, too, am so independent, this relationship will take a lot of working out." But it was also tender and teasing, loving and rewarding.

Rose Kennedy wrote in her memoirs, "Jack loved her ... and appreciated her. And it would be hard to imagine a better wife for him. She brought so many things that helped round out and fulfill his character. She developed his interests in art, music and poetry—especially poetry, in which he had had only a mild interest before." Much has been written about the relationship between John and Jacqueline Kennedy, but one need only look at this picture to see the tenderness and affection in Jack Kennedy's eyes as he regards his new wife.

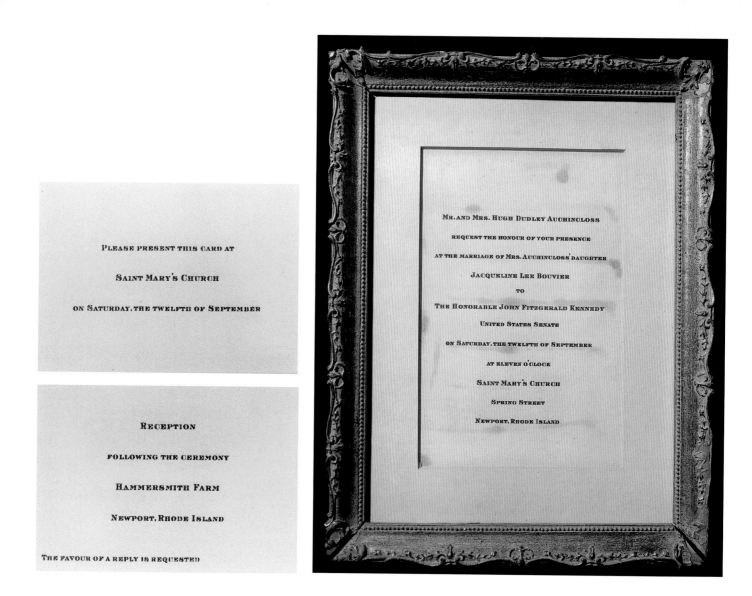

PLEASE PRESENT THIS CARD AT

SAINT MARY'S CHURCH

ON SATURDAY, THE TWELFTH OF SEPTEMBER

RECEPTION

FOLLOWING THE CEREMONY

HAMMERSMITH FARM

NEWPORT, RHODE ISLAND

THE FAVOUR OF A REPLY IS REQUESTED

MR. AND MRS. HUGH DUDLEY AUCHINCLOSS

REQUEST THE HONOUR OF YOUR PRESENCE

AT THE MARRIAGE OF MRS. AUCHINCLOSS' DAUGHTER

JACQUELINE LEE BOUVIER

TO

THE HONORABLE JOHN FITZGERALD KENNEDY

UNITED STATES SENATE

ON SATURDAY, THE TWELFTH OF SEPTEMBER

AT ELEVEN O'CLOCK

SAINT MARY'S CHURCH

SPRING STREET

NEWPORT, RHODE ISLAND

More than a thousand of these formal invitations were mailed out in August of 1953—the guest list was a curious mélange of Newport society, Hollywood celebrity, Boston pols, and Washington power brokers. Included with the invitations were two cards: one announced a reception at Hammersmith Farm immediately following the ceremony and the second, a small cream-colored admittance card, read, "Please present this card at St. Mary's Church on Saturday, the twelfth of September."

This particular invitation, wearing its age proudly in gilt-framed splendor, was Jacqueline Kennedy Onassis's own, one of the "many objects that had been kept in our apartment," Caroline Kennedy recalled during the opening of the First Lady Exhibit at the JFK Library.

The twenty-four-year-old bride's countenance bears a touch of noble grace. Indeed, in her elaborately designed gown—reminiscent of court dresses of the nineteenth century—Jacqueline could easily be a Hapsburg grand duchess posing for Franz Xaver Winterhalter. This stunning portrait has never before been published and comes from the personal collection of Jackie's step-brother Yusha Auchincloss.

"Remind me first thing Monday morning to start working on the guest list for the wedding. I'm going to invite close friends only," JFK called out to his secretary, Evelyn Lincoln, on the evening of June 25, 1953, as he left his office headed for an engagement party in Hyannis Port. Come Monday morning, she didn't have to remind him at all. As he came in, he gave her a handwritten list with instructions to find the appropriate addresses and to forward the names to the family's office in New York City.

Among the names the Senator jotted down on a yellow legal pad were those of President Harry S Truman and his family. The scope of the list expanded so quickly that the Senator's office issued a guideline for invitations in six categories, ranging from (a) Jack's personal friends to (c) important city, state, and federal officials to (e) workers for the Kennedy for U.S. Senate organization to (g) labor groups. All in all, more than seven hundred were invited to the wedding and an additional five hundred to the reception. Among the few who declined were Vice President and Mrs. Richard M. Nixon—they received a last-minute invitation to join President Eisenhower in Colorado.

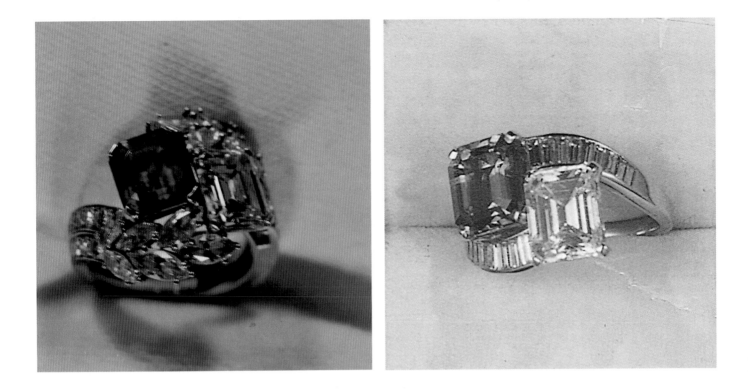

ABOVE LEFT "But I haven't one yet," Jacqueline Bouvier told reporters shortly after her engagement was announced, when asked to show off her ring. "Jack and I have looked at dozens of them. Some I didn't like and others weren't the right type."

Here is the ring that John F. Kennedy presented to his twenty-three-year-old fiancée. Created by Van Cleef & Arpels, it originally consisted of a 2.84-carat emerald matched with a 2.88-carat diamond set in a band of platinum.

During the White House years, Jackie asked the jewelers to redesign the ring. Mary Gallagher, Jackie's personal secretary, recounts that the redesign was one of Jackie's big projects in early 1962. Van Cleef sent a wax model to the White House, and as Mrs. Gallagher wrote in her diary, "Jackie asked for my opinion before making a definite decision. . . . I told her, 'To me it looks much too bulky and takes away from the whole beauty of the ring.' . . . 'Oh,' she replied, 'you're just like Jack.'"

Though the vote seems to have been two to one against, Jackie did get her ring reset with twenty additional round and marquis-shaped diamonds, totaling an additional 2.12 carats. As big around as a quarter, the ring is today in the archives of the John F. Kennedy Library, where it is sometimes put on display.

ABOVE RIGHT This sketch from the vaults of Van Cleef & Arpels shows the original, simpler design of the diamond-and-emerald engagement ring.

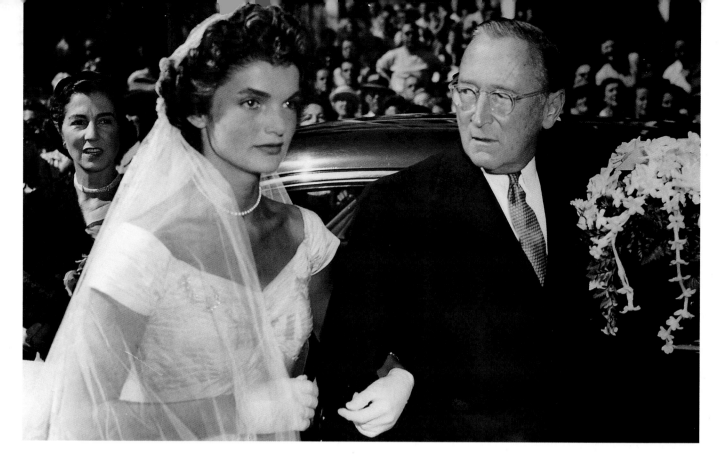

The hidden drama in this wedding story is perfectly portrayed in this photograph of Jackie arriving at St. Mary's Church with her mother and stepfather, Janet and Hugh D. Auchincloss. Missing is her father, John V. Bouvier III, and it was a source of genuine distress for the young bride. Yusha Auchincloss recalled that day some forty-five years later: "Jackie's father and I were good friends. It had been a bitter divorce. Jackie was close to her father and thought of her father and me as her best friends. He came up expecting to be part of the wedding. He was this Clark Gable character—all spruced up with a cutaway and everything. Jack Bouvier was made to feel uncomfortable here in Newport and wasn't invited to the reception. I tried to, sort of, diplomatically ease the situation, I and Bobby Kennedy and one of the ushers. Tried to smooth that over. He definitely wanted and obviously would have been proud to escort Jackie down the aisle, but he knew he was not welcome. I heard that he did come to the church and sit in the back, but I didn't see him. One of the ushers, Smathers, went and brought him to the church. Jack felt bad. Jackie was very surprised when my father stepped in. She was shocked, but she understood. It was a humiliating experience, but Jack Bouvier was such a gentleman that he would not be someplace where he would be unwelcome. Jackie, I don't think she ever forgave her mother, although she was very attentive to her once Janet became ill."

Yusha would later write in a memoir, *Growing Up with Jackie*, "Privacy had become public, possible conciliation had turned confrontational, and as an usher, brother, brother-in-law and friend, I hoped the event would quickly end, and I was glad to see the couple leave for Acapulco."

But on that morning, with a dignity that would later impress the world, Jacqueline Bouvier hid her dismay, rose to the occasion, and faced both family and guests with grace, charm, and poise.

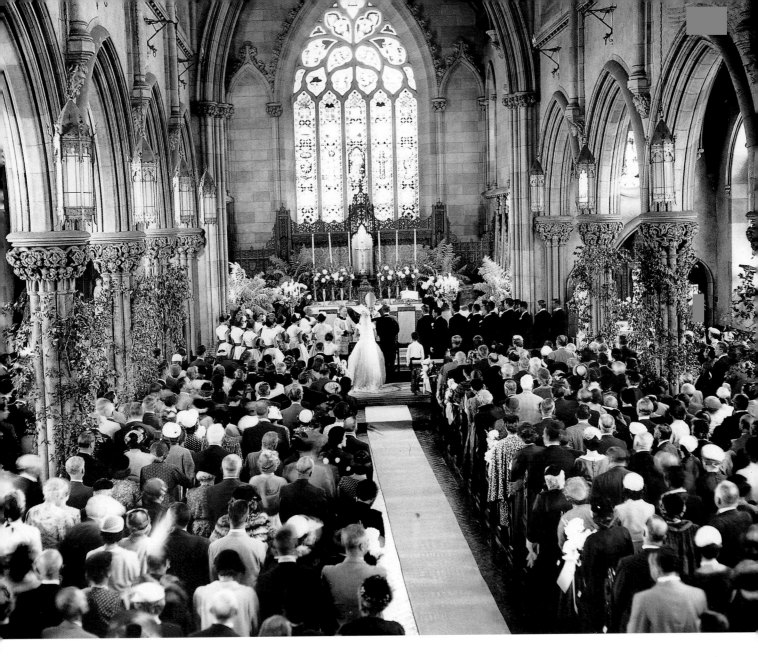

Seven hundred guests filled St. Mary's Church to capacity. The Gothic structure, tall and narrow, with sunlight gleaming through its stained-glass windows, was decorated with pale pink gladioli, white chrysanthemums, and smilax.

Among the invited guests were five U.S. Senators, the Speaker of the House of Representatives, twenty Congressmen, Nancy Lady Astor, British press tycoon Lord Beaverbrook, Lady Elizabeth Cavendish, Pamela Churchill (later Harriman), movie actress Marion Davies, the duke and duchess of Devonshire, Supreme Court Justice William O. Douglas, future British Prime Minister Anthony Eden, Alice Roosevelt Longworth, movie mogul Joe Schenck, Adlai Stevenson, IBM chairman Thomas Watson, Joe Alsop, writer John Hersey, and Broadway lyricist Alan Jay Lerner.

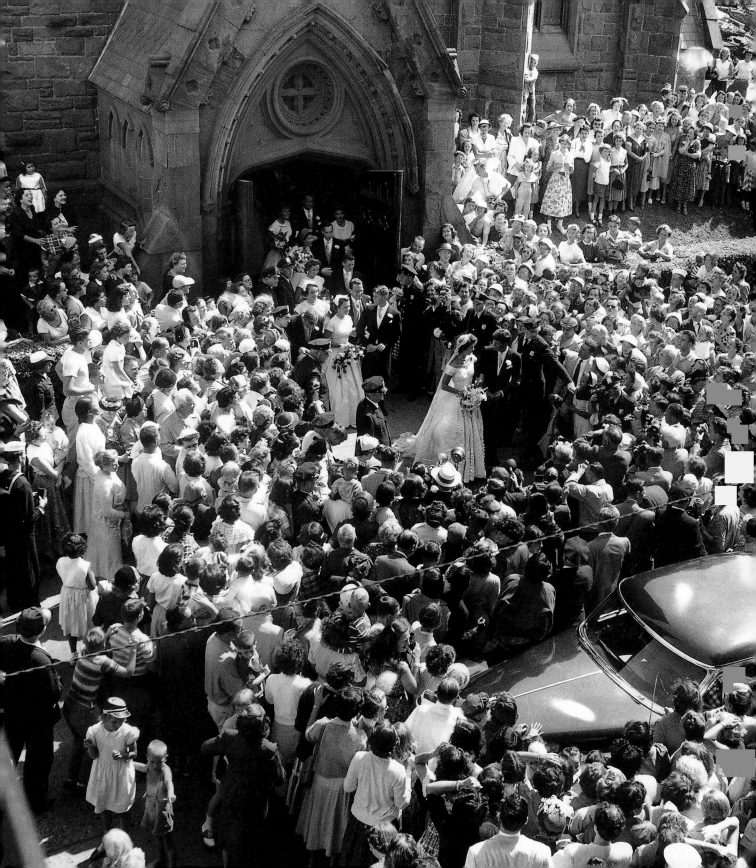

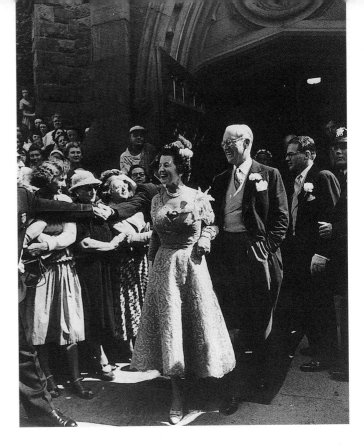

ABOVE Jackie spoke of her feelings toward her new in-laws. Of Rose, she recalled, "The first time I met her was about a year, a little more than a year before I married Jack, when I came that summer for a weekend. I remember she was terribly sweet to me. For instance, I had a sort of special dress to wear to dinner—I was more dressed up than his sisters were, and so Jack teased me about it, in an affectionate way, but he said something like 'Where do you think you're going?' She said, 'Oh, don't be mean to her, dear. She looks lovely.' She went out of her way to put me at ease, and I liked her enormously."

And of her father-in-law, she simply said, "I love him more than anybody—more than anybody in the world."

LEFT Making her debut as Mrs. John Fitzgerald Kennedy, Jackie faced a crowd of three thousand people who had gathered on Spring Street to watch the proceedings. Forty years later, Newporter Margaret Winters recalled that as a child she had a friend hoist her up so she could peek into the church window, only to be admonished by a priest for her unladylike deportment. Yusha Auchincloss remembered that "the crowds were unbelievable. . . . It was a mess, there were hundreds of people about. . . . She didn't want to have her picture taken by all these hordes of photographers."

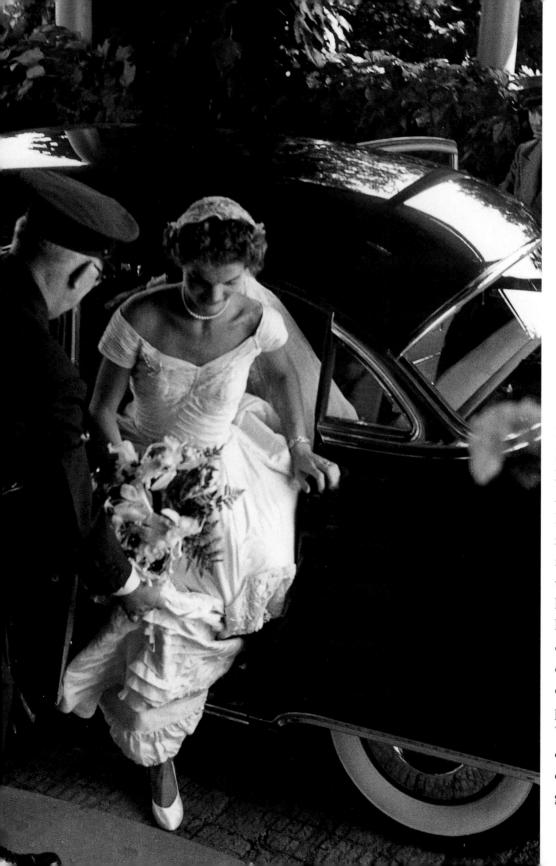

It's a ten-minute drive from St. Mary's Church alongside Narragansett Bay to Harrison Avenue and Hammersmith Farm. The ride offered a moment of privacy for the newly married husband and wife—a pleasant interlude between the clamoring crowds both inside and outside the church and the twelve hundred guests invited to the wedding breakfast. Under the porte cochere of the sprawling Victorian shingle house, chauffeurs and retainers gathered to assist the bride and groom out of the big sedan.

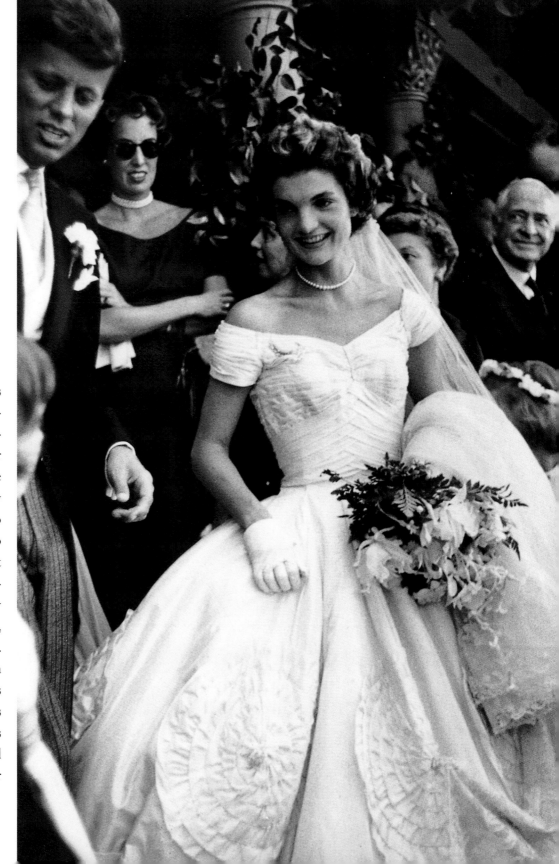

"The Kennedy family was somewhat overwhelming," recalled Toni Frissell in a published retrospective of her photographic career. "There are so many of them and they are so vital. . . . At a quarter to one, a big limousine drove into the portico. It was a radiant Jackie and her handsome newlywed husband. When she saw me with my camera, she said, 'Toni is a good friend of mine. Let's give her a chance to get a good picture before the guests arrive.'" Jacqueline Onassis was the editor of Frissell's book and personally selected this charming picture from her wedding to be included in it.

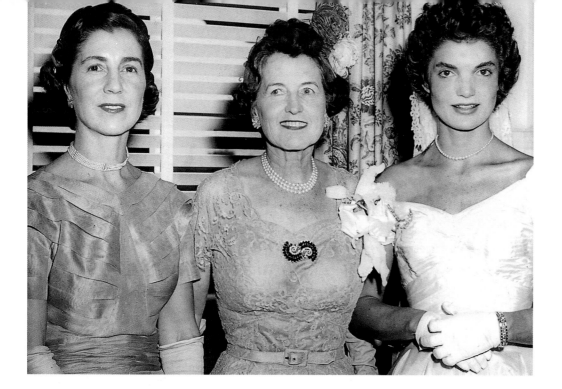

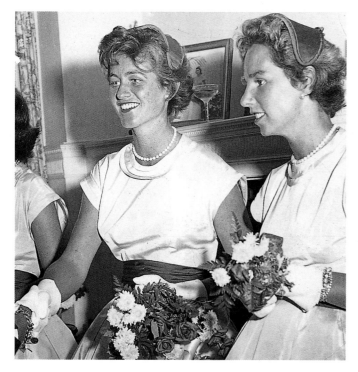

ABOVE *Women's Wear Daily* reported extensively on the fashions in the wedding—three separate articles noting what various women wore and what trends were visible, and providing sketches and photographs. They reported that Janet Auchincloss looked serene in a tasteful dress of silk organza in a shade described as "café au lait" with brown velvet accessories. It was a dress she had had made for her daughter Lee's wedding five months earlier. She wore a four-strand pearl choker and jade earrings. Rose Kennedy was the big fashion news, as she had recently returned from Paris, where she had selected a Jacques Fath couture dress of blue-gray lace over taffeta. She wore a large ruby-and-diamond brooch, with matching bracelet and earrings and three strands of pearls. Her Reboux hat of ruby and pale pink velvet with ostrich feathers complemented the bridal party's colors.

LEFT Pretty sisters-in-law Jean and Ethel Kennedy were two of Jackie's bridesmaids, seen greeting guests in Hammersmith Farm's formal sitting room. Here one can see the details of their pink faille silk gowns and Tudor-style caps.

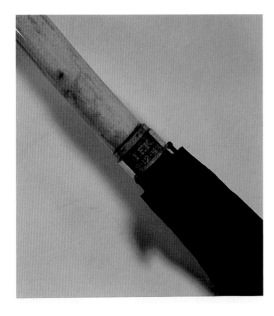

LEFT JFK's gift to his fourteen ushers was a Brooks Brothers umbrella, each personalized with JFK's initials, the wedding date, and the recipient's initials engraved on a brass band. Lem Billings gave his umbrella to the Kennedy Library.

Jackie's ten attendants received monogrammed silver picture frames, but none of them can be found today. "You must remember," recalled one of her bridesmaids, "in those days one was in wedding party after wedding party, and little of the booty survives today."

BELOW John Kennedy stands with his two brothers surrounded by the gentlemen of the wedding party. The ushers, culled from different parts of JFK's life, included relatives (brothers-in-law Sargent Shriver, Yusha Auchincloss, Tommy Auchincloss, and Michael Canfield, and cousin Joe Gargan), prep school friend Lem Billings, Navy buddies Red Fay and Jim Reed, Senate colleague George Smathers, college classmate Torbert Macdonald, and friends Charles Bartlett, Chuck Spalding, and Ben Smith.

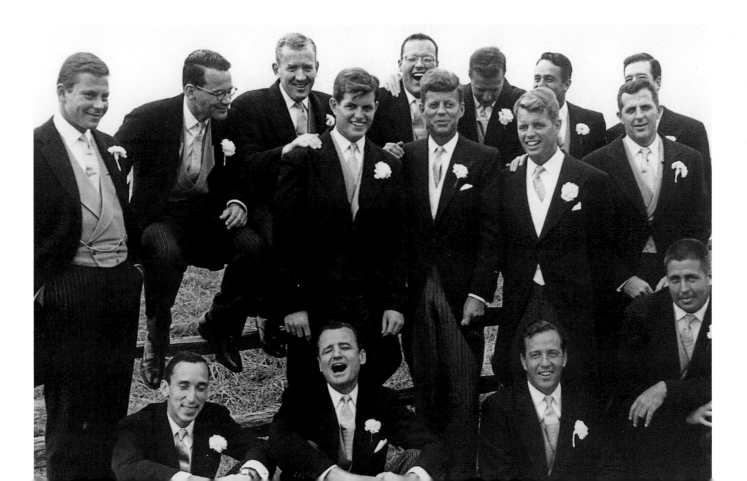

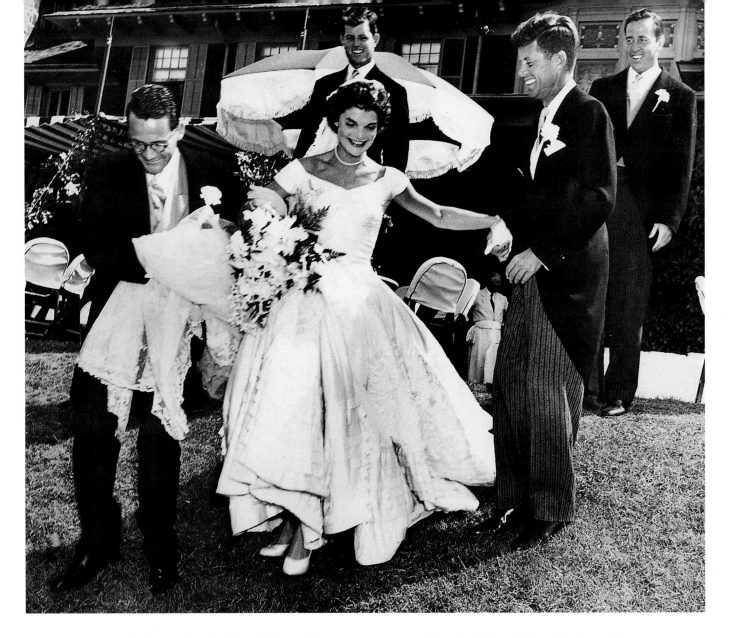

Charles Bartlett, lending Jackie a gallant arm, was accused by the bride of "shamelessly match-making" when he and his wife, Martha, invited John Kennedy to meet Miss Bouvier at dinner one night in 1951. "Usually that doesn't work out, but this time it did and so I'm very grateful to them," Jackie later said. Both Bartletts were in the wedding party; seven years later, Martha became god-mother to John Kennedy Jr.

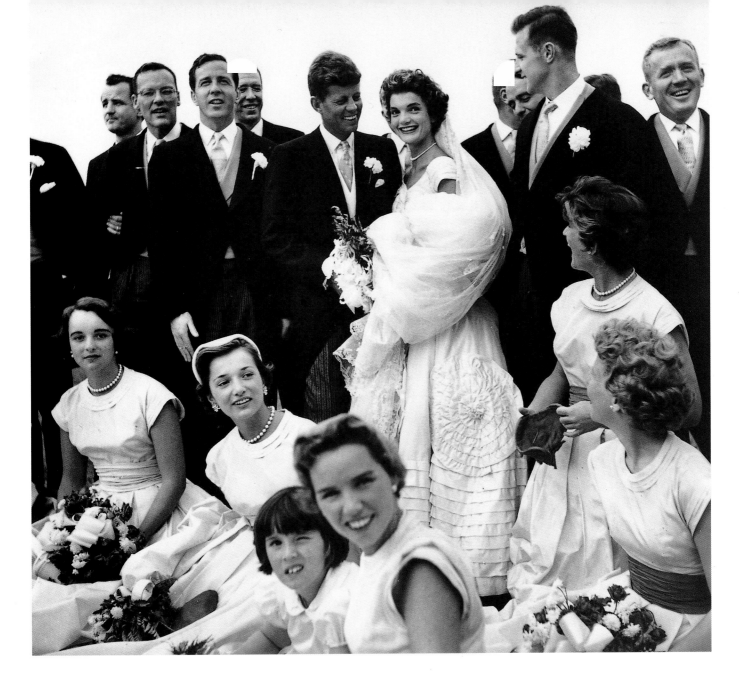

The wedding party relaxes for a moment while posing for formal portraits. Jackie's sisters—Nina, Lee, and Janet—sit in front of her. Nina Gore Auchincloss and Lee Bouvier were both married from Merrywood, the Auchincloss estate in McLean, Virginia. Janet Jennings Auchincloss was married from Hammersmith Farm in 1966, in a wedding in which Caroline Kennedy was a flower girl and John Kennedy Jr. was a page.

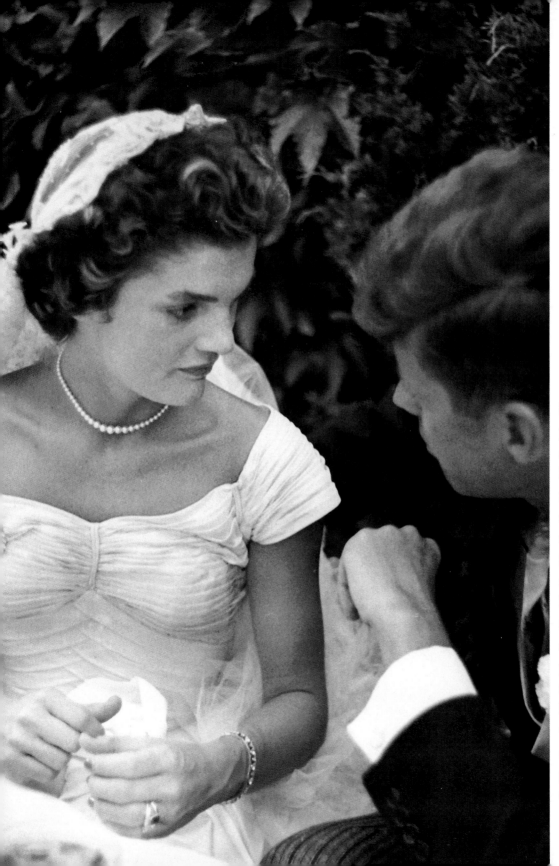

Surrounded by guests, reporters, servants, and musicians, Mr. and Mrs. John F. Kennedy share a private tête-à-tête. Here we can see two magnificent wedding gifts Jackie received—a diamond bracelet from her husband and the diamond pin from her father-in-law. Also visible are her engagement and wedding rings. Jackie once said of the plain gold band, "It's a man's ring. He bought it for me in a hurry in Newport just before we were married. It wasn't even engraved to me when he gave it to me. I had to put the date in later."

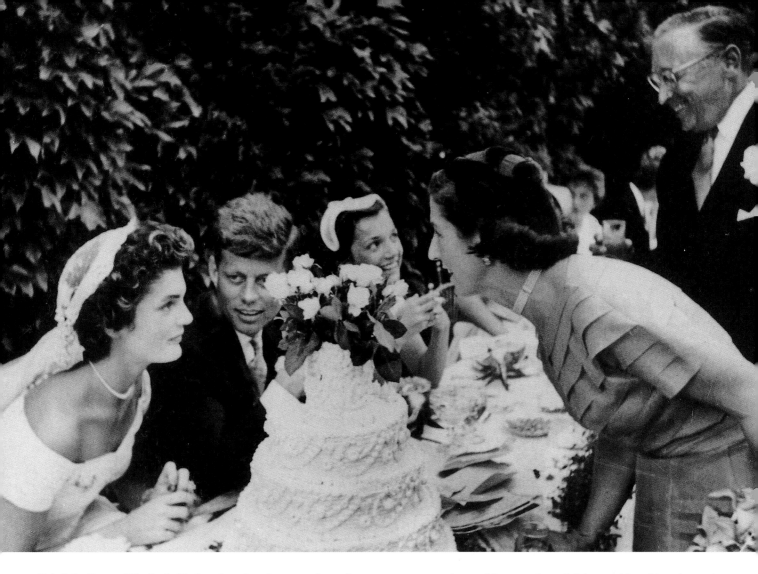

Britain's Queen Elizabeth II played a pivotal supporting role as an unwitting Cupid in the courtship of John Kennedy and Jacqueline Bouvier. Janet Auchincloss, shown here talking to her daughter, recalled that in the spring of 1953 Jackie was debating whether or not to travel to London to cover the Queen's coronation for the *Washington Times-Herald.* "She didn't want to go at all at first. I said to her, 'If you're so much in love with Jack Kennedy that you don't want to leave him, I should think he would be much more likely to find out how he felt about you if you were seeing exciting people and doing exciting things instead of sitting here waiting for the telephone to ring.' I think I was right. . . . Her drawings of the Coronation appeared on the front page of the *Times-Herald* three or four times, and they were really very good, very clever. . . . He must have seen them. He called me from Cape Cod the day she was flying back from England and said, 'That plane stops in Boston and I'm going to meet her there.' It was the first time that I felt that this was really a serious romance."

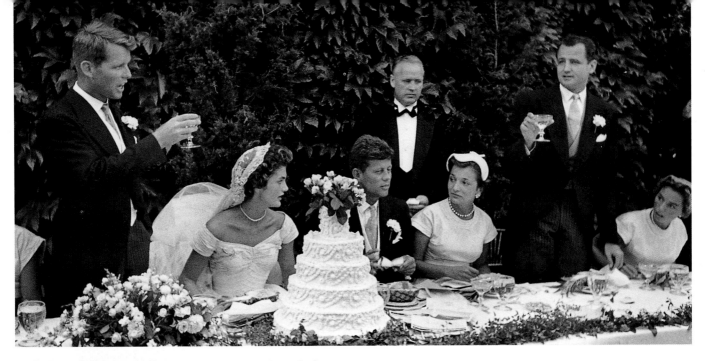

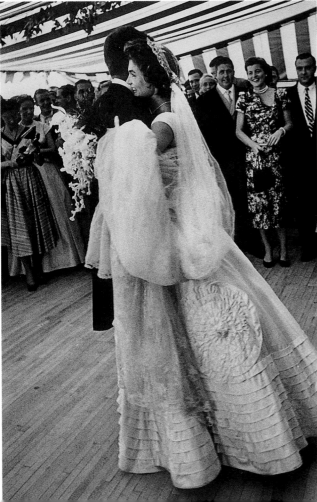

ABOVE Best man Robert F. Kennedy toasts his new sister-in-law, who shares a glance across her husband with sister Lee. "Every bridesmaid, every usher made speeches and toasts," Janet Auchincloss remembered in her contribution to the JFK Library oral history project.

"Have you heard I married an angel?
I'm sure that the change'll be awfully good for me . . ."

LEFT Chet Baker's recording of "I Married an Angel" was popular in the summer of 1953, and Jack Kennedy let these sentiments speak for him as he led his wife to the dance floor. Among those watching under the green-and-white-striped marquee are two of Jackie's new sisters-in-law, Ethel and Pat Kennedy.

This photograph comes from a scrapbook that Jackie made about her engagement and wedding. It includes numerous newspaper clippings with handwritten notations in Jackie's elegant script.

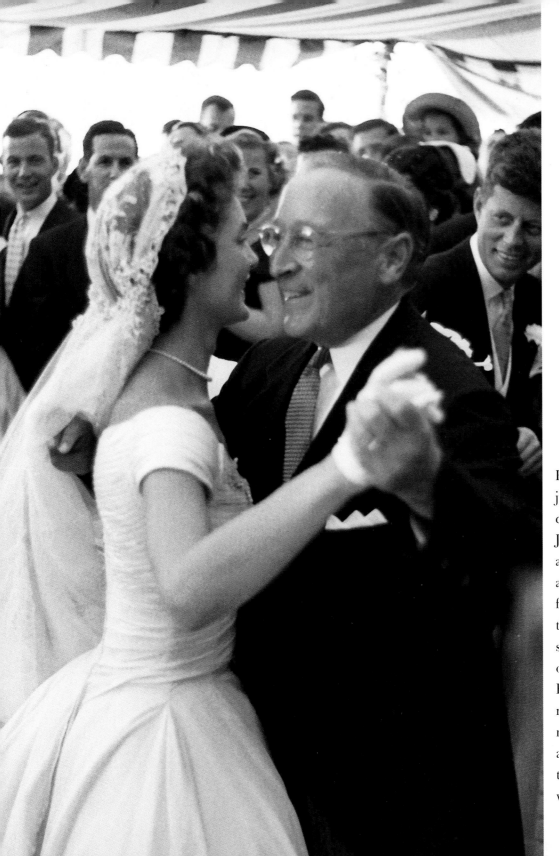

Hugh D. Auchincloss, having just cut in on the groom, dances with his stepdaughter. Jackie loved "Uncle Hughdie" and, although upset, appreciated his stepping in for her father. Hugh D. was a true gentleman, and according to his son, he would have "gone out of his way to make Jack Bouvier feel welcome at Hammersmith Farm that afternoon." Such was not to be, alas, and so Hugh D. took the traditional "second dance" with the bride.

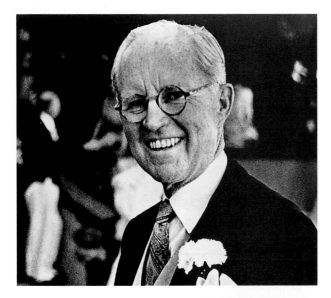

He was "the architect of our lives" in his wife's canny assessment, and Joseph P. Kennedy certainly looks the part as he stands proudly on the dance floor during the reception at Hammersmith Farm. The wedding was a splendid pageant, calling to mind that he was at one time a Hollywood movie mogul.

There was a great fondness between the Kennedy patriarch and Jackie; of all the Kennedy family, he was the one she was closest to. They would tease each other with great affection, and she could rely on his unwavering support. Once, she presented him with a painting she had done of all the Kennedys standing on the beach at Hyannis Port. "You can't take it with you," read the legend. "Dad's got it all."

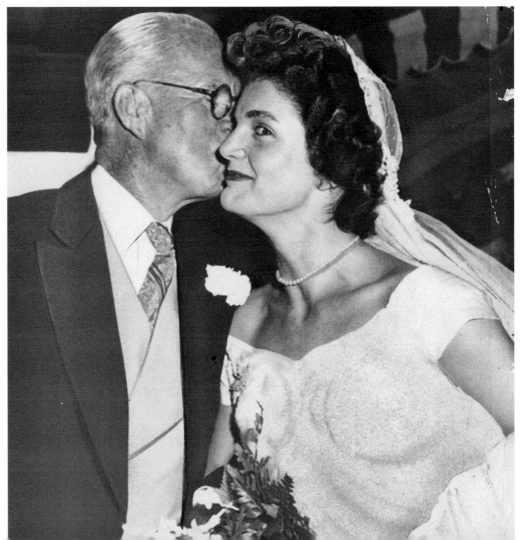

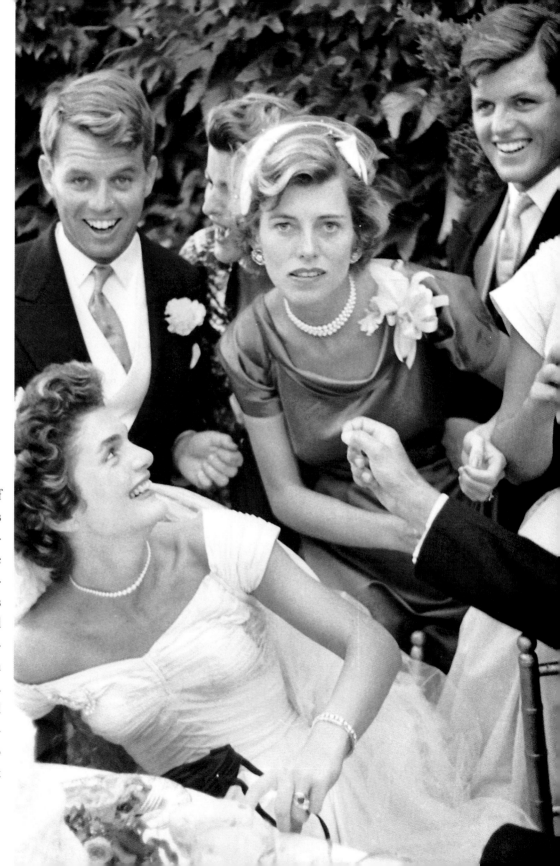

Doesn't it look as if the arm of the seated John F. Kennedy is holding an imaginary microphone up to his sister Eunice in anticipation of her serenading his bride? Jackie looks game, and Bobby, Pat, and Ted are clearly enjoying the moment. "How can I explain those people?" Jackie said. "They were like carbonated water, and [while] other families might be flat, they had so much interest in life, I thought they were wonderful."

It's a family affair ... James Lee "Jamie" and Janet Jennings Auchincloss were page and flower girl to their half sister Jackie. The Bouvier-Auchincloss family tree was so confusing that Jackie once told writer Diana Trilling, "There have been so many marriages in every part of the family—at Christmas it's a shambles. You don't know whom you have to send a card to, you don't know who your relatives really are." Nonetheless, Jackie revered the bonds of family; each of her siblings played a role in her wedding. Sister Lee (at the time married less than six months to her first husband, Michael Canfield) was the matron of honor. Stepsister Nina Auchincloss (herself a half sister to writer Gore Vidal) was maid of honor, and stepbrothers Yusha and Tommy Auchincloss (themselves half brothers) were ushers.

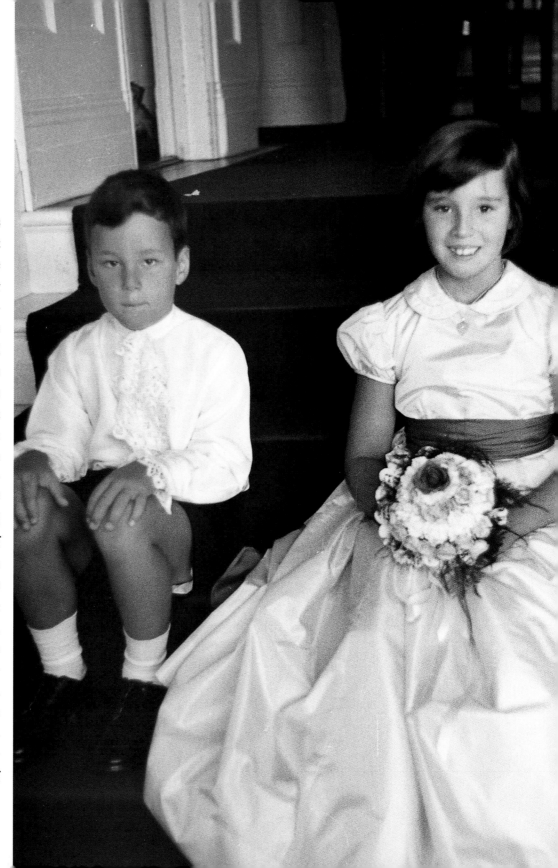

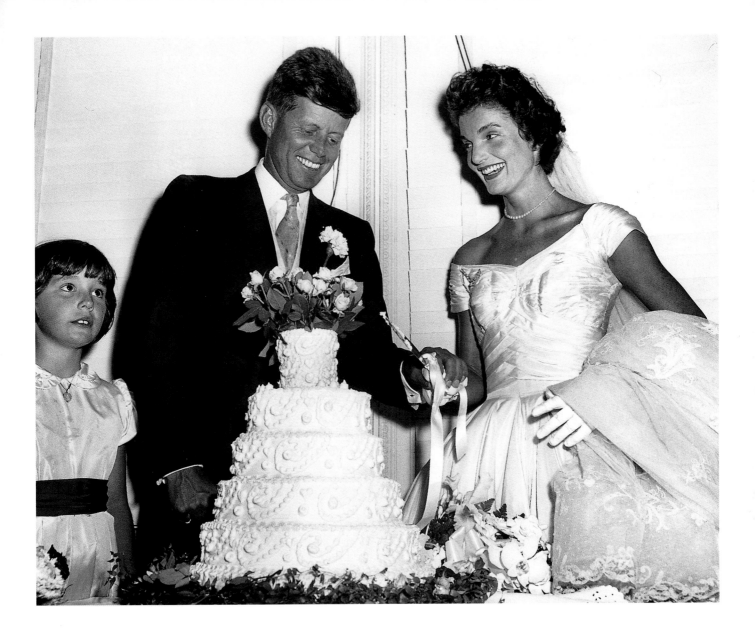

Jackie went through two different cake-cutting ceremonies to please the multitude of photographers but drew the line when one of them asked her to pose with her husband clinking champagne glasses. "Too corny," she ruled.

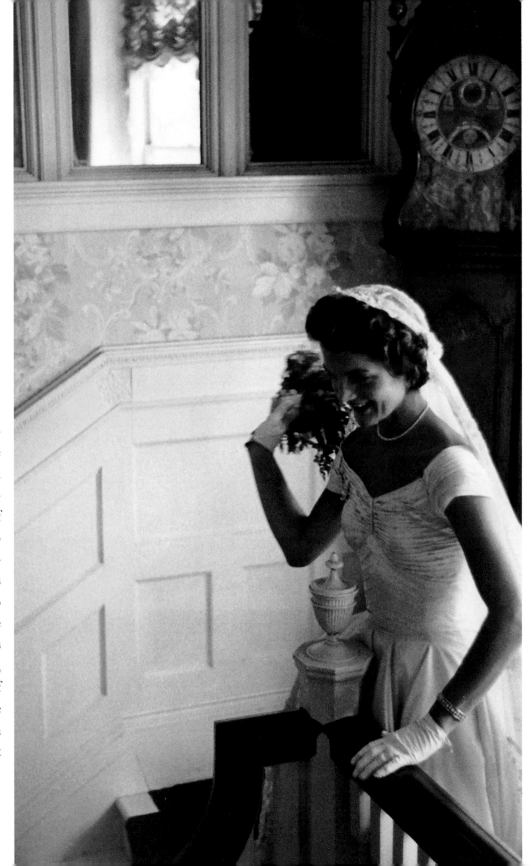

With a radiant smile, Jacqueline stands at the top of the stairs in the main hall in Hammersmith Farm and prepares to toss her bouquet of pale pink and white orchids to the unmarried maidens gathered below. Fate, or perhaps good aim, sent the bouquet to Nancy Tuckerman, her close childhood friend. "Tucky," as Jackie affectionately called her, joined the White House staff as social secretary in the spring of 1963 and remained a close aide to Jackie for the next thirty-one years.

Here's an aerial view of Hammersmith Farm, a rambling shingled cottage with a romantic design of turrets and gables. Guests arrived up the long driveway, entered the house to go through the receiving line, and exited onto the back lawn for refreshments and dancing.

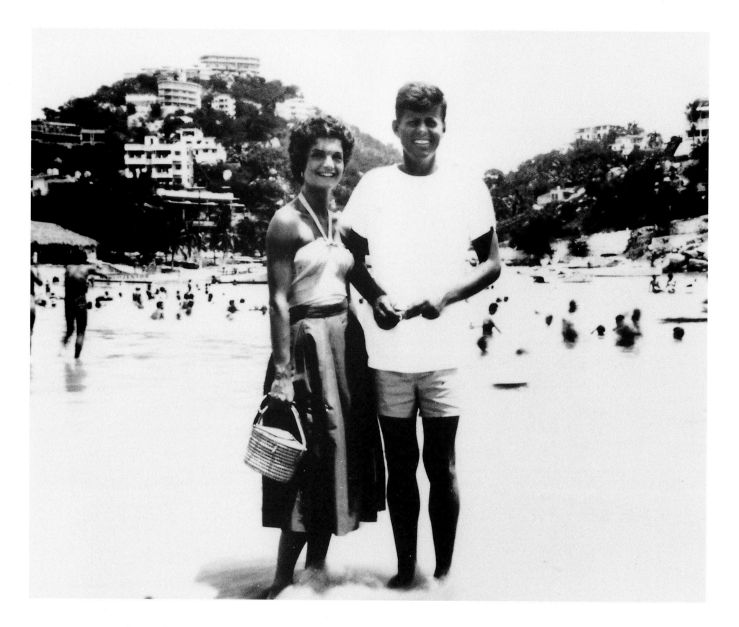

The newlyweds flew from Newport to New York City, where they spent their wedding night in the Waldorf-Astoria Hotel. They flew to Mexico the next day, to Acapulco, where they stayed in a pink stone villa perched above the Pacific Ocean, lent to them by the President of Mexico. They posed on the beach a few days later. This photograph comes from Jackie's wedding scrapbook.

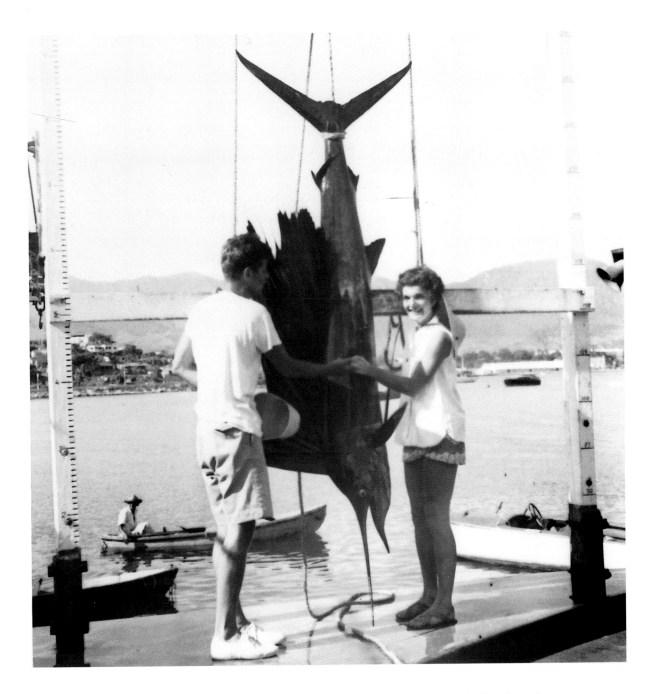

Jackie once told an interviewer about a highlight of their honeymoon: "My husband caught a ten-foot sailfish. . . . I was in the boat [but] all I did was pour water on him. It was so hot in that boiling sun and he had to fight the fish for about three hours, so I stood there pouring water on him." The sailfish later hung in the White House, in the appropriately named Fish Room. This photograph also comes from Jackie's wedding scrapbook.

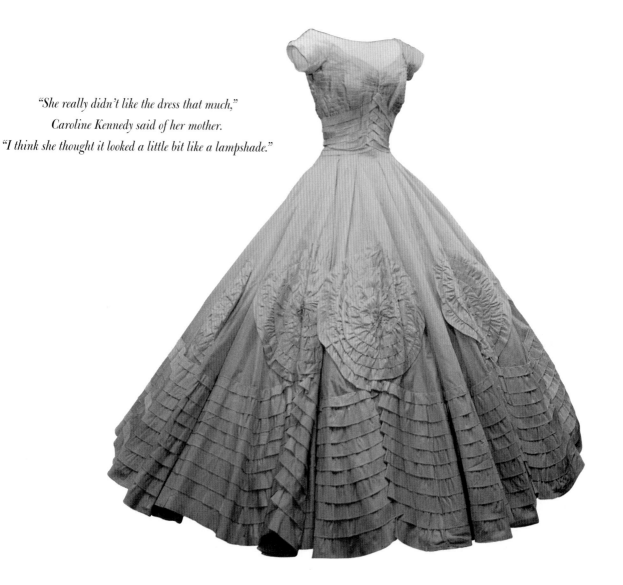

"She really didn't like the dress that much,"
Caroline Kennedy said of her mother.
"I think she thought it looked a little bit like a lampshade."

Jacqueline Bouvier turned to her mother's dressmaker, Ann Lowe, to create the dress in which she would be wed to the dashing junior Senator from Massachusetts. After deciding, at the request of her fiancé, upon a traditional styled gown, the two worked on a design that was described at the time as "ivory silk taffeta with interwoven bands of tucking forming the bodice and similar tucking in large circular designs swept around the full skirt." It was ivory, rather than white, to complement the "something old" she wore—her grandmother's exquisite heirloom veil that fell from a diadem of orange blossoms and lace in a circular train.

Before the advent of celebrity designers, Ann Lowe was well known to high society. An African American from Clayton, Alabama, she came to New York in 1929 and dressed Rockefellers, Roosevelts, du Ponts, and Auchinclosses, and was responsible for the dress Janet Lee Bouvier wore when she married Hugh D. Auchincloss. Jackie's gown required fifty yards of material and took more than two months to make. Lowe charged what was then a lot of money for a wedding gown—five hundred dollars. She also designed the pink faille silk gowns and matching Tudor-style caps worn by Jacqueline's bridal attendants.

RIGHT The bodice of the wedding dress featured an intricate pattern of pleated and tucked bands of ivory silk taffeta. The elaborate design is Victorian in feeling and is a triumph of the dressmaker's art.

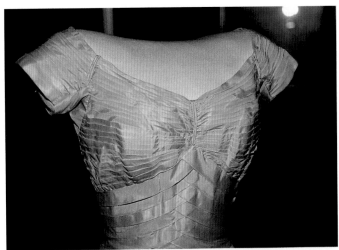

BELOW "We found the dress all crumpled up in a Lord and Taylor's box in the warehouse. It looked as if it were on its way to being thrown out," Caroline Kennedy remembered and then added, "It's in good condition right now. It had a lot of work done on it." Today it is preserved with loving care in the archives of the John F. Kennedy Library in Boston. It was put on display to celebrate the library's expansion of exhibits honoring Jackie's role as First Lady. Caroline and her uncle Senator Ted Kennedy opened the exhibition in May 1997.

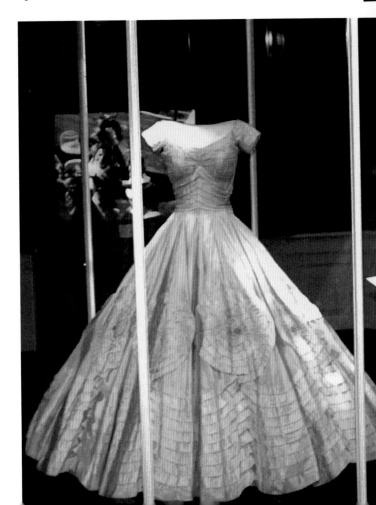

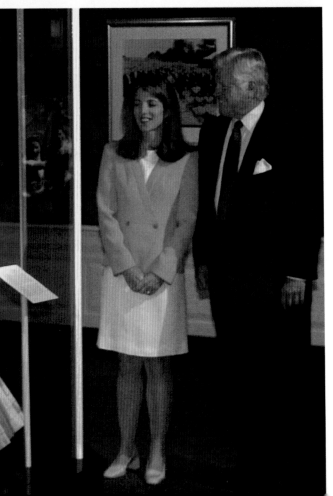

PATRICIA KENNEDY AND PETER LAWFORD

April 24, 1954
New York City

Mr. and Mrs. Joseph Patrick Kennedy

request the honour of your presence

at the marriage of their daughter

Patricia

to

Mr. Peter Lawford

on Saturday, the twenty-fourth of April

at four o'clock

The Church of Saint Thomas More

65 East Eighty-ninth Street

New York

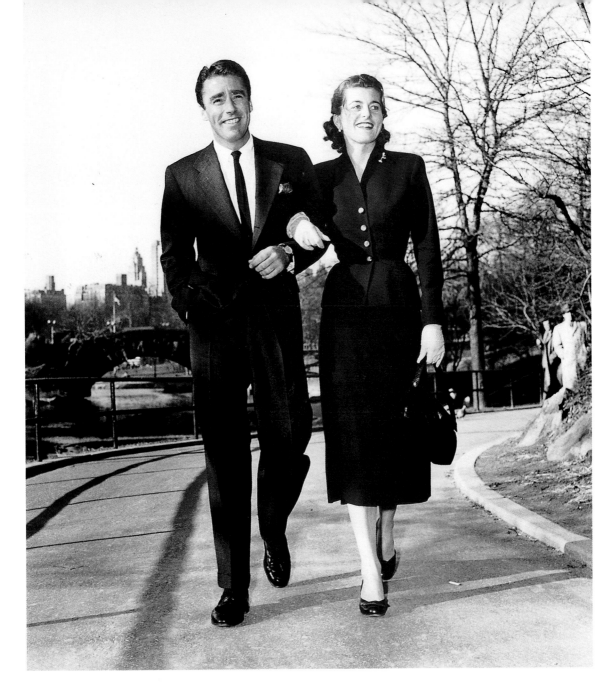

at Kennedy's engagement to the British-born screen star Peter Lawford was announced on February 12, 1954, and a week later they posed for photographers while strolling through New York's Central Park. Peter had appeared in more than thirty movies, including the 1942 Academy Award–winning *Mrs. Miniver*, *The Picture of Dorian Gray*, and a trio of MGM musicals: *Easter Parade*, *Good News*, and *Royal Wedding*.

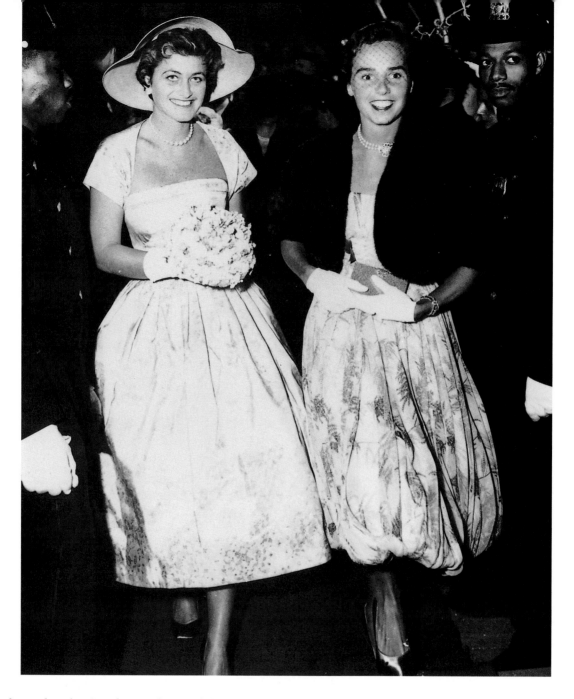

Jean Kennedy was her sister's only attendant, and she arrived at the Church of St. Thomas More with her sister-in-law Ethel. Jean's ensemble was a Christian Dior design, described in *The New York Times* as being "a bouffant gown of pink and blue hydrangea printed silk taffeta, a picture hat of hyacinth blue Milan trimmed with matching velvet ribbon." She carried a Victorian posy of pink, blue, and lavender blossoms. Ethel chose a bouffant style as well and wore a short mink jacket to ward off any April chills.

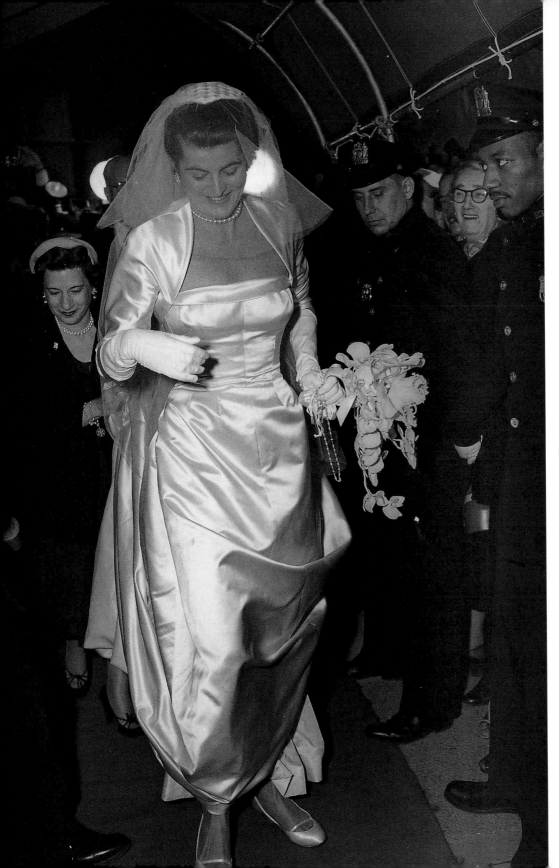

Pat was, in many ways, the most sophisticated of the Kennedy sisters. She had worked in the television industry and had traveled widely. She went to Hattie Carnegie, one of America's leading designers, for her white satin gown—a simply cut strapless dress of white satin, with a close-fitting jacket (known as a shrug because of the way it slipped off one's shoulders). The draped skirt ended in a small train. Her tulle veil was attached to a cap of woven satin bands. She carried a bouquet of white orchids.

65

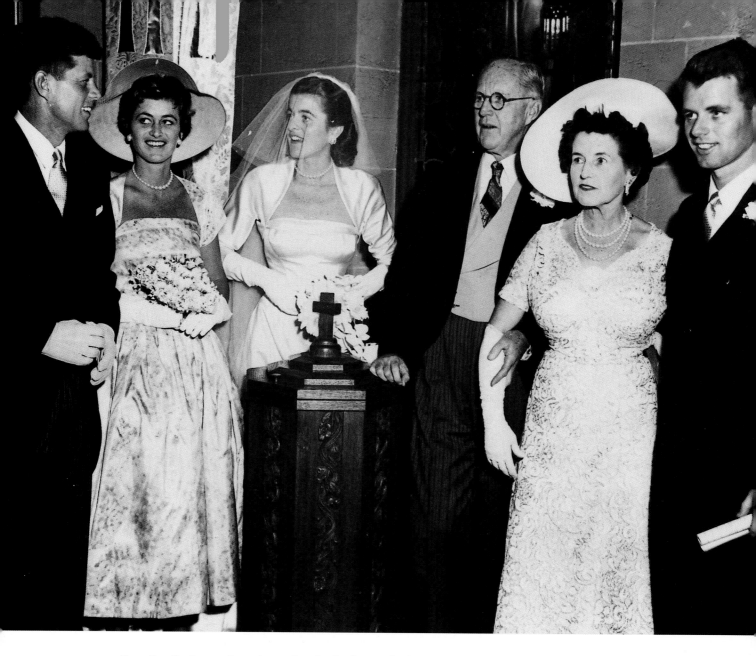

Peter Lawford was a few minutes late for the four o'clock ceremony, and his bride waited with her family around the baptismal font at the back of the church. JFK fidgets with his formal gray gloves as he jokes with his two sisters (Eunice was in Chicago, where she gave birth two days after the wedding to her first child, Bobby Shriver). Rose was elegantly turned out in a dress of white lace traced in blue. Her white straw hat was trimmed with pale blue velvet ribbon, and she wore matching elbow-length gloves and strapped satin slippers.

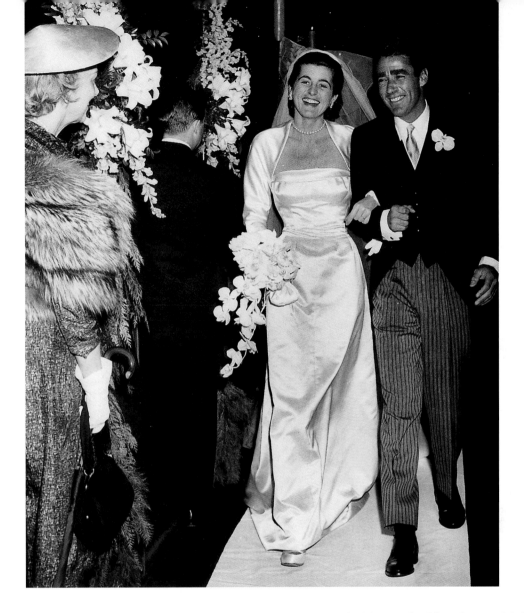

Mr. and Mrs. Peter Lawford walk down the aisle, having just been married by the Reverend John J. Cavanaugh, former president of Notre Dame University and a close friend of the Kennedy family. Among the guests were actresses Marion Davies and Greer Garson (the star of Peter's first film, *Mrs. Miniver*), Supreme Court Justice William O. Douglas, statesman Bernard Baruch, Mr. and Mrs. Morton Downey Sr., and Mr. and Mrs. Igor Cassini.

Pat Kennedy first met Peter Lawford in Palm Beach during the Christmas holidays in 1952. They continued to see each other as her television work with Father Patrick Peyton's Family Rosary crusade and Family Theater took her to Los Angeles and New York, where a courtship ensued. International telephone lines conveyed Peter's proposal—Pat was in Tokyo, on the first leg of a round-the-world trip on assignment for the U.S. Information Service. She flew back to San Francisco, where Peter was waiting with an eight-carat diamond engagement ring from Van Cleef & Arpels.

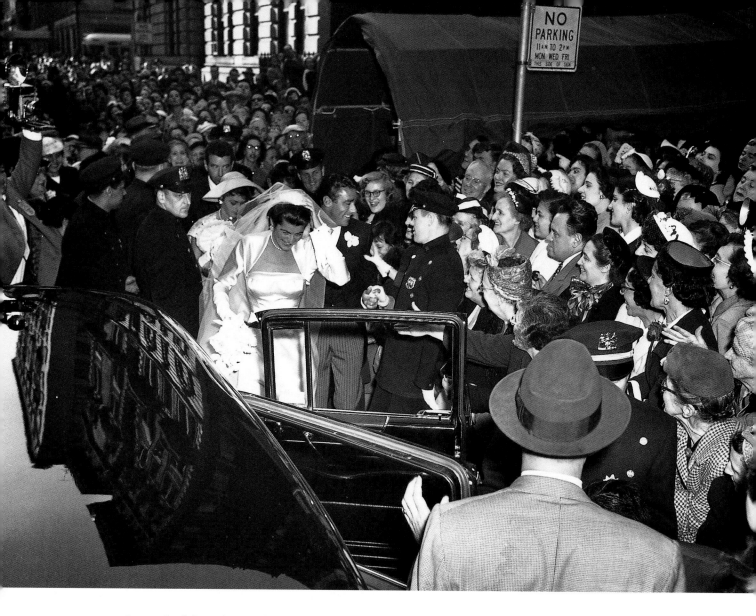

A crowd of three thousand people, mostly women, gathered behind police barricades on East Eighty-ninth Street to watch the wedding party arrive and depart the four o'clock ceremony. Peter's new movie *It Should Happen to You*, directed by George Cukor and costarring Judy Holliday and Jack Lemmon, had opened a few weeks earlier and was a big hit. *The Boston Globe* reported that two women, watching the guests arrive by taxi, ran around the corner, hailed their own cab, pulled up to the church, and grandly marched under the long green canopy and swept into the church. A moment later, escorted by police, they made their exit.

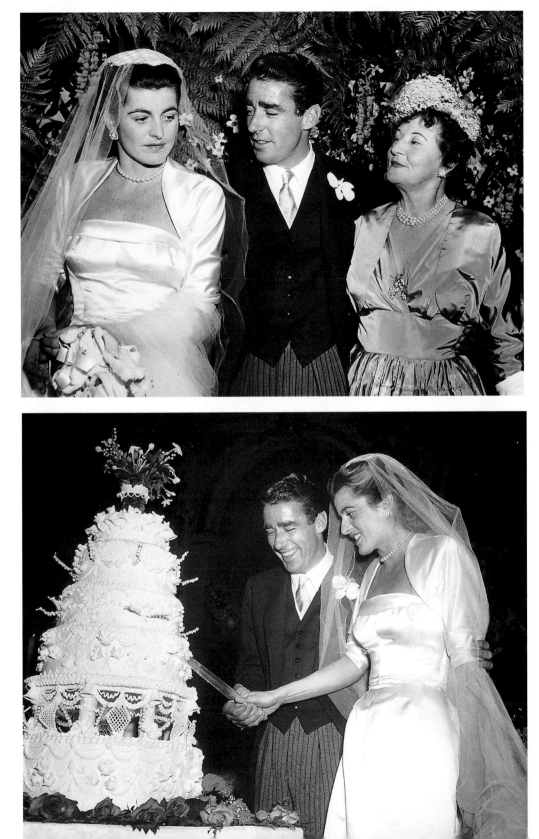

TOP "Patricia . . . was a beautiful bride. Her gown was lovely and she smiled radiantly. She was the prettiest of the Kennedy girls," wrote Lady May Lawford in her posthumously published autobiography, *Bitch.* Famously cantankerous, Lady May had a difficult relationship with the entire Kennedy family (and, if pictures could talk, one would certainly need to buy a new thesaurus to interpret this photo), but she did rise to the occasion and justly praise her new daughter-in-law.

BOTTOM The wedding cake was a handsome five-tier confection decorated with wedding bells, doves, swans, roses, and lilies of the valley. A spirit of romance dominated the wedding reception. Spring was in the air, and the ballroom of the Plaza Hotel resembled a country garden—decorated with pink snapdragons, tulips, delphinium, and branches of flowering dogwood.

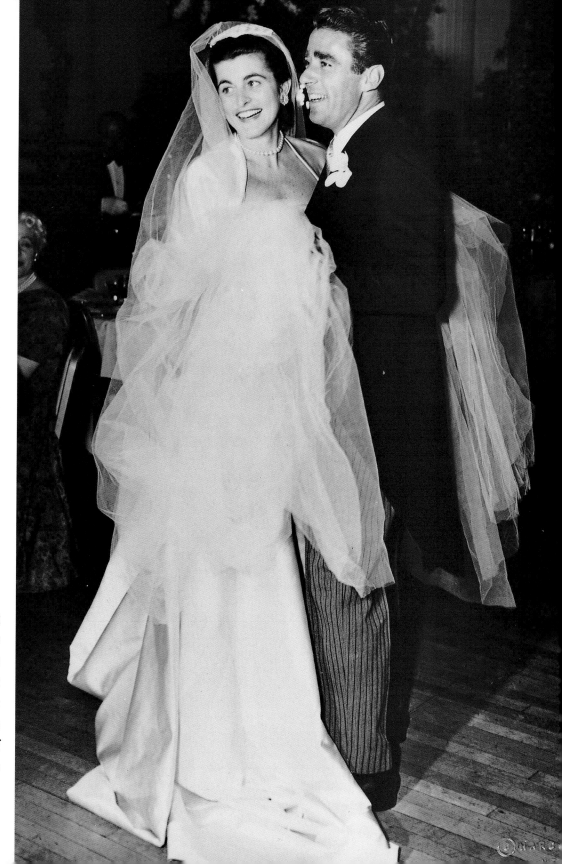

The Tony Award–winning Best Musical of 1954 was *Kismet,* its romantic melodies adapted from Alexander Borodin's classical score. Peter led his bride onto the dance floor to the romantic strains of the show's hit song, "Strangers in Paradise."

70

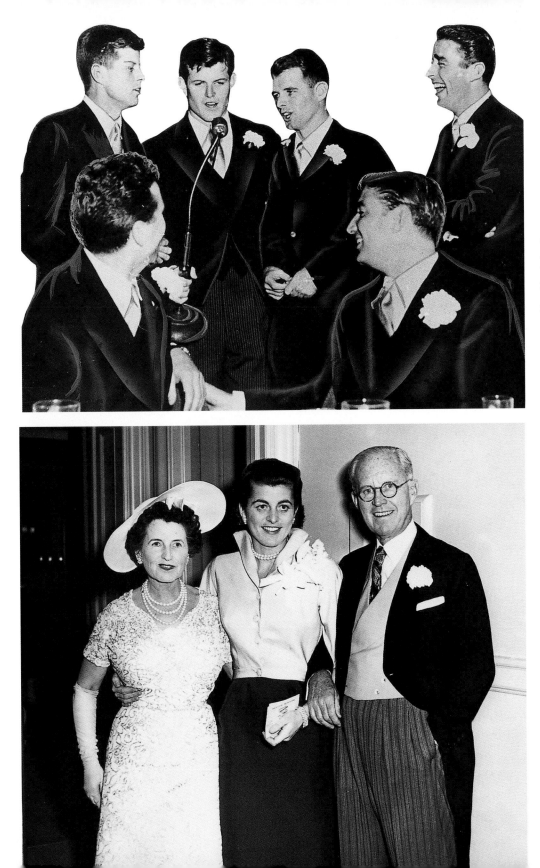

TOP The three Kennedy brothers, their duty as ushers fulfilled, serenade the newest member of the family during the reception, with best man Bob Neal and usher Peter Sabiston looking on.

Patricia was the second Kennedy sister to marry into a titled British family—Peter's father was Lieutenant General Sir Sidney Lawford, a World War I hero knighted by King George V. Pat and Peter had four children, their eldest, Christopher, and three daughters, Sydney, Victoria (named in honor of her uncle Jack's 1958 Senate victory), and Robin. Alas, the Lawfords were divorced in 1966.

BOTTOM Pat Kennedy, dressed in her going-away outfit, poses with her parents in their suite at the Plaza Hotel.

JEAN ANN KENNEDY AND STEPHEN EDWARD SMITH

May 19, 1956
New York City

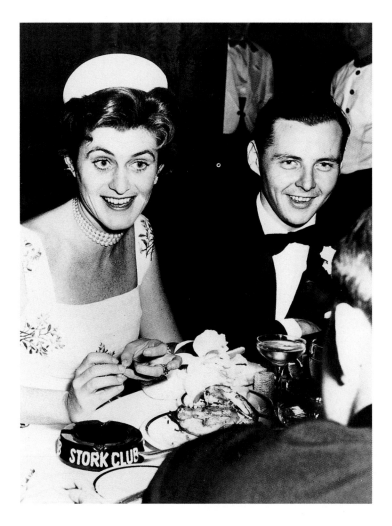

No other nightspot in New York City matched the Stork Club for ultimate chic during the 1950s, and it was here that the young couple celebrated their upcoming wedding. *The New York Times* announced their engagement on May 4, 1956, making special note of the prospective bride's work with the Christopher movement since her graduation from Manhattanville College and her fiancé's service as a first lieutenant with the Air Force. Steve had been assigned to Otis Air Force Base near Hyannis Port, and from there he courted Jean and ultimately won her heart.

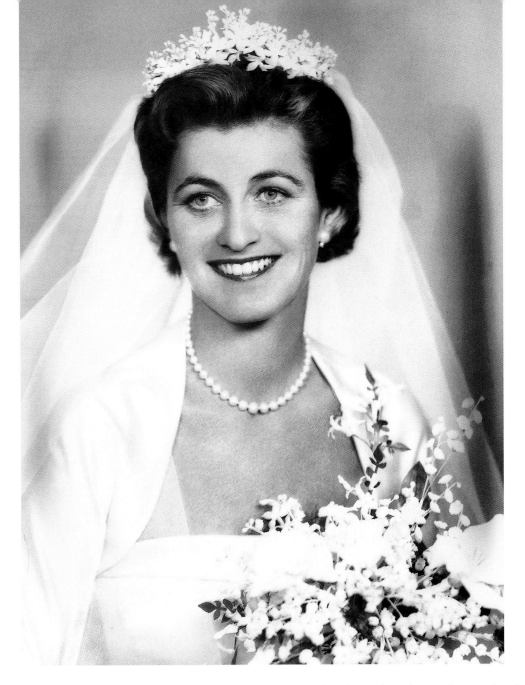

Jean's gossamer tulle veil was attached to a coronet of orange blossoms, and she carried a bouquet of white orchids and stephanotis. The gown's "shrug" jacket helped form a portrait neckline, and the bride's long neck was elegantly set off with a single strand of pearls. Her only other jewelry was small pearl-and-diamond earrings.

This handsome formal portrait was taken by society photographer Dorothy Wilding, who was noted for her portraits of the Duke and Duchess of Windsor (her photographs of them were among the fabled couple's favorites).

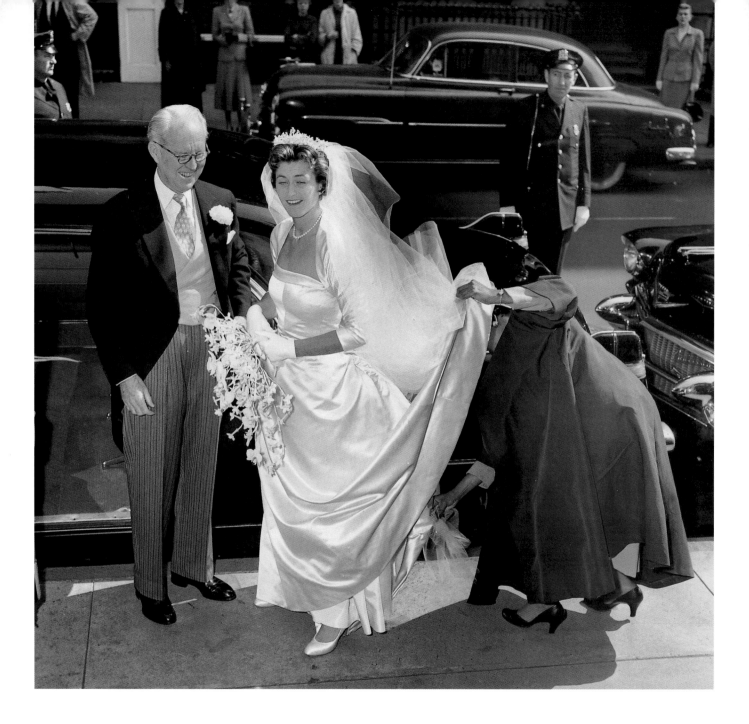

Unique in American history, Joseph P. Kennedy and Jean Kennedy Smith are the only father and daughter who have served as U.S. ambassadors. Joseph P. Kennedy was Ambassador to the Court of Saint James from 1938 to 1940; fifty years later, his youngest daughter, Jean Kennedy Smith, was appointed Ambassador to the Republic of Ireland, where she served from 1993 to 1998.

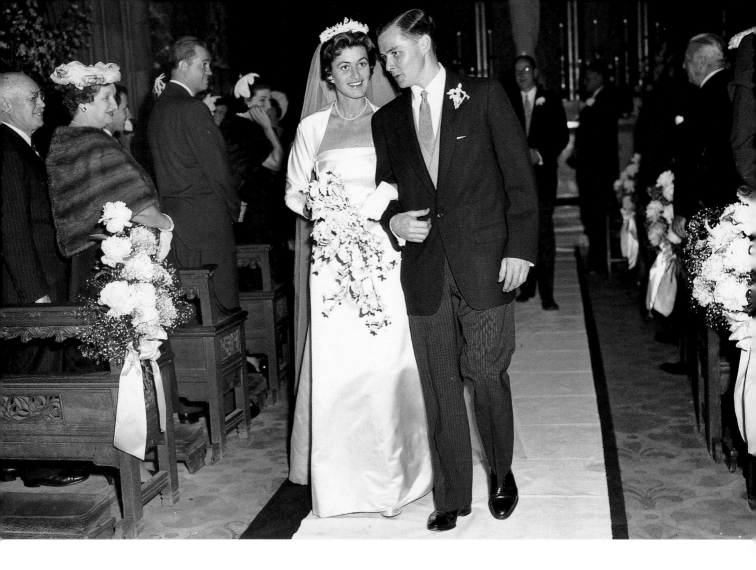

"Daddy gave me the choice of a big wedding and a small present or a small wedding and a big present," Jean Kennedy Smith once said. She chose the latter and was married in the small and exquisite Lady Chapel, tucked behind the main altar of St. Patrick's Cathedral. In a display of charming frugality, Jean wore her sister Pat's Hattie Carnegie gown, and matron of honor Eunice wore one of the bridesmaids' dresses from her own wedding three years earlier. Francis Cardinal Spellman officiated, and Philip Smith stood as his brother's best man.

The few select guests were ushered to their seats by the bride's three brothers (Senator Kennedy flew in that morning from Boston, where he was involved in an internal state political battle; he flew back right after the wedding); John Smith, another brother of the groom; and friends Theodore Donahue and Lem Billings.

And as for the "big present" from Joe and Rose—it was a splendid diamond pin.

JEAN ANN KENNEDY AND STEPHEN EDWARD SMITH

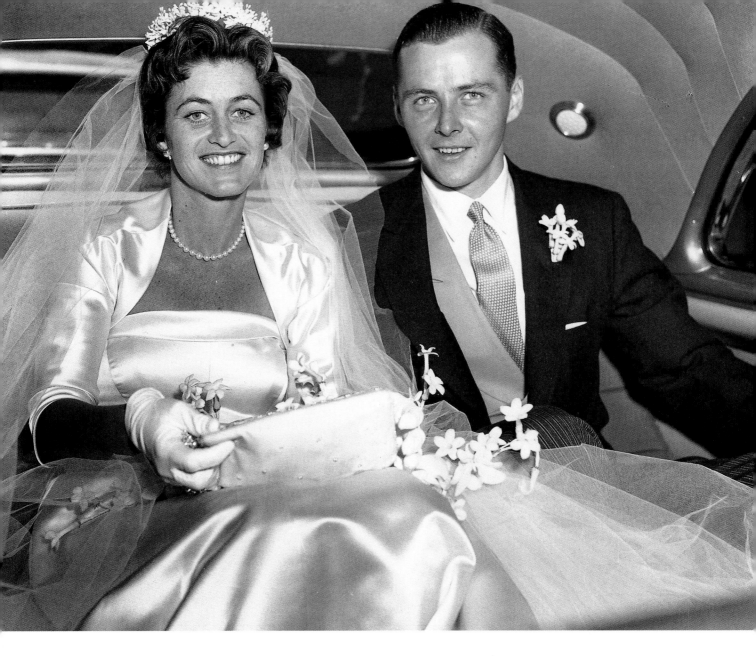

Mr. and Mrs. Stephen Edward Smith leave St. Patrick's Cathedral en route to their wedding break-fast at the Plaza Hotel. They were the least well-known couple in their generation of the family, working quietly behind the scenes to advance the family's political, philanthropic, and business interests. The Smiths were married for thirty-four years until Stephen's death in 1990. Their four children are sons Stephen Jr. and William and daughters Amanda and Kym.

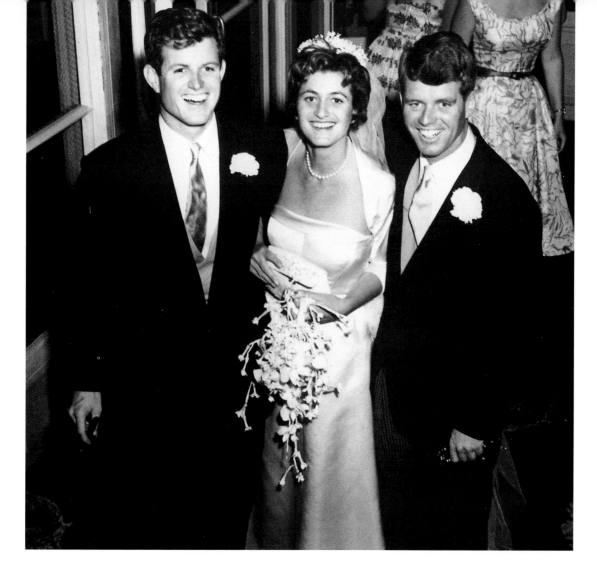

In his commendable book *The Kennedy Women*, Laurence Leamer recounts that "growing up Jean's closest friends in the family were . . . the two family members closest to her own age, Bobby and Ted. Her youngest brother had a special affinity with Jean." At the Plaza Hotel during the reception, Ted offered a toast to his sister, telling the assembled guests how he was always moved out of his room whenever visitors were expected. "Jean said to me once, 'Listen, Teddy, I know that you've been going through all this and we're going to sail up to Maine. I want you to have a room by yourself and come along.'

"I got into the boat and I had my room decorated and I thought: 'That was awful nice of old Jeannie to do a thing like that for me.' We were just about to cut away, we were actually in motion already, and a couple came down to the dock waving: 'Hey, Jeannie. Hey, Jeannie! We finally made it.'

"'My gosh!' Jeannie said. 'We're going to have to change. You'll have to sleep with me.'

"That was the first time in my life I slept with my sister, or with any woman. That's good old Jeannie."

Peals of laughter surrounded her as the bride covered her face with her hands, giggling through her mild embarrassment.

RIGHT The bride dances with one of her ushers, Lem Billings. Lem was a lifelong friend to the Kennedys—he had been JFK's prep school roommate and best friend and forged close bonds with several members of the third generation, most notably Michael LeMoyne Kennedy and his brother Robert F. Kennedy Jr.

BELOW A reception for members of the families and close friends was held in the Baroque Suite and Crystal Room of the Plaza Hotel, both lavishly bedecked with flowers and garlands, where Lem Billings's witty toast left the bridal party giddy with laughter. After changing into a pale-colored two-piece suit, the new Mrs. Stephen Smith and her husband bade farewell on the steps of the Plaza and left for a European honeymoon.

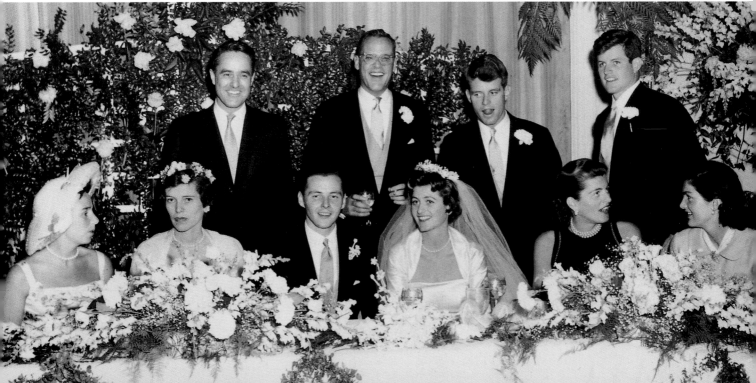

EDWARD MOORE KENNEDY AND VICTORIA ANNE REGGIE

July 3, 1992
McLean, Virginia

Ted Kennedy chose the words of a nineteenth-century British poet to best express his feelings upon marrying Victoria Reggie in an intimate ceremony in his Virginia home. It was late in the afternoon on a quiet summer Friday, and their families surrounded the couple as a judge performed the wedding in front of the fireplace in the Senator's living room.

Different family members read verses of poetry from George Eliot, Elizabeth Barrett Browning, and A. L. Alexander from an anthology that the couple had discovered in the library of Rose Kennedy's home in Hyannis Port. The verses had been underlined by the Senator's mother, which was a poignant way of having her symbolically present at the wedding.

Both the Senator and Ms. Reggie had children from previous marriages, and they all took part in the ceremony, with the exception of Congressman Patrick Kennedy, whose flight from Rhode Island had been canceled. Vicki was attended by her daughter, Caroline Reggie Raclin; her sister Alicia Reggie Freysinger; and the Senator's daughter, Kara Kennedy Allen. The Senator's "best men" were his son Ted Jr.; his son-in-law, Michael Allen; and his young stepson, Curran Raclin.

The bride wore a knee-length dress of white silk with a white lace overlay, featuring a rounded neckline and short sleeves. She wore a pearl bracelet and earrings and carried three creamy pink roses. Her attendants wore white orchids with yellow centers.

Among the other family members present were the bride's parents, Judge and Mrs. Reggie, the Senator's three sisters, Jean Kennedy Smith, Patricia Kennedy Lawford, and Eunice Kennedy Shriver; Sargent Shriver; and Ethel Kennedy.

The wedding dinner was served at round tables decorated in yellow and white, and the menu included a mixture of foods that celebrated the heritage of the Senator and his new wife. Sugar-coated almonds, a Lebanese good-luck wedding tradition, were placed at every plate, an acknowledgment of Vicki's ethnic ancestry.

Various toasts were offered, including one from Ted Kennedy Jr., who welcomed Vicki and her two children into their family and noted the joy that she had brought to his father's life. The couple was "overwhelmed" and embraced Ted when he finished.

The Kennedys and the Reggies date their friendship from the 1956 Democratic National Convention, where Vicki's father, Judge Edmund Reggie, lent his support to then-Senator John F. Kennedy's unsuccessful bid for nomination as Vice President. The Senator's courtship with Vicki began shortly after he attended a dinner honoring her parents' fortieth wedding anniversary and culminated with a proposal during a Metropolitan Opera performance of Puccini's *La Bohème* at New York's Lincoln Center.

During the ceremony the couple were serenaded with their favorite song, the ballad "You'll Never Know"—"You'll never know just how much I love you . . . You'll never know just how much I care . . ."

These thoughts were echoed by the bride: "I love Ted with all my heart, and I look forward to spending the rest of our lives together. The ceremony was an intimate family gathering filled with love and happiness. It was a special day, and I feel truly blessed."

*"And then my heart with pleasure fills
and dances with the daffodils."*

Shortly after his wedding, Ted Kennedy reflected that "the people who had been closest to me over the course of my life had disappeared, with that enormous amount of emotion and feeling and love. I thought I probably wouldn't want to go through that kind of experience again. . . . But then, this became so inevitable after Vicki and I started going out that I decided I didn't want to live the rest of my life without her, and as the relationship developed, it brought a new kind of serenity, stability, and emotional security that obviously has an impact on one's attitude and view of life. I think it makes you a better person, and so, it's a joyous, happy time."

The spirit of hope, promise, and renewal is evident in the gift the Senator gave his new wife to celebrate their wedding—a painting he did of yellow daffodils, representing the first breath of springtime.

Each guest at the wedding received this reproduction of the painting on the cover of a program commemorating the special day.

EDWARD MOORE KENNEDY AND VIRGINIA JOAN BENNETT

November 29, 1958
Bronxville, New York

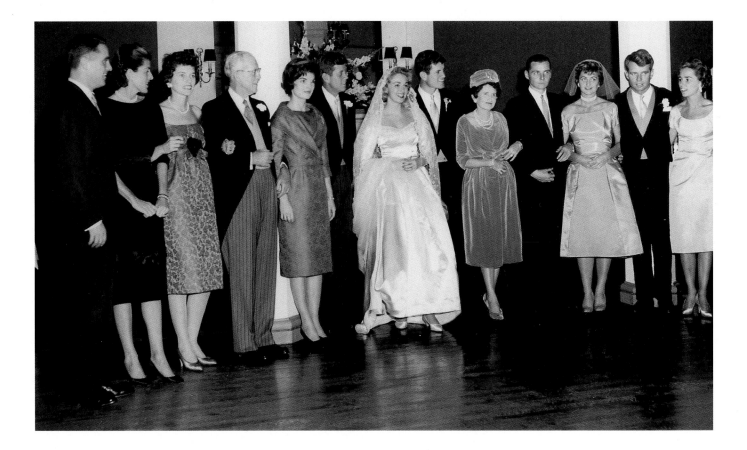

ed Kennedy had been married previously. He was the last of his generation to marry, and his wedding to the lovely Joan Bennett in November 1958 capped the family's year, which had seen Jack win an overwhelming reelection to the U.S. Senate, as well as the births of Victoria Lawford and Michael Kennedy.

There exists but one formal portrait of the entire family, taken the morning of JFK's election to the presidency in 1960.

Here is a rare "runner-up" to that famous photograph—a picture welcoming Joan Kennedy into the family, with everyone present except for Peter Lawford, who was filming and couldn't get away to attend. Patricia Lawford, who had given birth three weeks earlier, stands between Sargent and Eunice Shriver.

Ted and Joan were married for twenty-four years, divorcing in 1982, and are the proud parents of two sons, Ted Jr. and Patrick, and a daughter, Kara.

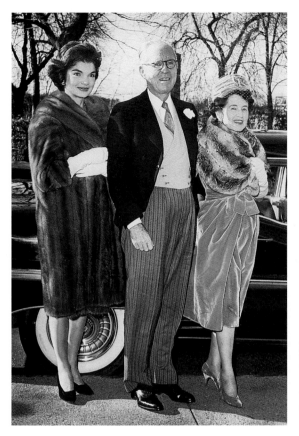

ABOVE It was blustery cold that morning, and both Jackie and Rose bundled up for the trip to Bronxville. Ambassador Kennedy poses proudly with his wife and daughter-in-law before entering St. Joseph's Church.

RIGHT What an enviable position for a young bride to be in—dancing with one handsome brother-in-law while another handsome brother-in-law tries to cut in.

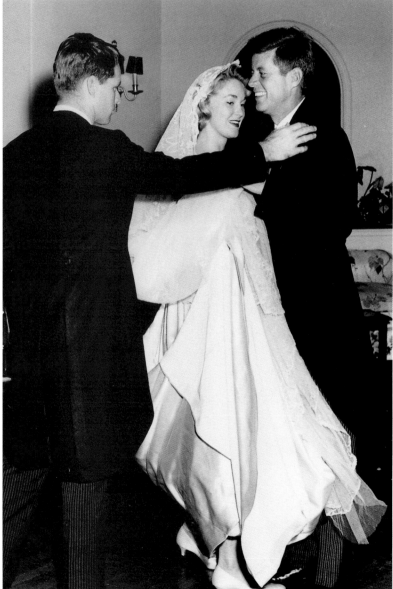

THE THIRD GENERATION
1973–1998

> *I hope they will comprehend that the span of any life is short and all the days and hours are precious. I hope they will live life fully . . . in all the dimension of both its duties and its beauties.*

ROSE FITZGERALD KENNEDY,

SPEAKING OF HER GRANDCHILDREN IN

TIMES TO REMEMBER

KATHLEEN HARTINGTON KENNEDY AND DAVID LEE TOWNSEND

November 17, 1973
Washington, D.C.

Like her aunt and namesake, Kathleen Hartington Kennedy was the first of her generation to wed. The eldest of Robert and Ethel Kennedy's children, Kathleen was a sophomore at Radcliffe College when she met David Townsend. He was a graduate student who tutored her in a course on American Southern writers. A native of Maryland, David was a doctoral candidate in English at Harvard University. Their rela-

tionship grew so quickly that they chose to marry while Kathleen was still an undergraduate. So, in the fall of her senior year, Kathleen planned her wedding. When other classmates were taking the LSATs or writing their résumés, Kathleen was choosing Scripture readings and devising a ceremony that was personal, meaningful, and spiritual.

ABOVE Days shy of her sixteenth birthday, Caroline Kennedy was one of her cousin's bridesmaids. All ten bridesmaids were dressed in emerald-green velvet, with lace trim at the collars and cuffs. Oscar de la Renta chose wide soft-brimmed hats, in the same velvet, to complete the ensembles he designed.

RIGHT Rose Kennedy, followed by her daughter Eunice Shriver and granddaughter Maria, enters Holy Trinity Church in Georgetown.

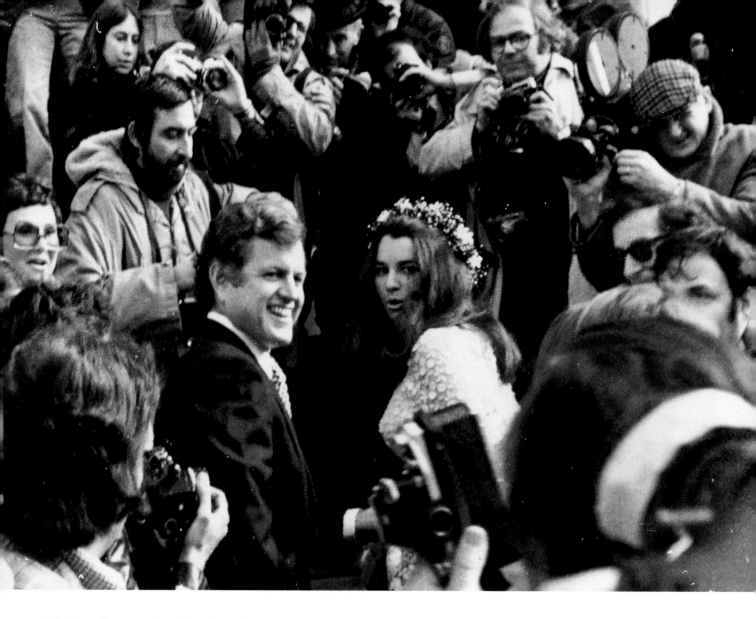

Ted Kennedy escorted Kathleen into the church and gave away the bride. It was a bittersweet moment for him—filling in for a beloved, and much missed, father and brother. Bittersweet, too, in the ripple of fate that placed his son half a mile away in Georgetown University Hospital. Ted Jr. had been diagnosed with bone cancer and had had his right leg amputated an hour or so before the wedding ceremony. The irony of the two events, juxtaposed over a few hours a few blocks from each other, would strain credulity in drama, and yet is true.

Kathleen's immediate thought was to postpone the wedding, and her offer to do so was both gracious and sensitive. In the end, the decision was made to go forward. At one point during the ceremony, as the congregation sang "When Irish Eyes Are Smiling," there were tears of gladness and more than a few prayerful tears for their young cousin.

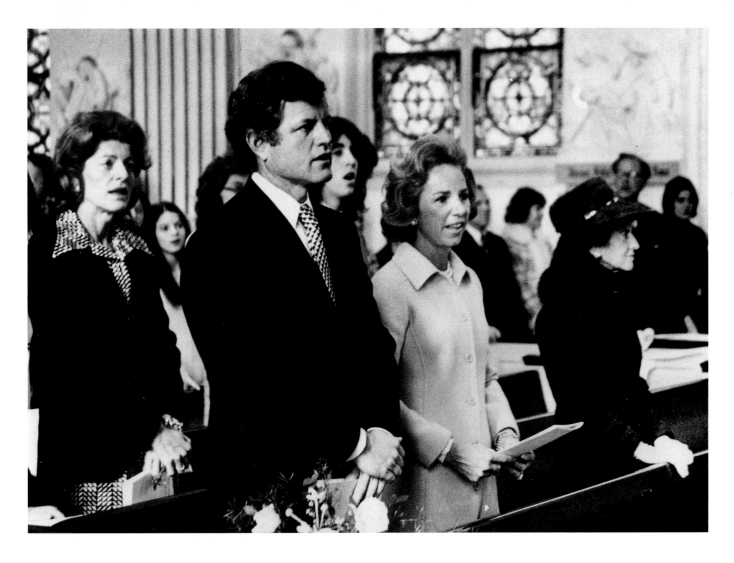

Georgetown's Holy Trinity Church has a long association with the Kennedy family. President Kennedy worshiped there the morning of his inauguration in 1961, and in 1983 it was the site of a memorial Mass in his honor. It has served as a family parish church and the site of happy events like this marriage ceremony. Ted Kennedy shares the front pew with his sister-in-law and his mother. Patricia Lawford and her son, Christopher, can be seen in the second row.

If ever two were one, then surely we.
If ever man were loved by wife, then thee;
If ever wife were happy in a man,
Compare with me ye women if you can.

RIGHT Kathleen chose "To My Dear and Loving Husband"—a seventeenth-century poem by Anne Bradstreet, wife of a Massachusetts Bay Colony Governor—to recite as part of her marriage service. Mr. Townsend, described as "tall, smiling, with reddish hair and with a Lincolnesque beard," responded with Walt Whitman's "Fast-Anchor'd Eternal O Love!" The young altar boy is John Kennedy Jr.

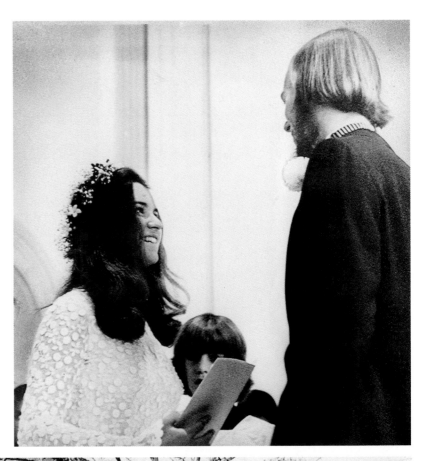

RIGHT David and Kathleen Townsend's wedding was a joyous ceremony. They had carefully planned the service; it was threaded with tradition—ushers in cutaways, "Ave Maria" sung from the choir loft—and infused with informality and a deeply felt ecumenical spirit. David handmade the two gold bands, which were inscribed in Gaelic, and the couple took great care in choosing the music and Scripture readings.

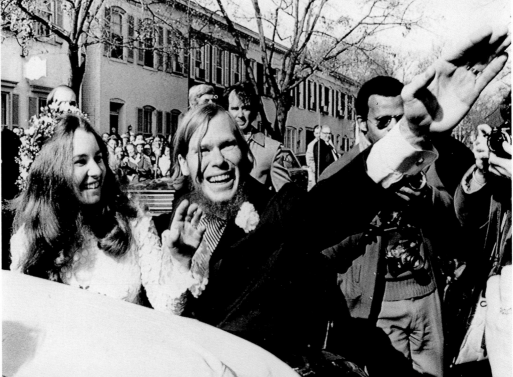

90

MICHAEL LeMOYNE KENNEDY AND VICTORIA GIFFORD

March 14, 1981
New York City

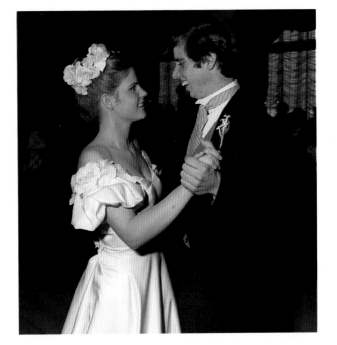

"She was the prettiest bride I've ever seen in my life. Really the best-looking bride. It made you want to get married, it really did." Those were the thoughts of artist Andy Warhol, one of the guests at the wedding of Victoria Gifford to Michael LeMoyne Kennedy. Michael was RFK's fourth son, and in many ways, his mother's favorite. Vicki, the daughter of football great Frank Gifford, had met Michael when she interned in Ted Kennedy's Senate office in 1975. Their relationship bloomed and they were married on a blustery spring morning in New York's St. Ignatius Loyola Church.

Vicki was especially lovely in a white satin gown, with little cap sleeves pushed off the shoulder and a glimmering tulle veil caught in a cap at the back of her head. Her attendants, Martha Richardson, stepsisters Lisa and Siri Lindley, and sisters-in-law Kerry, Rory, Courtney, and Kathleen, wore lilac and white satin and carried posies of purple violets. Michael and his sixteen groomsmen wore formal morning suits, replete with gray gloves. It was a splendid wedding, with a lavish reception at the St. Regis Hotel. Among the guests were Ted Kennedy, Caroline and John Kennedy, Eunice Shriver, Pat Lawford, Art Buchwald, NFL Commissioner Pete Rozell, football announcers Don Meredith and Howard Cosell, ABC executive Roone Arledge, and historian Arthur Schlesinger Jr.

Michael Kennedy died tragically in a skiing accident in December 1997, leaving his widow, Vicki, and their three children, Michael Jr., Kyle, and Rory.

SYDNEY MALEIA LAWFORD AND JAMES PETER MCKELVY

September 17, 1983
Centerville, Massachusetts

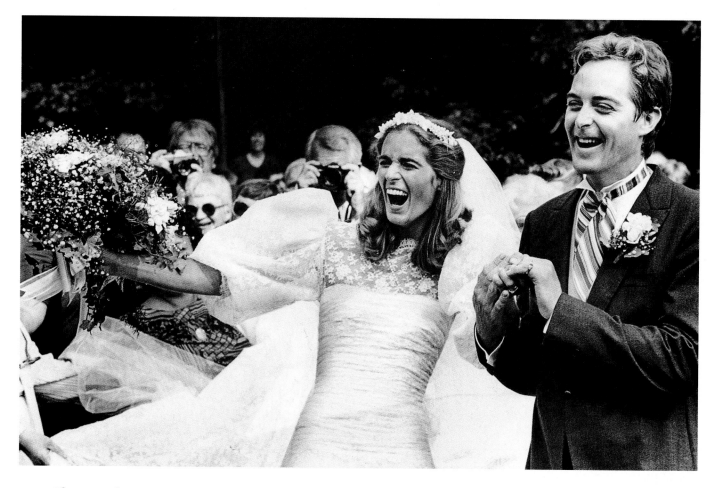

It was as close to a perfect day as possible: a couple so obviously in love, the lingering hint of summer in a gleaming sunlit afternoon, family and friends gathered to celebrate. Peter and Sydney had known each other for many years, and their happiness was celebrated in toast after toast.

The wedding was held at Our Lady of Victory Church in Centerville, with bridesmaids in tea-length dresses of French blue and a cordon of ushers in cutaways. It was warm in the church, and Sydney engaged confidences with Peter throughout their wedding ceremony. The wedding dinner took place under a pair of blue-and-white-striped tents on the lawn outside of Rose Kennedy's house and lasted well into the night. The best man, Peter's elder brother, Bill, offered a pithy toast: "May the force be with you."

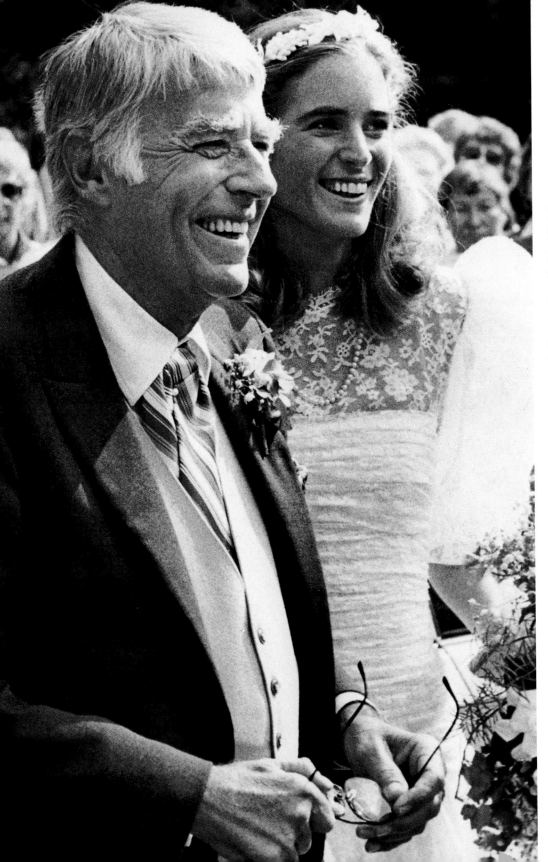

During Ted Kennedy's 1980 Presidential campaign, Sydney Lawford wrote to her father, "When I'm introduced, it's not 'Senator Kennedy's niece,' it's 'Peter Lawford's daughter' and people almost pass out!! You're really loved and admired by so many people, Daddy. It makes me feel so proud."

Sydney was named after her paternal grandfather, and one can clearly see that she inherited much of her good looks from her father's side of the family.

When asked at the reception what advice he might offer his daughter and son-in-law, Peter Lawford looked wistful and said, "Be as happy as you can and free and compatible and loving and that's about it.

"I wish them love and happiness. Joy. What else is there?"

93

Sydney drew gasps of admiration in her Jean-Louis Scherrer gown. Tall and slender, she chose a dress whose shirred bodice accentuated her figure and whose appliquéd lace gave the design richness and texture. Her veil was held in place by a coronet of flowers and provided the only hitch in her wedding-morning preparations—"I was trying for an hour to figure out how to put it on and Mrs. Scherrer came in and wrapped my hair around it."

The bride's father was introspective before the ceremony. He told a reporter, "It's tough when you have to give your oldest daughter away. It's easier with sons, I've been told. I always said I'd tough it out when my time came." But by the time they reached the church, he was in fine humor. As father and daughter stopped to pose for photographers and onlookers outside the church, a voice in the crowd called out, "Peter, stand up straight!" With mock indignation, Peter puffed out his chest and replied, "Madam, this is as straight as it gets."

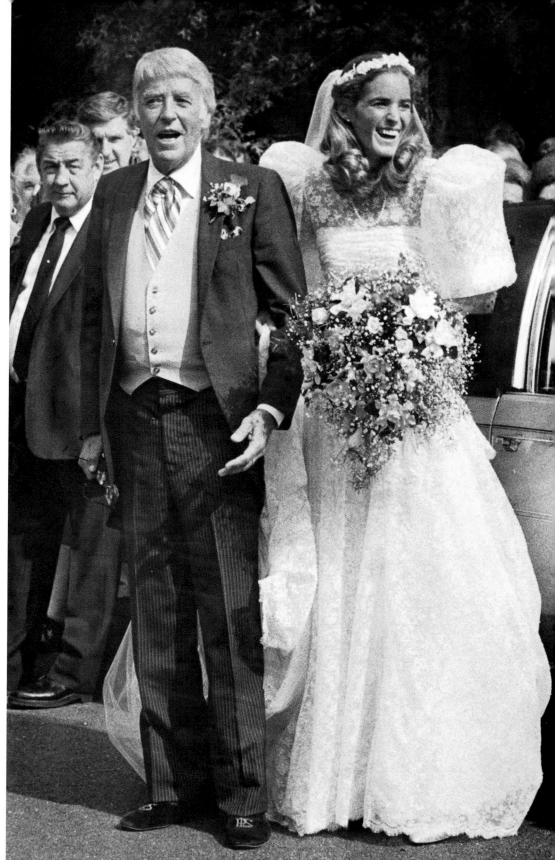

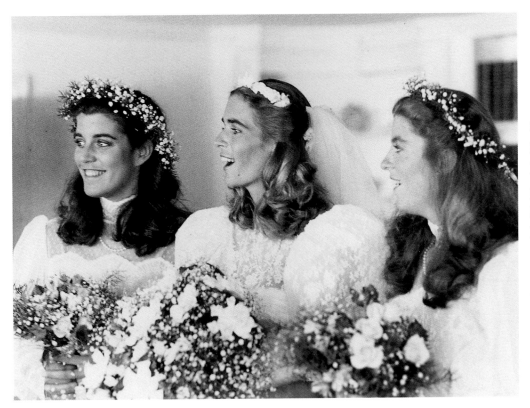

LEFT Three beauties: Flanked by her sisters, Victoria and Robin, the bride poses for photographs in the library of her grandmother's house in Hyannis Port.

BELOW Sealed with a kiss—Sydney Lawford becomes Mrs. James Peter McKelvy as their families and friends watch with delight.

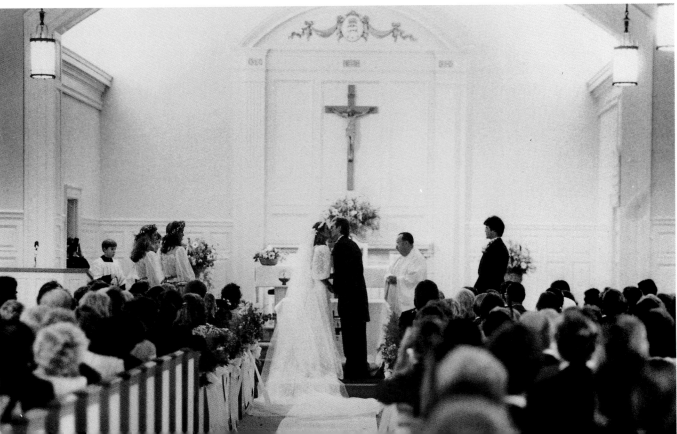

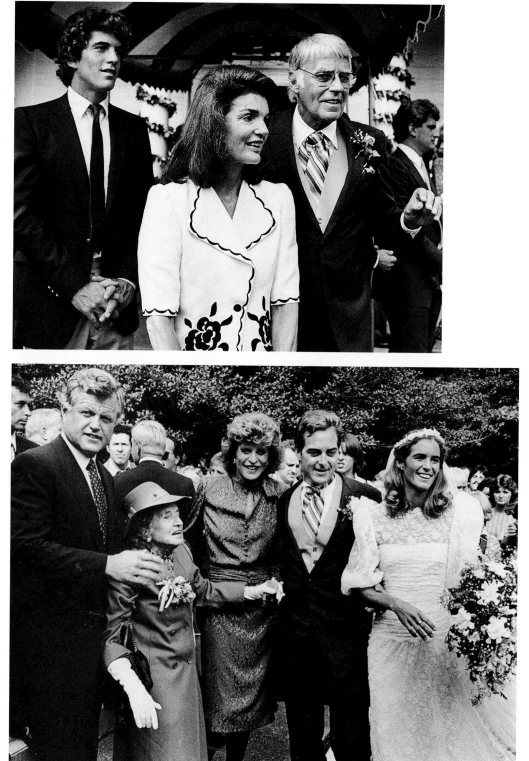

TOP "Sydney is my godchild," Jacqueline Onassis once said. "I'm very proud of her." Jackie understood the pressures a divorced father could feel when called upon to give his daughter away. It was thirty years earlier, almost to the day, when Jack Bouvier had succumbed to such tension. With a blend of affection and exquisite courtesy, Jackie made sure that Peter felt comfortable throughout the day, sitting next to him in church and later engaging him in conversation at the wedding dinner.

BOTTOM Sydney's marriage was the last family wedding that Rose Kennedy was well enough to attend. Elegantly dressed in a royal blue coat and hat, she was seated in a place of honor next to her daughter Patricia and surrounded by her family. With her grandson Christopher reading from the Scriptures, the nuptial Mass must have had special meaning for her.

CHRISTOPHER KENNEDY LAWFORD AND JEANNIE OLSSON

November 17, 1984
Bequia, West Indies

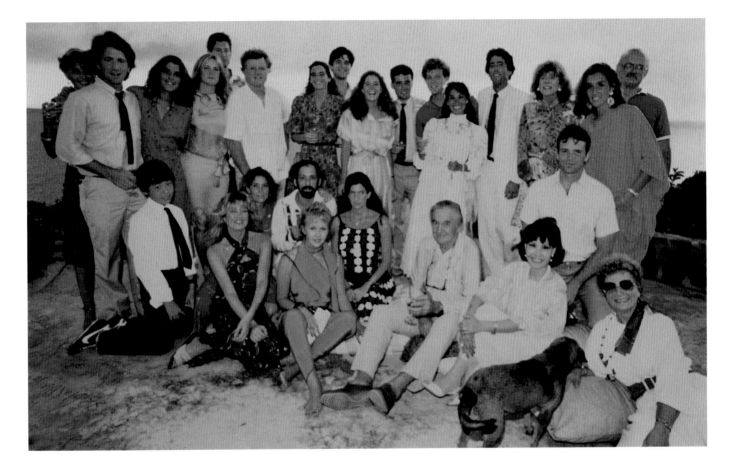

\mathcal{C}hris Lawford and his wife, Jeannie, met while he was a law student at Boston College in the early 1980s. Of Swedish and Korean descent, Jeannie was a journalist whom Chris credits with being his "support system" through the arduous years he studied law.

Dressed in white, the two were married in a private double-ring ceremony on the small island of Bequia in the West Indies. Among the family members present were the groom's mother, Patricia Kennedy Lawford; his three sisters; cousin William Smith; and Senator Ted Kennedy. There had also been a big family party a few weeks earlier, at New York's Club A disco, to celebrate the engagement. Pat Lawford, Joan Kennedy, and Ethel Kennedy represented the senior generation, while Caroline Kennedy, John Kennedy, and Bobby Kennedy Jr. were among the contemporaries toasting the young couple.

MARIA OWINGS SHRIVER AND ARNOLD SCHWARZENEGGER

April 26, 1986
Hyannis, Massachusetts

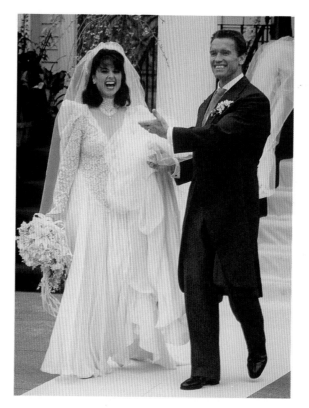

*D*on't look at him as a Republican," Maria Shriver teased her liberal uncle Ted. "Look at him as the man I love, and if that doesn't work, look at him as someone who can squash you."

Hyannis natives still talk of the excitement and energy that the wedding of Maria Shriver and movie star Arnold Schwarzenegger brought to town in April 1986.

Maria and her mother, Eunice Kennedy Shriver, shared more than the same taste in dress designers (in 1953 Eunice flew to Paris to get a Christian Dior original; thirty-three years later

Maria turned to Christian Dior's Marc Bohan to design her silk mousseline gown). Both women enjoyed long courtships with their prospective spouses. Eunice and Sargent Shriver dated for nine years before their marriage, and Maria knew Arnold for seven before accepting his proposal. "I thought he was interesting and I was impressed by his sense of humor," she told TV personality Kathie Lee Gifford. "But I was embarking on a television job in Philadelphia. I wanted to feel that I was making my own life and that I was okay with me before I could expect someone else to buy into me."

Arnold arrived twenty minutes early for his wedding, rolled down the window in his limousine, and with a broad smile and a stogie, waved to the crowd. The night before, upon presenting his in-laws-to-be with an Andy Warhol portrait of Maria, he said "I'm not really taking her away, because I am giving this to you so you will always have her. I love her and I will always take care of her. Nobody should worry."

TOP LEFT Barbara Walters surveys the view from underneath the brim of her straw hat. A longtime friend of Eunice Shriver's, the esteemed journalist brought a touch of spring to the raw April morning with her jonquil yellow suit.

BOTTOM LEFT "The best part of the reception was seeing that they were as genuinely happy as they seemed to be," Diane Sawyer remembered. The journalist turned heads as she jogged around Hyannis the morning of the wedding.

TOP RIGHT "Dear Abby" columnist Abigail Van Buren and her husband, Morton Phillips, arrived at the church in a white Silver Cloud Rolls-Royce.

BOTTOM RIGHT Oprah Winfrey, a recent Oscar nominee for Steven Spielberg's *The Color Purple,* read Elizabeth Barrett Browning's "How do I love thee" during the ceremony. She and Maria became friends when they both worked at the same Baltimore television station in the early days of their careers.

TOP LEFT Marc Bohan had dressed Eunice Shriver during her years as chatelaine of the American embassy in Paris, so it was a particular delight for him to design the ensemble she wore to the wedding of her only daughter. The color—"bright green, Irish green, of course."

TOP RIGHT Arnold's mother, Aurelia Schwarzenegger Jadrny, arrives looking especially lovely in a pale lilac silk dress. She had hosted an "Austrian clambake" the previous evening, with a menu that mixed Wiener schnitzel and lobster, strawberry short-cake and Sacher torte.

BOTTOM LEFT "It was the most beautiful wedding ceremony I've ever been to in my life," said Ethel Kennedy the day after the wedding at a fund-raiser for eldest son Joe's Congressional race.

BOTTOM RIGHT "Very simple, a striking suit with a white collar, not that dressed-up but very elegant" was designer Marc Bohan's professional assessment of Jacqueline Onassis's ensemble. They sat together at the wedding lunch—"So charming, very kind."

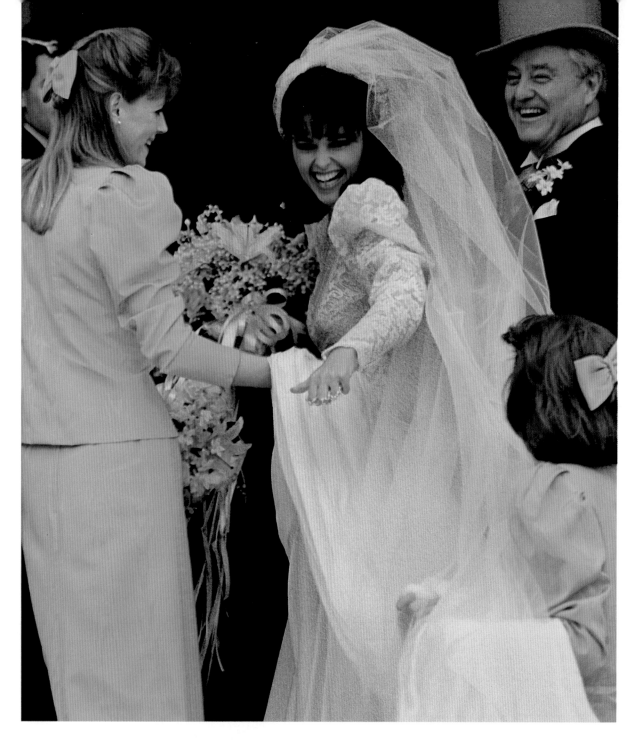

A dapper Sargent Shriver, in a gray top hat, escorts his radiant daughter into the church. Bridesmaid Charlotte Soames Hambro (whose daughter Clementine was Princess Diana's youngest bridesmaid) and Caroline Kennedy help with the eleven-foot train.

"I'm not usually this nervous," Arnold announced to the guests from the altar.

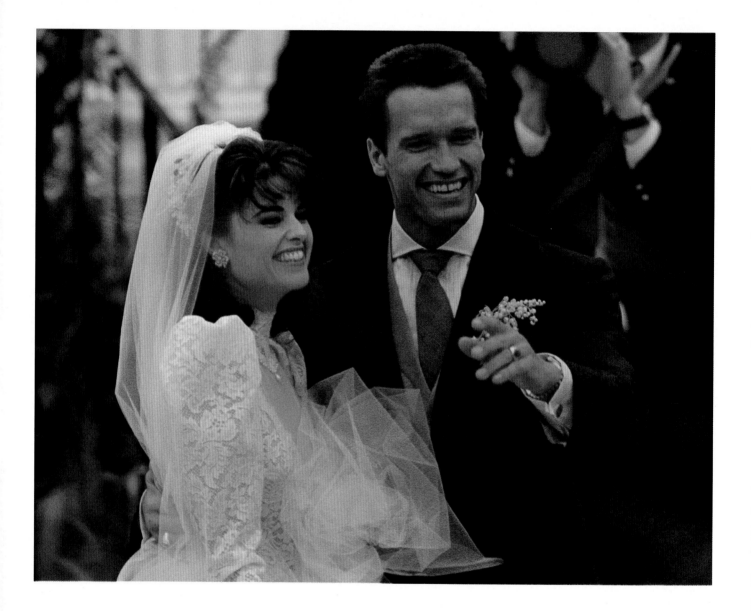

ABOVE "I don't think anybody realizes how much of [the planning] Maria and Arnold did themselves. They picked the readings and planned it all," remembered one of their attendants. The planning included selecting a Marc Chagall print to grace the cover of the wedding program and selecting *The Sound of Music*'s bridal march for their recessional.

OPPOSITE With a matched pair of glorious smiles and extravagant gestures, Maria's parents wave good-bye as the newlyweds drive away from the church. Both Eunice and Sargent Shriver gave readings during the nuptial Mass.

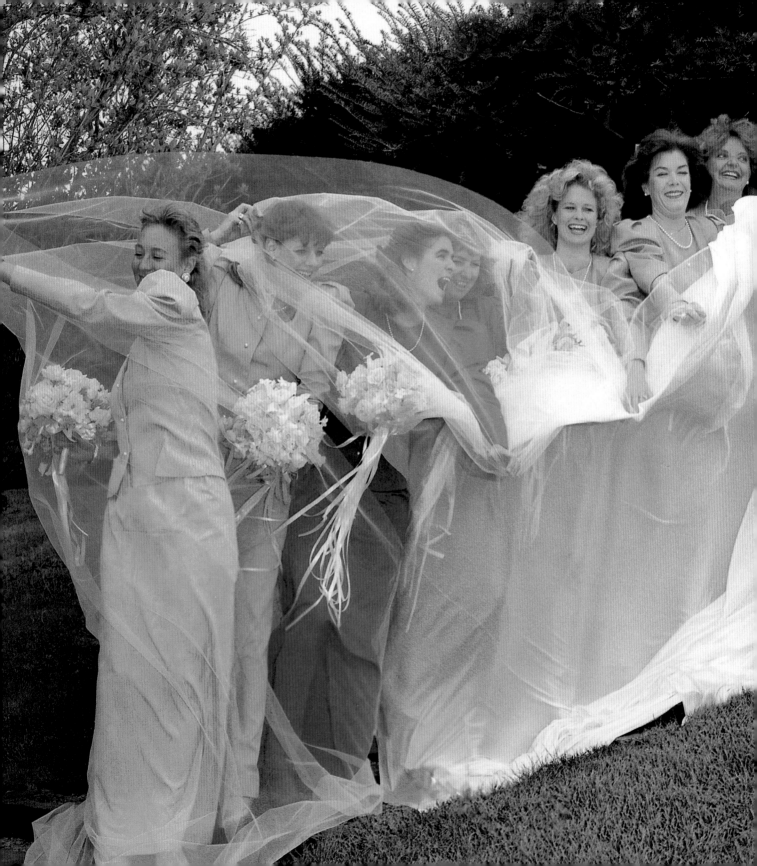

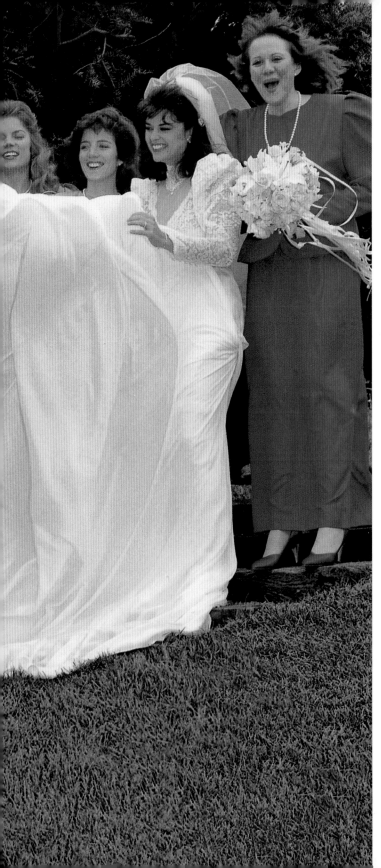

Maria's ten bridesmaids wore gowns designed by Marc Bohan. "The idea [for the different colors] came from Mrs. Shriver," he recalled. "We were having lunch in New York and there were flowers on the table. 'What if the colors were like a bouquet of flowers?' she suggested. It would be so pretty and much easier for [each bridesmaid] to choose her favorite color."

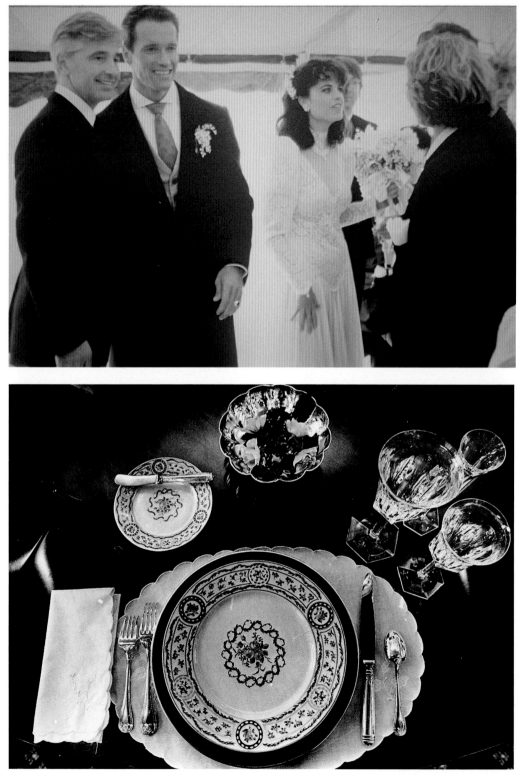

TOP Mr. and Mrs. Schwarzenegger received their guests under a large tent on the grounds of the Hyannis Port compound. Maria changed into white running shoes upon returning from church, having broken two toes in an accident a few days before. Maria had spent eight months planning her wedding. "She was so incredibly calm," recalled bridesmaid and former classmate Theo Hayes. "She had gone over every single detail. She knew where everything and everyone belonged. You could give her a name, and she'd know exactly whom they were going to sit with."

BOTTOM Dinner at the Schwarzeneggers' would be served on Louveciennes Haviland Limoges china and eaten with Malmaison Christofle flatware; fine wines would be drunk from matching Malmaison crystal. These were the choices Maria registered for.

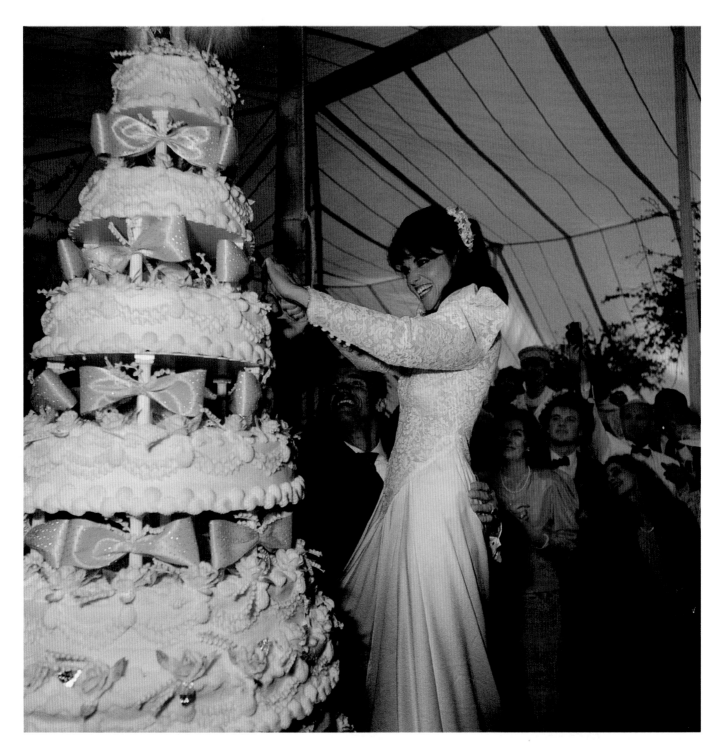

The wedding cake was a replica of her mother's, and so, too, was the look of vigorous resolve as Maria Shriver cuts into the eight-tier confection.

TIMOTHY PERRY SHRIVER AND LINDA STURGES POTTER

May 31, 1986
Washington, D.C.

It was a season of Kennedy weddings, and Timothy Shriver and fiancée Linda Potter had a bit of a "pre-Broadway tryout" a month earlier when both were in the wedding party of his sister Maria's wedding to Arnold Schwarzenegger. Their wedding luckily avoided a media crush, and they were able to celebrate with a modicum of privacy. Linda was a childhood friend of Tim's cousin Courtney and had known her husband-to-be for many years.

The attractive couple wed in an ecumenical ceremony that included New York Episcopal bishop Paul Moore conducting a service outside Georgetown University's Dahlgren Chapel. Afterward, accompanied by a pair of bagpipers, the couple, escorted by their parents, Sargent and Eunice Shriver and Robert and Isabel Potter, entered the chapel for a second ceremony conducted by the Reverend Richard Fragomeni.

The wedding party numbered thirty, with four best men—cousin John Kennedy Jr. and the groom's three brothers, Bobby, Mark, and Anthony. The very newly wed Maria Shriver was matron of honor. One of the groomsmen was Dino Bradlee, a childhood neighbor of Caroline Kennedy and the son of *Washington Post* legend Ben Bradlee. Among the family present were Pat Lawford, Jean Kennedy Smith, Jacqueline Onassis, Ethel Kennedy, and Edward Kennedy. Vernon Jordan, Art Buchwald, and Kennedy Center director George Stephens were among the four hundred invited guests.

A reception was held at the McLean, Virginia, home of the bride's parents.

RIGHT The Georgetown University campus was familiar territory for the family of John F. Kennedy. Caroline Kennedy had grown up just a few blocks away, on N Street, and her brother, John, was born at the university's hospital in the early-morning hours after Thanksgiving 1960. Jacqueline Onassis walks with her daughter, Caroline, and Ed Schlossberg, whose own wedding was six weeks away.

CAROLINE BOUVIER KENNEDY AND EDWIN ARTHUR SCHLOSSBERG

July 19, 1986
Centerville, Massachusetts

*T*here would be another "royal wedding" across the ocean later the same week, but on July 19, 1986, the eyes of the world were focused on a simple country church in a small town on Cape Cod. Caroline Kennedy and Ed Schlossberg chose his forty-first birthday to wed in a ceremony that was both simple and elegant, surrounded by family, friends, and the lords and ladies of the thousand-day reign of Camelot.

Celebrated artist Jasper Johns, a friend of Ed's for more than twenty years, said of the wedding, "There was a kind of prettiness to the church. It was prettier than I know how to explain. Visually, it was very sweet." Robert Rauschenberg, another close friend of the groom's, remembered, "It was wild roses from the dunes and honeysuckle. Very sweet. And the attitudes, particularly of the bride. She laughed . . . because she was happy."

She had grown up before our eyes, from an enchanting toddler clacking around in her mother's high heels into the slender and wistfully pretty woman in a gown of white silk organza. Covered in embroidered shamrocks in an elegant tribute to her father's ancestory, Caroline's wedding dress featured a round neck, short sleeves, and a plain skirt that gathered into a long train. Jackie's friend society couturier Carolina Herrera designed the dress, with no input from the mother of the bride. "I think Caroline wanted to surprise her with a dress she would like," Herrera said at the time. "You can see they adore each other."

The same can obviously be said about Caroline and Ed. In turning to a man twelve years her senior, Caroline followed the example set by her mother (who was twenty-four to JFK's thirty-six) and grandmother (Janet Lee was twenty-one when she married the thirty-seven-year-old "Black Jack" Bouvier). Ed's maturity and searing intelligence complemented Caroline's inquisitive mind and strong sense of privacy. An author and artist, Schlossberg also runs a New York–based company that designs museum exhibits and installations. Like the Kennedys, he finds respite in Massachusetts, though he retreats to a small town nestled in the Berkshires, across the state from Hyannis.

When asked for his general impression of the wedding, Rauschenberg laughed and said, "I feel as if there are seventy-five thousand Kennedys." Perhaps on that special day, as we watched this exceptional young woman marry, there were that many and more.

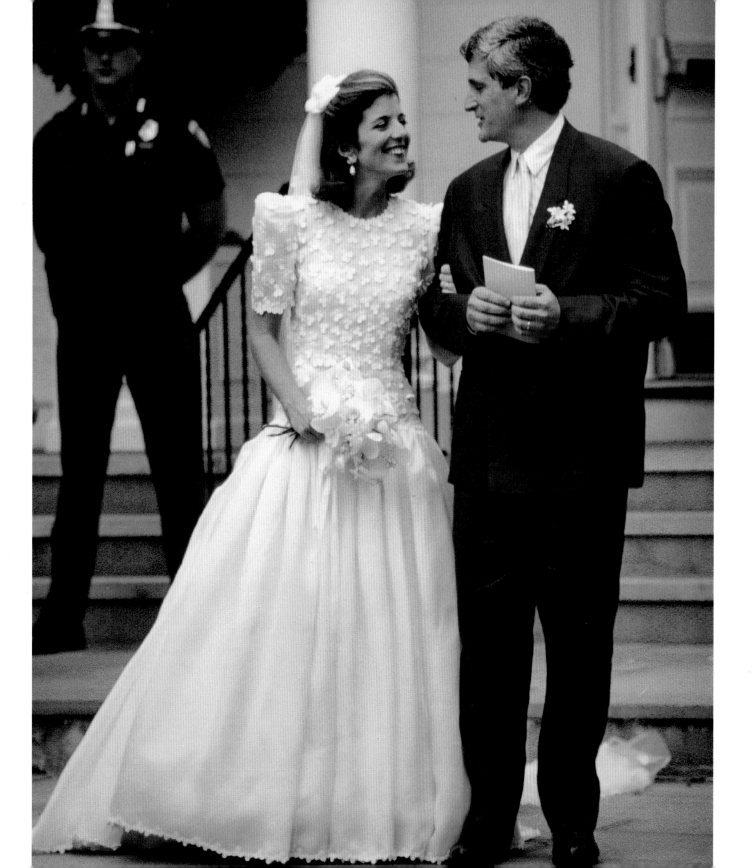

TOP Late in the afternoon on the day before the wedding, everyone gathered at the church for a rehearsal conducted by Rev. Donald MacMillan, a Jesuit priest who had married Caroline's cousin Sydney Lawford McKelvy. Several family members had roles in the double-ring ceremony. The couple had chosen specific readings for the service. "Caroline and Ed seem to have a good grasp of Scripture," MacMillan told a reporter. Ed's sister, Maryann Gelula, read a portion of Isaiah, and Caroline's uncle Steve Smith read from Corinthians.

When the party exited, Ted Kennedy told onlookers that he was "delighted" to be an important part of the wedding and that it would "be a beautiful birthday present for my mother, who will be ninety-six years young [Rose Kennedy's birthday was a few days away]."

BOTTOM Back at the compound, Jacqueline Onassis checks security arrangements outside her Irving Avenue home. When asked why the bride's mother had not attended the rehearsal, Reverend MacMillan said, "She knows how to walk down the aisle."

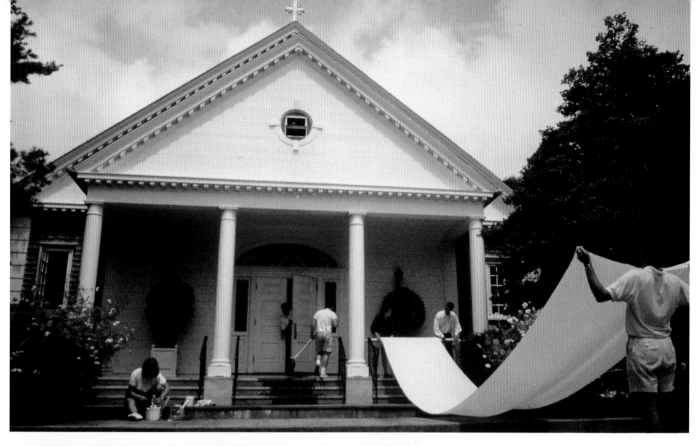

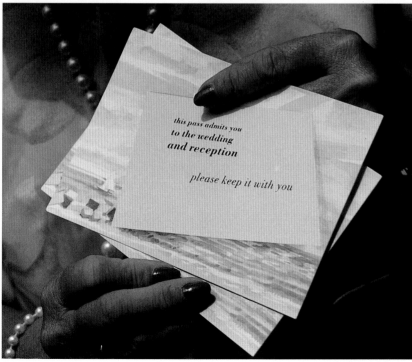

this pass admits you
to the wedding
and reception

please keep it with you

ABOVE Our Lady of Victory gets a last-minute touch-up the morning of the wedding: Some paint, a sweep, and the white carpet is rolled up in preparation for the march down the aisle.

Jackie's close friend Bunny Mellon decorated the exterior of the church with two whiskey barrels planted with white and purple cosmos and a pair of yew trees.

LEFT Ed and Caroline dispensed with tradition and had wedding invitations designed with pastel views of the church and Rose Kennedy's Hyannis Port home. This card of admittance, which guests were required to show at both the church and the family compound, incorporates a view of the sea-wall and a small skiff sailing on the bay.

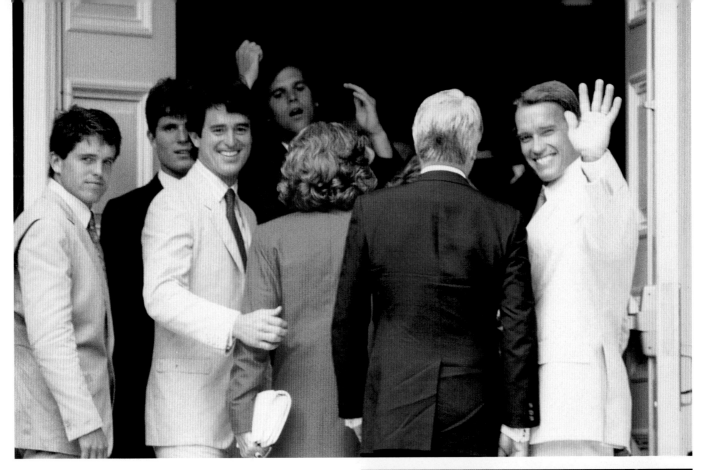

ABOVE Arnold Schwarzenegger waves to the crowd as he enters the church with his new in-laws, the Shriver family (from left, Mark, Anthony, Bobby, Eunice, and Sarge). This was the third family wedding within three months, as Arnold and Maria were married in April and Timothy Shriver and Linda Potter were wed in May.

Cousin Bobby Shriver led the prayers to the faithful, invoking the name of President Kennedy in a solemn moment and making the congregation laugh in another, when, after a particularly tongue-twisting Scripture passage, he sarcastically thanked Caroline for choosing it for him to read.

RIGHT Stunning in hot pink, Eunice Shriver waves to the crowd.

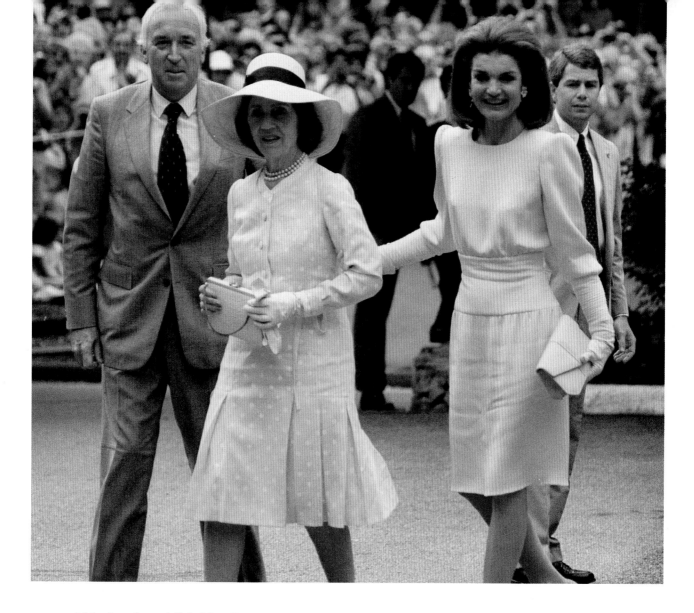

This photo has a delightful pedigree. It was taken by Lynn Wooten, a Kennedy admirer from North Carolina, who sent it to Jackie, who liked it so much that she autographed Mr. Wooten's picture and asked for two additional prints to give to her mother, Janet Auchincloss Bingham, and stepbrother Yusha Auchincloss.

Yusha and Janet came up from Newport that morning. As Yusha remembered, "It was a very nice reception. Jackie didn't want us to leave. She had hired a plane to bring my stepmother and me over to the Cape for the wedding. She kept saying, 'You have to wait until the cake is cut.' In the end, we stayed so long that our plane was rerouted to Providence, and Jackie had arranged for a car to meet us there and take us back to Newport."

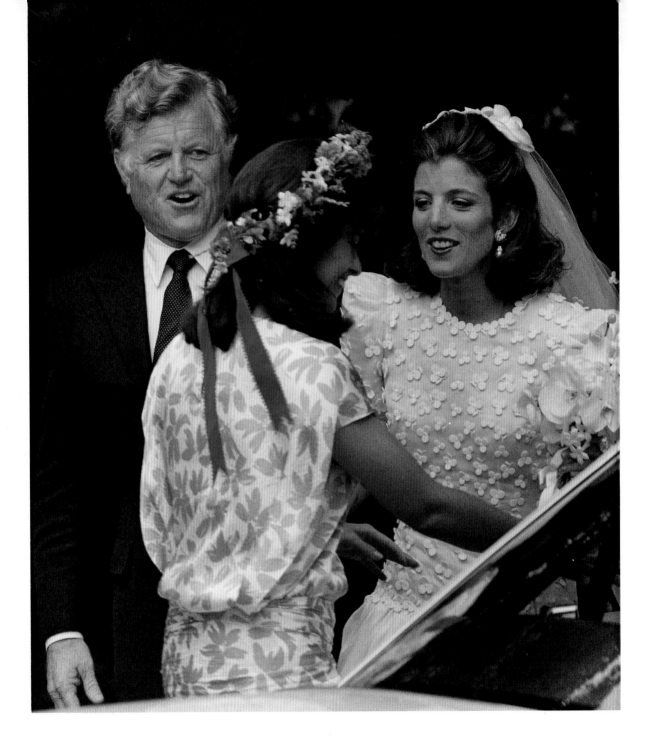

Trading places? It was less than three months earlier when Caroline Kennedy was the maid of honor and Maria Shriver the bride. Caroline's only jewelry is a pair of pearl-and-diamond earrings borrowed from her mother and said to have been a gift to Jackie from President Kennedy.

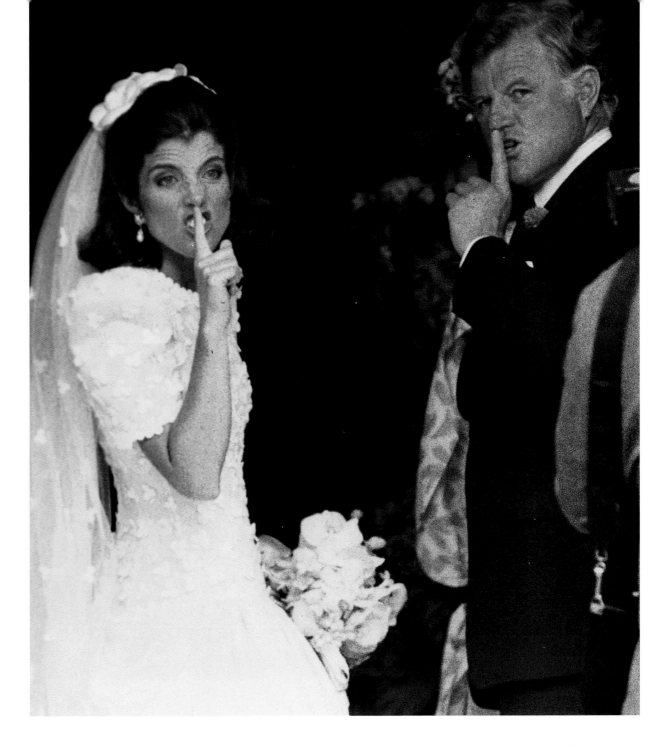

"Shush" is the word, at least at the penultimate moment before walking down the aisle. In an effort to encourage the hundreds of onlookers to a modicum of decorous behavior, both Caroline and her uncle Ted revert to the universal gesture of piqued kindergarten teachers. (P.S. It worked!)

CAROLINE BOUVIER KENNEDY AND EDWIN ARTHUR SCHLOSSBERG

RIGHT His sister Caroline's was the fourth wedding for John Kennedy that summer of 1986 and, he boasted, "my third time as best man, and I get better each time. This one is extra special because it's my sister and I'm glad I get to see it up close." John said that his mother remained "pretty calm because everything's been planned out. It's pretty cool."

BELOW With the entire bridal party on the steps of Our Lady of Victory, John waves goodbye to his sister and new brother-in law.

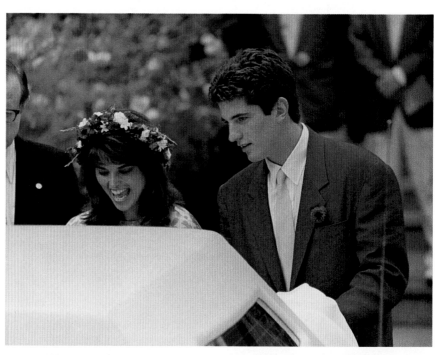

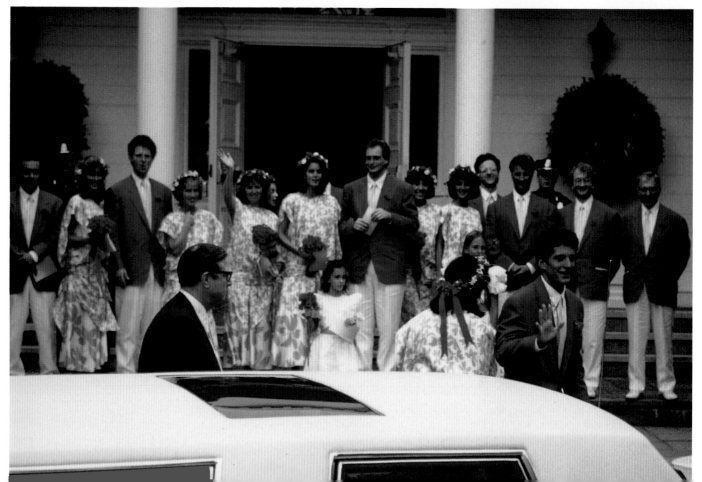

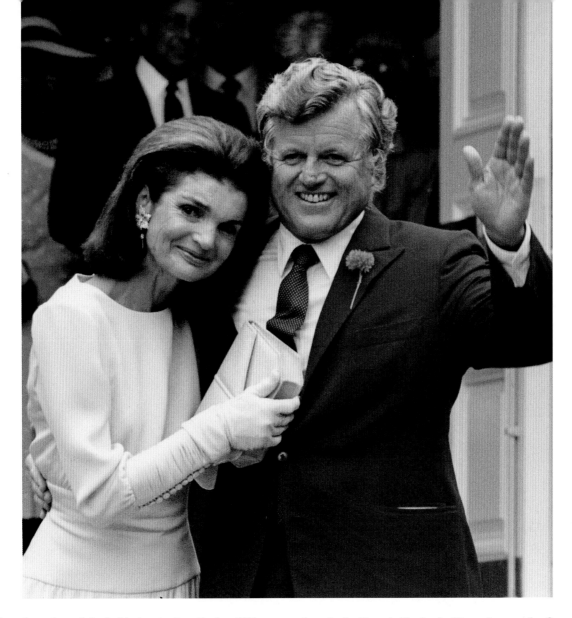

The overjoyed mother of the bride leaves Our Lady of Victory Church on the arm of her brother-in-law, Senator Edward Kennedy. He performed the bittersweet duty of escorting his twenty-eight-year-old niece down the aisle of the picturesque country church (Caroline was the third of his nieces he has "given away"). Jackie wore a pale green dress and laid her head touchingly on Ted's shoulder as the newlyweds drove off. Our Lady of Victory is located in Centerville, about six miles away from the Hyannis Port compound. The Kennedys' parish church, St. Francis Xavier in Hyannis, was the first choice, but even Jackie's considerable charm could not persuade the church to cancel a very popular Saturday-afternoon Mass in order to accommodate the couple.

Senator Kennedy brought tears to many eyes at the reception when he offered a quartet of toasts, first to his mother, then to Ed's parents, then to the new Mr. and Mrs. Schlossberg, and finally to Jackie, "that extraordinary woman, Jack's only love. He would have been so proud of you today."

TOP The mother of the groom, Mae Schlossberg, and her husband, Alfred, leave the church after the Catholic ceremony. Though Jewish, Ed's father appreciated the ecumenical spirit of the service. The Schlossbergs gave a wedding-morning brunch for their family and friends at the hotel where they were staying. They had been invited to Jackie's Irving Avenue home for a drink the previous night, before heading out to the rehearsal dinner.

Jackie danced with all the Schlossberg men at the reception and earned high marks from a member of the family: "Jackie goes out of her way to be pleasant and friendly."

BOTTOM Not everyone knows that Lee Radziwill was born Caroline Lee Bouvier. Jacqueline Kennedy not only named her daughter after her only sister but asked Lee to be godmother to her firstborn child. Nearly twenty-nine years after the christening, which was held in the Bouvier Chapel of St. Patrick's Cathedral in New York, Lee was an honored guest at the wedding. Long admired for her cultivated taste, she wore an elegant white silk dress with a design of gray architectural shapes and pronounced the wedding a "divine event."

TOP LEFT Caroline's aunts Jean Smith and Pat Lawford after the ceremony.

BOTTOM LEFT Joan Kennedy, pretty in pale mauve, and Arnold Schwarzenegger chat it up after the wedding.

Many of the other guests were former aides of President Kennedy, among them Ted Sorensen, Dave Powers, McGeorge Bundy, Richard Goodwin, John Kenneth Galbraith, and Arthur Schlesinger Jr., gathered in a poignant reunion of the New Frontier.

ABOVE Carly Simon, Jackie's neighbor on Martha's Vineyard, organized the music for the wedding reception and serenaded the couple with a spirited rendition of "Chapel of Love" and a touching version of "Loving You's the Right Thing to Do."

The reception was held under two tents on the grounds of Rose Kennedy's home and featured a menu of cold pea soup with shrimp, apples, and mint; roast chicken and rice; cold beef sirloin salad; and ice cream with raspberries. A band named the Supreme Court played "The Girl from Ipanema," and Maria Shriver danced barefoot. Writer George Plimpton created an extravagant fireworks display as a wedding gift, featuring a rose for Rose Kennedy, a seashell for Jackie, and a jumble of multiple explosives entitled "What Ed Schlossberg Does."

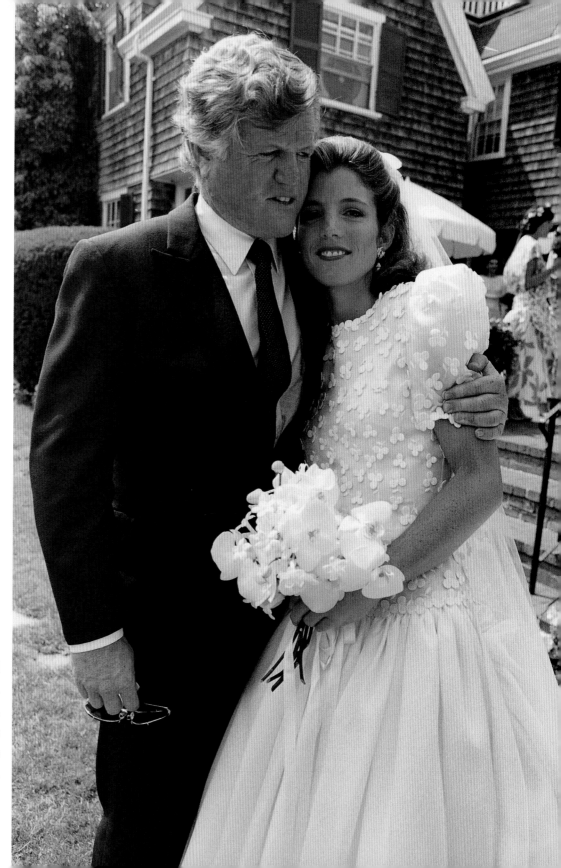

Ted Kennedy enjoys a special bond with his niece Caroline. After the ceremony they posed together behind the Hyannis Port house where Caroline shared many happy summers with her family.

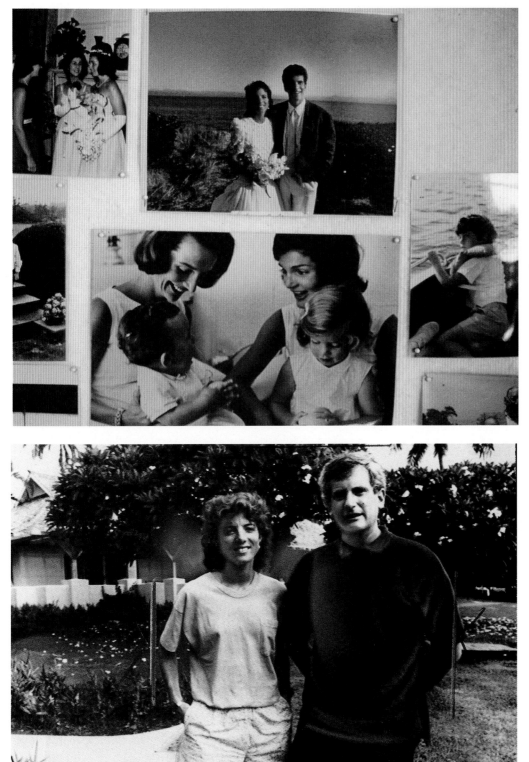

TOP John Kennedy's toast to his sister and her fiancé was the most moving moment of the rehearsal dinner the night before the wedding. "It's been the three of us alone for so long, and now there's a fourth." Their grandmother kept this charming photograph of John and Caroline in her dressing room.

BOTTOM The Schlossbergs spent their wedding night at Boston's Ritz-Carlton Hotel before traveling to Hawaii for a honeymoon trip that ended in Tokyo. Hawaii was a popular choice for members of the Kennedy family—Bob and Ethel Kennedy and Pat and Peter Lawford also went there on their honeymoons.

VICTORIA FRANCIS LAWFORD AND ROBERT BEEBE PENDER JR.

June 13, 1987
Southampton, New York

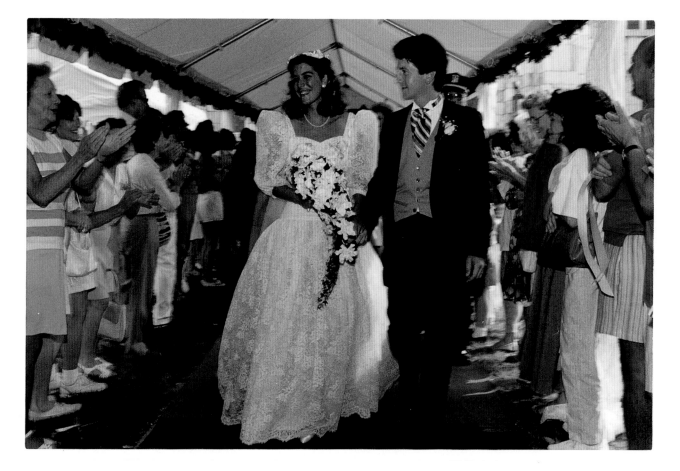

Victoria Francis is the third child, and second daughter, in the Lawford family. On November 4, 1958, the day she was born, her godfather, John F. Kennedy, won an overwhelming victory in his reelection to the U. S. Senate—hence the name Victoria (Francis was a tribute to her parents' close friend Frank Sinatra).

Victoria married Robert Pender on June 13, 1987. They were wed at the Church of the Sacred Hearts of Jesus and Mary in Southampton, New York. Her brother, Christopher, escorted her down the aisle, and her sisters, Sydney and Robin, were her matron and maid of honor. Among the other attendants were her cousins Kara Kennedy and Kerry Kennedy and her new sister-in-law, Dr. Suzanne Pender. The groom's friend Christopher Welch served as best man.

A reception was held at the Southampton home of Patricia Kennedy Lawford.

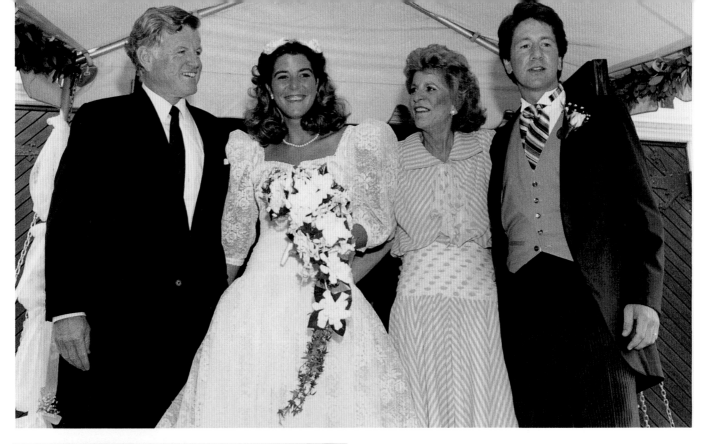

ABOVE Mr. and Mrs. Robert Beebe Pender Jr. are joined by the mother of the bride and her uncle Ted as they stand outside the church.

For her wedding, Victoria chose an ivory-colored dress featuring a sweetheart neckline, puffed sleeves, and a full lace skirt flowing from a shirred bodice. She carried a trailing bouquet of white orchids and ivy. Like her mother thirty-three years before, she was adorned with a single-strand pearl necklace.

LEFT Their own first anniversary was just a month away when Caroline Kennedy and Ed Schlossberg attended her cousin's wedding. Among the other family members present were Joan Kennedy, escorted by her son Ted Jr., and Jacqueline Kennedy Onassis, escorted by her son, John Jr.

CHRISTOPHER GEORGE KENNEDY AND SHEILA SINCLAIR BERNER

August 15, 1987
Winnetka, Illinois

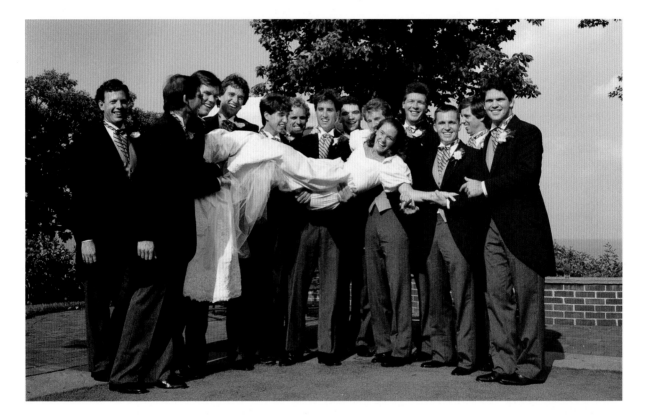

The big noise in Winnetka on August 15, 1987, was the wedding of Christopher George Kennedy and Sheila Sinclair Berner. "It was jammed and there was a great crowd of spectators outside," said the Reverend Thomas Raftery, who celebrated the ceremony with Kennedy family friend Father Gerard Creedon and Reverend John Fahey, who had married the bride's parents.

Christopher Kennedy and Sheila Berner met while students at Boston College. A year after his graduation, they chose Sheila's childhood church in which to become husband and wife. Family members from both sides were in the wedding party. It was a sunny summer afternoon, and the twelve ushers playfully lifted Sheila off her feet as they posed for photographers.

The new Mr. and Mrs. Kennedy settled in Chicago, where Sheila became a lawyer and Chris went to work at the Merchandise Mart, the monolithic Chicago design and retail center that is the center of the Kennedy family's business holdings. He became the first family member since Sargent Shriver to work at the Mart, as it is commonly called.

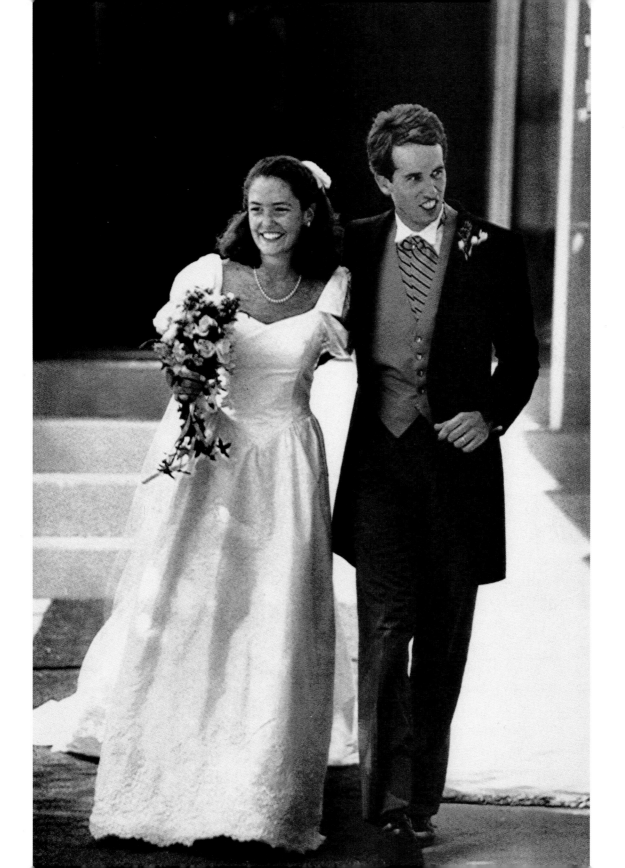

MARY KERRY KENNEDY AND ANDREW CUOMO

June 9, 1990
Washington, D.C.

\mathscr{A}merica had seen marriages between great political families before (Julie Nixon and David Eisenhower in 1968, Sharon Percy and John D. Rockefeller IV the year before), but the marriage of Mary Kerry Kennedy to Andrew Cuomo was a cause for both celebration and more than a little speculation. From the tabloids' talk of "Cuomo-lot" to the sedate editorial pages of *The Washington Post*, the press spoke nonstop of the birth of a new political dynasty and even of how the wedding would strengthen the Presidential aspirations of the groom's father, New York Governor Mario Cuomo. "A merger, not a takeover," proclaimed Mary McGrory in *The Washington Post*. But Governor Cuomo summed it up most accurately: "The only consequence of this marriage that is significant is the consequence to Kerry and Andrew. There is no political implication in the sense of a new force coming out of two old ones."

That's not to say that politics and public service are an anathema to the handsome couple— far from it. Kerry Kennedy, a lawyer, has served as executive director of the Robert F. Kennedy Center for Human Rights and works on behalf of Amnesty International. Andrew became the U. S. Secretary of Housing and Urban Development in the Clinton Administration, after heading New York's Housing Enterprise for the Less Privileged (HELP). "I want to be working hard and my husband to be working hard, and I want both of us to be involved in something caring and constructive," Kerry pledged shortly after graduating Brown University. "I want to be married and madly in love and have a million children."

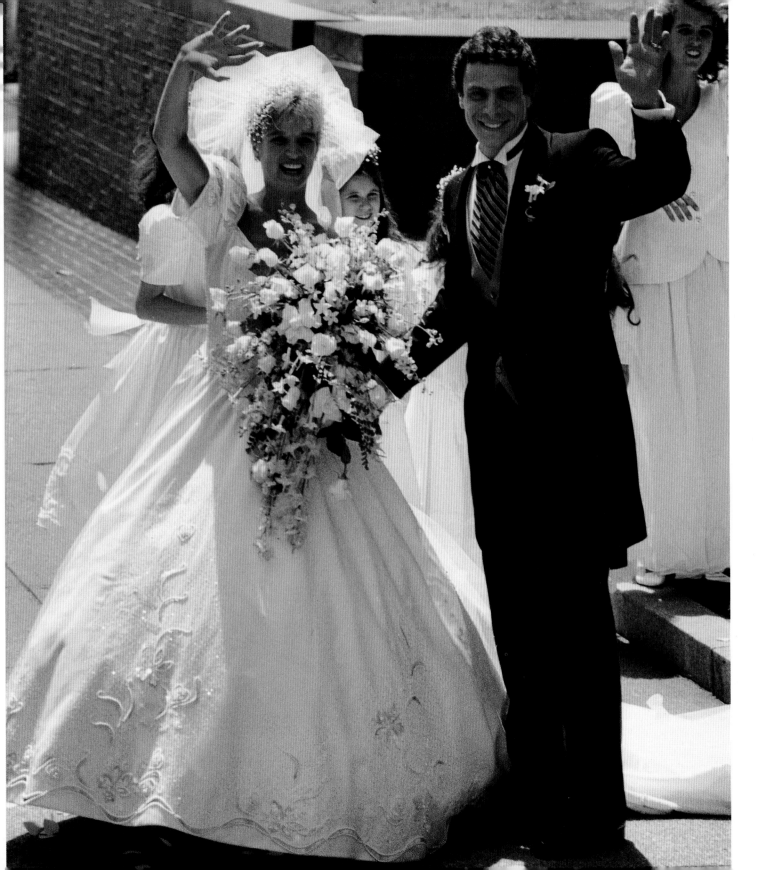

It's not every bride who has editorials written about her in her hometown newspaper, and fewer still when the hometown paper is *The Washington Post.* Respected journalist Mary McGrory wrote: "Surely she is a young woman of originality and flair, and not afraid of breaking precedent. After a parade of little boys and girls from both tribes, all in white, bearing rings, strewing rose petals, and a file of fifteen bridesmaids and fifteen ushers, a blare of trumpets announced the bride. There stood Kerry Kennedy, a brown-eyed blonde, like an apparition. The sun streaming in from a window high above the organ shone through her cloud of veil and glinted on the brilliants on her hoop-skirted satin dress. She was alone, and as she made her way up the long aisle, the congregation burst into applause."

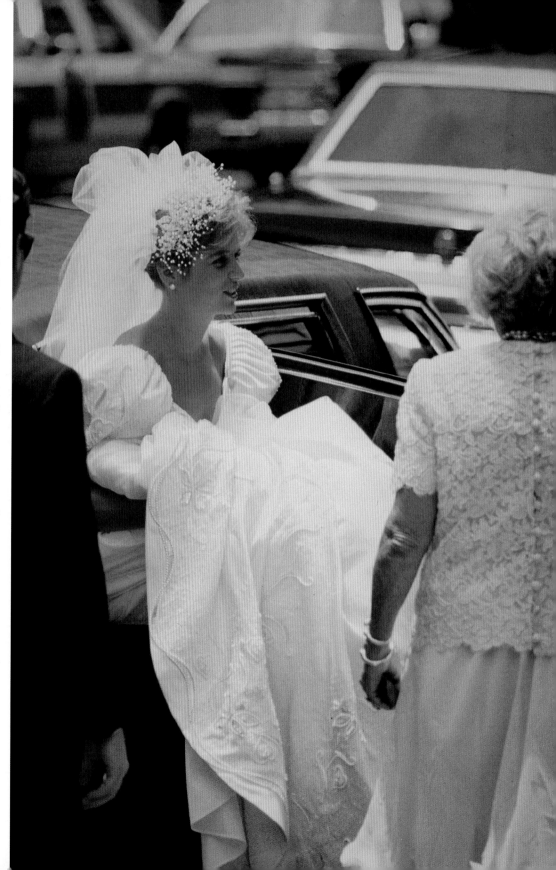

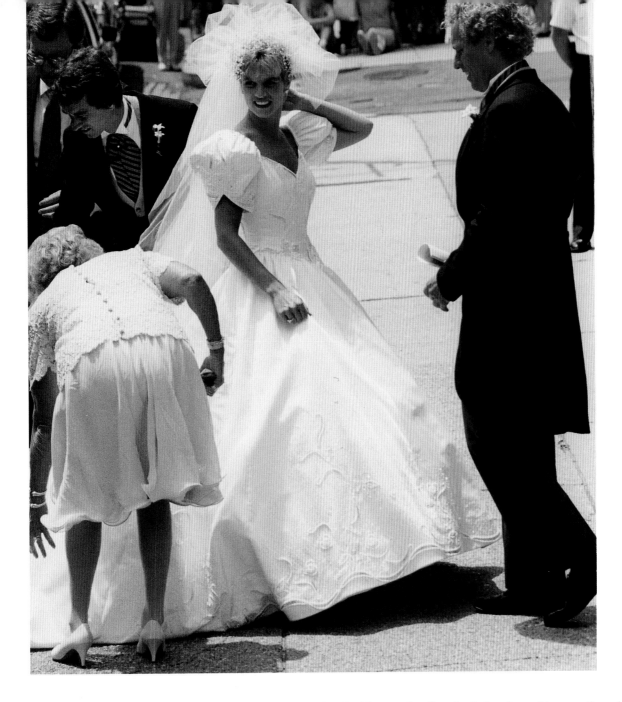

Kerry gets an assist from her mother and elder brothers Bobby and Joe as she sweeps out of her limousine. She bought her Scaasi gown off the rack at a boutique. It was made of gleaming white silk satin with a Basque bodice, a sweetheart neckline, puff sleeves, a voluminous skirt, and a cathedral train. It was embroi-dered with crystals, silver bugle beads, and hearts of pearl. Her tulle headpiece and veil were held in place by a coronet of lilies of the valley. Andrew's brother-in-law Kenneth Cole designed Kerry's shoes and those of the women in the bridal party.

MARY KERRY KENNEDY AND ANDREW CUOMO

ABOVE Like cygnets following their mother, the coterie of bridesmaids accompany Kerry into the cathedral. There were two maids of honor, Kerry's younger sister, Rory, and her close friend Mary Richardson (who would become her sister-in-law a few years later). Among the thirteen bridesmaids were her sisters and Andrew's sisters. They wore white silk satin jackets and long white chiffon skirts and carried bouquets of pale pink roses.

RIGHT The bride greets her cousin John Kennedy Jr. at the entrance to the church.

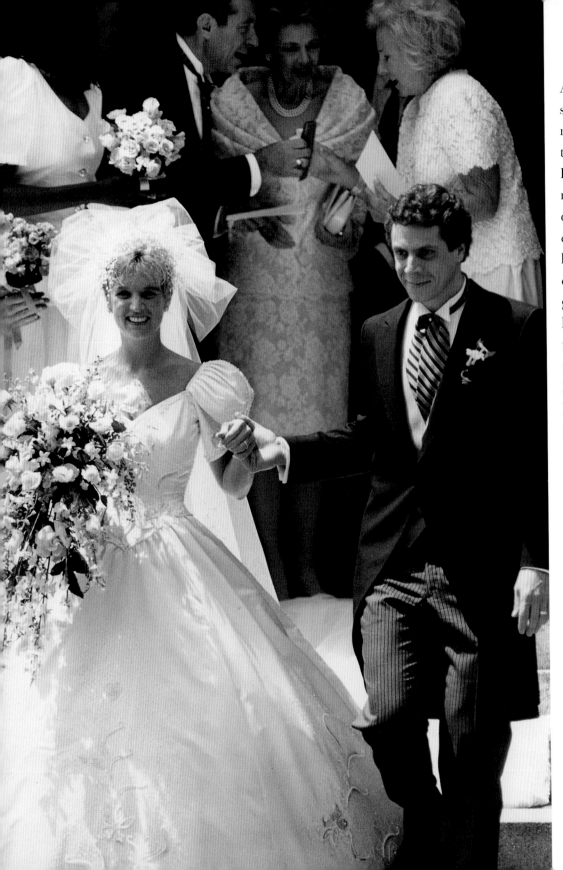

As the newlyweds descend the steps of St. Matthew's, their new in-laws can be seen chatting in the background. Ethel Kennedy wore a pale pink reembroidered two-piece lace dress, and Matilda Cuomo chose a champagne-colored lace dress with a deep shawl collar. Governor Cuomo groused with good-natured bonhomie about formal wear the morning of the wedding, telling *The New York Times*'s Maureen Dowd, "Penguins look good in tails, birds look good in tails. Tails are the ultimate expression in form over substance. Who likes them? Probably three people in the country, and I would neither vote for these people nor appoint them to any office." (He opted for a less formal dress coat.)

Ethel Kennedy later paid a special tribute to the senior Cuomos in her toast to the couple, noting that "after the wedding, as in the marriage of Andrew's extraordinary parents, Matilda and Mario, the world will be twice-blessed by their love."

135

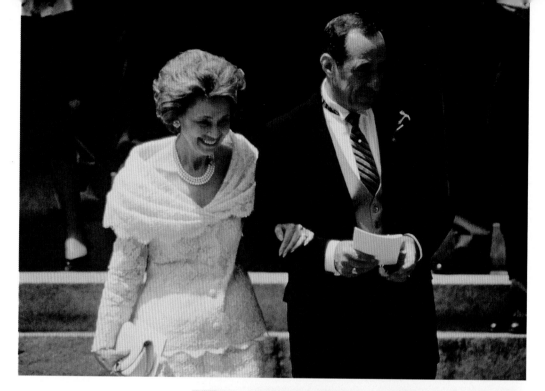

ABOVE Matilda Cuomo praised her son and daughter-in-law: "Just look at the two of them, their values and their priorities are so much the same. You just know this marriage will last a lifetime."

During the ceremony, her husband offered a reading from Philippians: "Don't do anything from selfish ambition or from cheap desire to boast, but always be humble with one another, always consider others better than yourselves."

Father Gerard Creedon, an Irish priest and close family friend, performed the wedding. The couple had taken a special interest in the spiritual importance of the ceremony. At their request, Creedon charged the young couple to uphold "family traditions, and their commitment to human rights and justice." He read prayers written by Kerry that remembered deceased family members, including Kerry's brother David, who had died six years earlier. Her tribute to him was especially moving: "For all of those who watch over us, especially David, who we remember with love, we pray to the Lord."

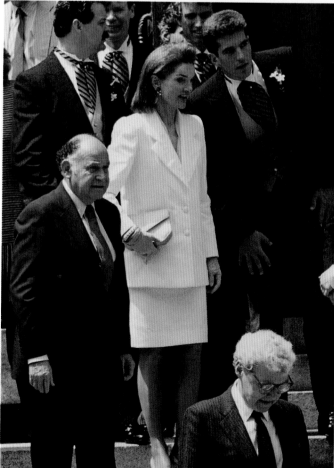

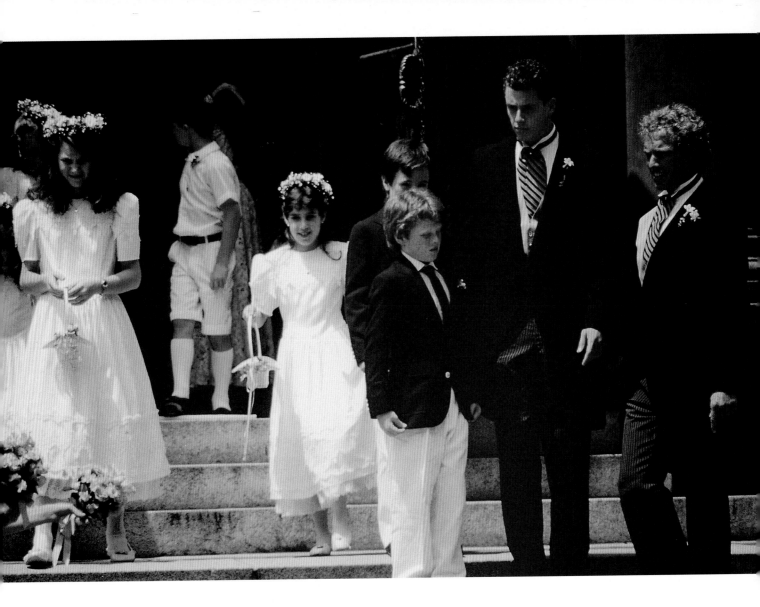

ABOVE Congressman Joe Kennedy's twin sons, Matthew and Joe, served as pages. Kerry and Andrew's eleven nieces and nephews were part of the wedding party, as flower girls and pages. Their special responsibility was to shower their aunt and uncle with tissue-paper hearts.

OPPOSITE PAGE, BOTTOM: One of the loveliest aspects of this wedding was that a joyous event took place in a church known primarily for being the site of President Kennedy's funeral. How wonderful for Jacqueline Onassis to have happy memories of a church that she had chosen specifically for the President's funeral Mass. Mrs. Onassis is seen here with son John and companion Maurice Tempelsman on the steps outside St. Matthew's Cathedral.

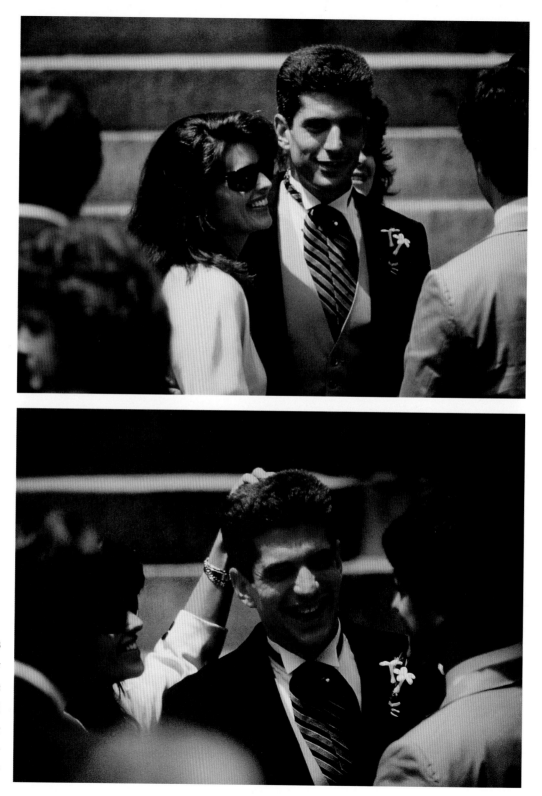

Maria Shriver playfully teases her cousin John Kennedy about his brush-cut hairstyle (which he abandoned quickly) while talking with her brother Mark after the wedding. Her reported advice? "Let it grow."

KENNEDY WEDDINGS

ABOVE LEFT Maria Shriver holds her month-old daughter, Katherine Eunice Schwarzenegger, while John Kennedy, NBC newsman Tim Russert, and Caroline Kennedy enjoy themselves at the reception. Among the other guests were New York Mayor David Dinkins, film director Francis Ford Coppola, actress Kitty Carlisle Hart, and newspaper columnists Jimmy Breslin, Art Buchwald, and Mike McAlary (who was one of the multitude of ushers).

ABOVE RIGHT Ted Kennedy visits with a bevy of his female Kennedy relatives—Amanda Smith, Pat Kennedy Lawford, Robin Lawford, Sydney McKelvy, and Caroline Kennedy.

Later on, Rory Kennedy offered a warm, funny toast to the couple, as did the best man, the groom's nineteen-year-old brother, Christopher. Mario Cuomo said it was the best minute of the day for him.

LEFT Cousins and close friends Maria Shriver, Caroline Kennedy, and Sydney McKelvy vamp for a candid photo during the wedding reception at Hickory Hill.

KARA ANNE KENNEDY AND MICHAEL DALE ALLEN

September 8, 1990
Centerville, Massachusetts

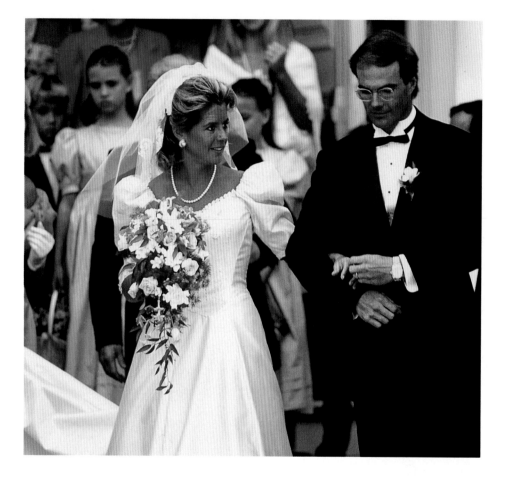

"My wedding day memories are a montage of special moments. We lucked out on the weather, and I
remember feeling that the gospel choir captured the joy of the day when they nearly lifted the
roof off the church with their rendition of 'Oh Happy Day.' During our vows, I looked over
at Michael and saw that his eyes were as moist as mine. It was the happiest day of my life.
It was also so meaningful that we could have the reception at my grandmother's home
so that she could be with us to share our happiness."

KARA KENNEDY ALLEN

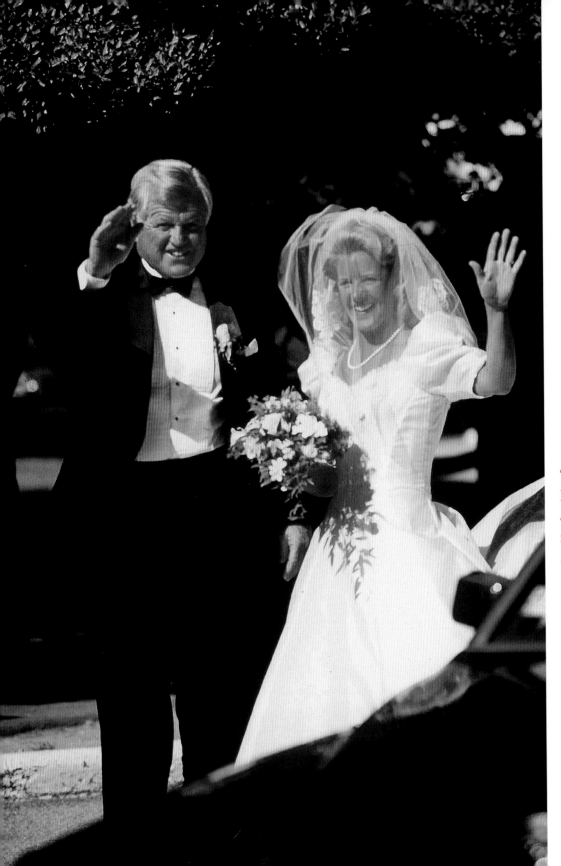

"The easiest job was walking Kara down the aisle; the hardest job was giving her away." So said Ted Kennedy on the day he finally became "Father of the Bride." After a trio of "dress rehearsals"—escorting his nieces down the aisle—he knew what the job entailed and what to expect during the day. Still, upon first seeing Kara come down the stairs of her mother's home on Squaw Island, Ted's eyes filled with tears and he had to take a moment to compose himself.

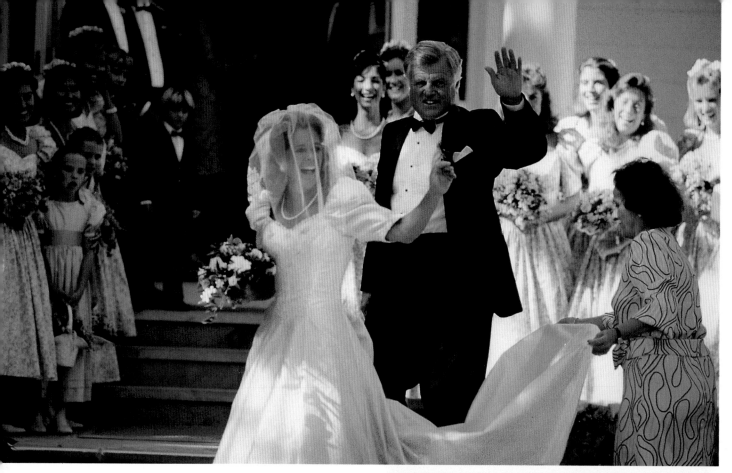

ABOVE Priscilla of Boston designed Kara's dress. It was made of ivory silk, with a V-shaped neckline appliquèd with sixteenth-century English lace. Kara wore a shoulder-length mantilla edged with lace and carried a bouquet of gardenias, roses, freesia, ivy, and fern. Priscilla Kidder was no stranger to the weddings of political daughters, having designed Luci Baines Johnson's wedding gown in 1966. She also designed the dresses for Kara's twelve attendants in French silk cotton printed in tones of ivory, pink, and green.

RIGHT Pretty-in-pink Ethel Kennedy arrives with her daughter Kathleen Kennedy Townsend.

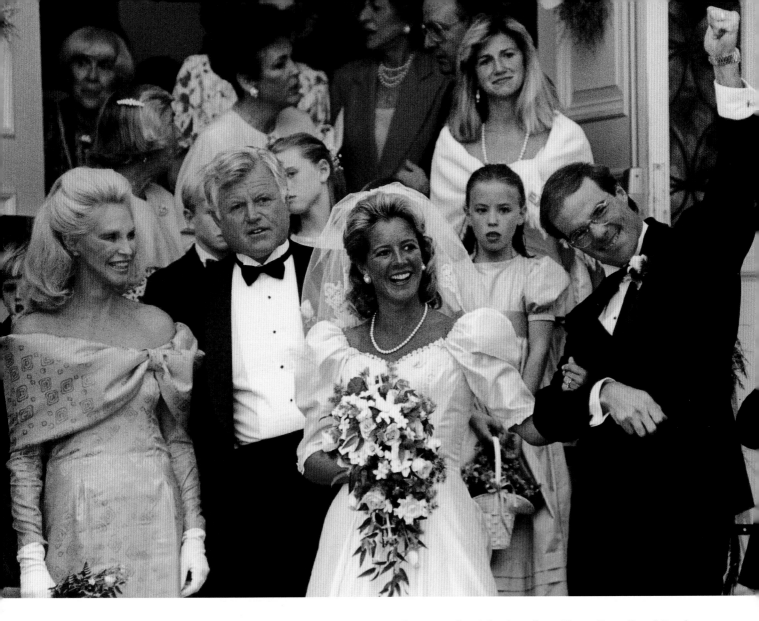

The ceremony was a joyous celebration, with many personal touches. The wedding program's cover was a scene of the Hyannis Port compound that Ted Kennedy had painted in 1964 while recovering from a plane crash. The Reverend James English performed the ceremony. He had officiated at Kara's First Communion, and both her brothers had served as altar boys when English was at Georgetown's Holy Trinity Church. Reverend William O'Neill, a friend of the Allen family, assisted.

Music was integral to the ceremony, befitting Joan Kennedy's expertise. Selections from Henry Purcell and Beethoven were included, but the musical highpoint was a rousing gospel rendition of "Oh Happy Day" sung by Roxbury's Twelfth Baptist Church Singers.

Prayers were offered for the groom's father, Max Greathouse Allen, the bride's uncles John and Robert Kennedy, and her uncle Stephen Smith, who had died a month before the wedding. Jean Kennedy Smith, who was in mourning, was one of the few family members who did not attend.

TOP Pat Lawford greets her daughter Robin, one of the bridesmaids, as Sydney McKelvy and Eunice Shriver look on.

BOTTOM Jacqueline Onassis "adored" her brother-in-law Ted and relied on him many times during the course of their forty-one-year "in-law-ship." Jackie also remained close to Joan Kennedy. Such was her confidence that in 1960, her will stipulated that the Ted Kennedys be entrusted to raise her daughter, Caroline, in the event that anything happened to her and JFK.

"In the last year, I've been so happy to watch my daughter falling in love with a wonderful man," Joan Kennedy said at the time. "She has just become radiant, and working together on all of the preparations for Kara and Michael's wedding, I've been thrilled to see her joy and commitment." Joan wore a pale lavender dress made of silk jacquard with a wide off-the-shoulder collar, created by her favorite designer, Alfred Fiandaca. During the cermony Joan delivered an eloquent reading of the prayer of St. Francis of Assisi.

The reception was a delightful party. Upon arriving at the family compound, the couple visited with the bride's grandmother Rose Kennedy, who had celebrated her one hundredth birthday that summer. A huge white-and-green tent was set up outside Rose's house and a buffet smorgasbord was offered to the guests. A seven-tier cake was topped with a replica of the family sailboat, the *Victura*. The Senator had decorated the three Kennedy boats with nautical flags that spelled the names Kara and Michael. The boats—the *Victura*, the *Mya*, and the *Glide*—bobbed in the water off Nantucket Sound. Michael Allen, an avid sailor, was a member of the United States team that won the 1980 Sardinia Cup and was a founding member of the Museum of Sailing in Newport, Rhode Island.

MATTHEW MAXWELL TAYLOR KENNEDY AND VICTORIA ANNE STRAUSS

July 13, 1991
Philadelphia

The wedding of Max Kennedy and Victoria Strauss was filled with romance and was touched by an ecumenical spirit new to a family long respected for its unwavering Roman Catholic faith.

The romance started in Aspen, Colorado, where they met at a Christmas Eve party in 1986, and culminated near the Cliffs of Moher, on Ireland's west coast, overlooking the Atlantic Ocean, with a proposal of marriage.

Though they married in a Catholic ceremony, Vicki's Jewish heritage was honored and celebrated, both during the wedding itself and afterward at the reception. The marriage celebrant, family friend Father Gerard Creedon, proclaimed, "Let us put aside religious bigotry and racism, things that reduce our humanity," and Strauss family friend Mrs. Norman Cohn offered a Hebrew prayer at the reception.

Both Max and Vicki attended the University of Virginia Law School (where both Robert Kennedy and Edward Kennedy studied). Their dedication to the underprivileged is showcased in a project they organized at Hickory Hill, running a summer camp for homeless children.

RIGHT Caroline Kennedy and husband Ed Schlossberg were but two of the 350 guests. Among the others were Olympic decathlon champion Rafer Johnson, who gave a reading during the ceremony; Eunice and Sargent Shriver (whose daughter, Maria, would give them a fourth grandchild ten days later); and a host of Philadelphia Main Liners.

BELOW The groom is distinguished by his choice of a black waistcoat to complement his cutaway and gray-striped trousers. Brothers Michael, Christopher, Bobby, and Doug and cousin William Kennedy Smith join Max outside the Four Seasons Hotel in downtown Philadelphia.

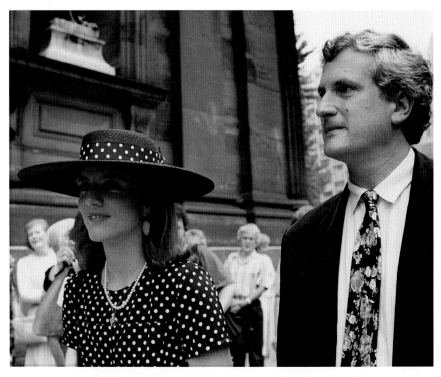

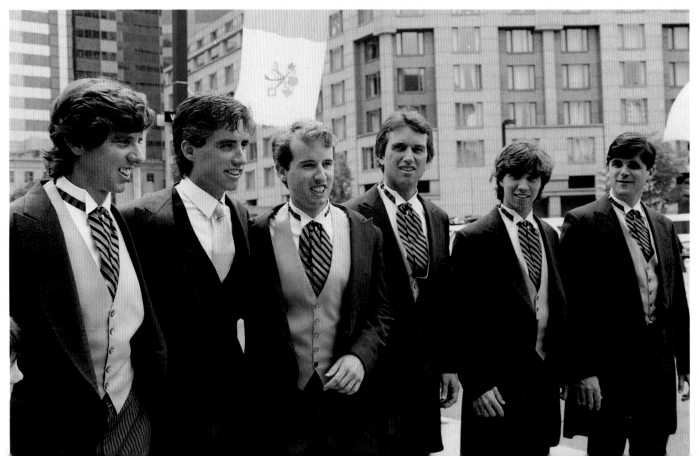

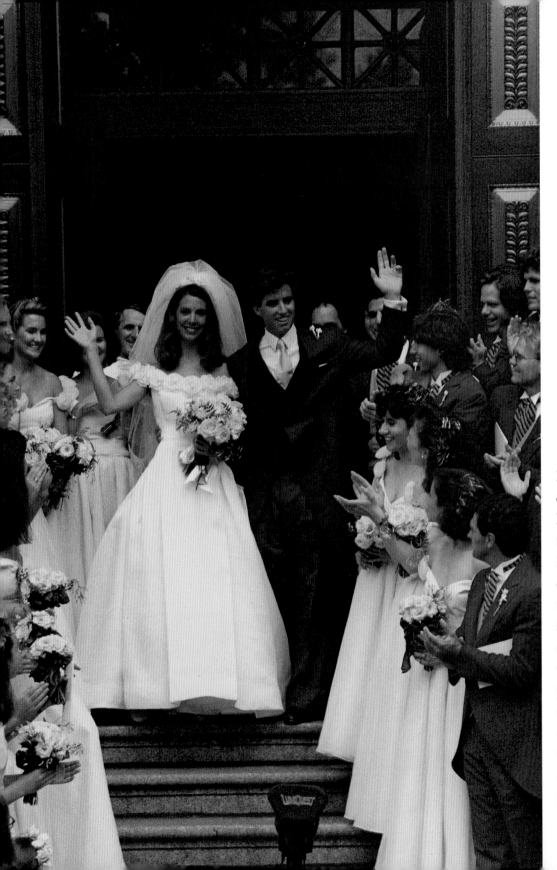

Reveling in the warm applause of their bridal party, Vicki and Max Kennedy stand outside the Cathedral Basilica of Saints Peter and Paul. Vicki's sumptuous Vera Wang gown was custom-made of off-white satin-faced organza, with an off-the-shoulder neckline trimmed with silk flowers. The gently pleated skirt fell from a dropped waist and had a long detachable train. Her fingertip veil fell from a wreath of silk organza flowers with beaded pistils and stamens.

149

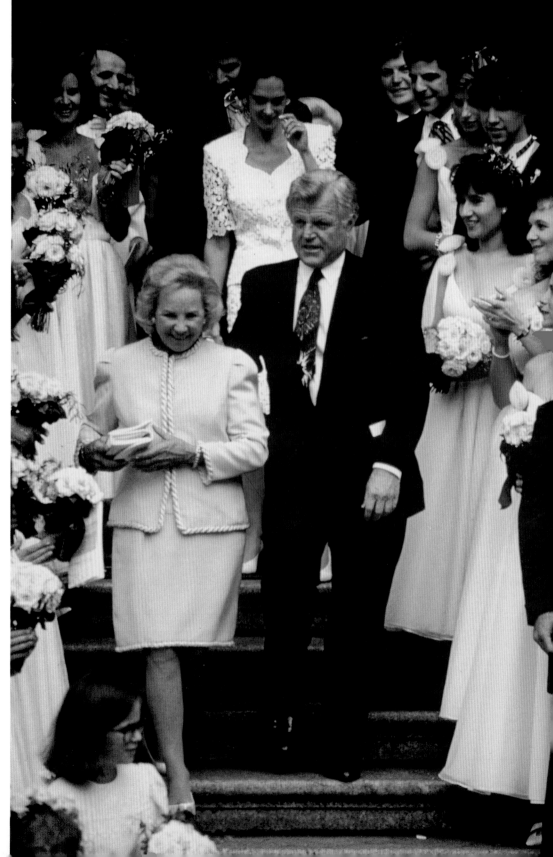

Ethel Kennedy looked particularly fetching in a pale aqua silk suit, the jacket trimmed with braided piping. Senator Edward Kennedy escorted her at the ceremony. Behind them are Vicki's parents, Benjamin Strauss, of Haverford, Pennsylvania, and Mrs. Bonnie Strauss Gould, of Los Angeles, California. Later at the reception, Ted toasted the young couple by invoking the memory of his older brother: "If Robert Kennedy were here today, he would be so proud of Max's commitment and integrity, and he would be welcoming Vicki warmly and a little shyly into the family."

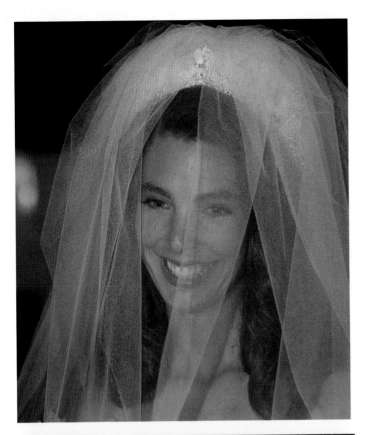

TOP Vicki and her mother, Bonnie Strauss Gould, a television journalist, planned the entire wedding—from the program with a cover depicting the romantic Irish cliffs where Max proposed to the ivory silk tea-length dresses for the sixteen bridesmaids to the sumptuous flowers designed by Robert Isabell to the tented reception at Andalusia, an historic estate on the banks of the Delaware River.

BOTTOM At the reception, Max spoke of his namesake, General Maxwell Taylor, who was the Joint Chief of Staff of the U.S. Army in the Kennedy Administration, and later Ambassador to Vietnam. Max proudly wore a pair of cuff links that the General had given him. Vicki introduced the customs of a Jewish wedding celebration to the Kennedys. She handed Max a glass wrapped in a napkin. He placed it on the floor and stepped on it, a custom commemorating the destruction of the temple in Jerusalem. Then, as Peter Duchin's orchestra played "Hava Nagila," the young couple sat in two chairs, which were raised and carried about as guests danced the hora around them. Later Ethel Kennedy experienced the same thrill as she was sat in a chair and raised while guests danced to an Irish tune.

MARK KENNEDY SHRIVER AND JEANNE EILEEN RIPP

June 26, 1992
Newport, Rhode Island

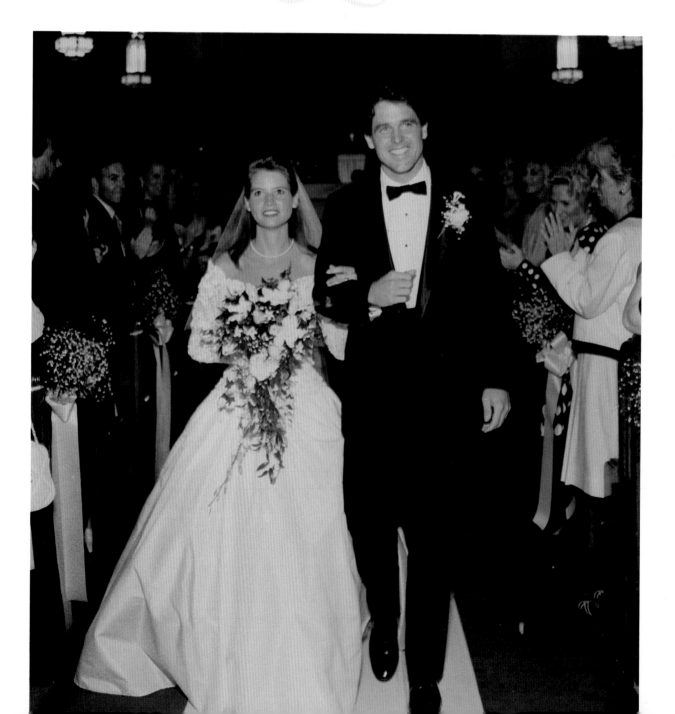

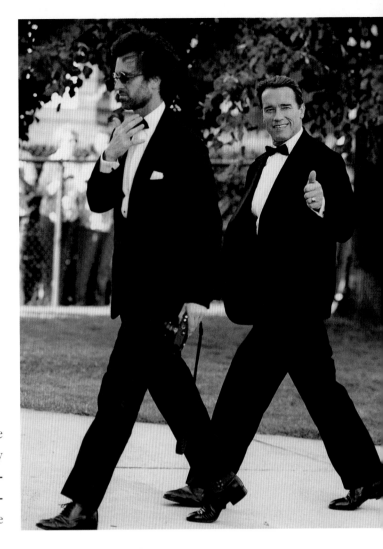

OPPOSITE If asked what came to mind at the mention of the words *Newport* and *wedding* and *Kennedy*, one could safely wager that the answer would be the 1953 JFK and Jackie nuptials at Hammersmith Farm. But Newport was the site of another Kennedy wedding, that of JFK's nephew Mark Shriver, in the summer of 1992.

St. Augustin's Church is located in the heart of Newport's famous Fifth Ward, the bastion of the working-class Irish, and the ladies of the Fifth Ward were out in force to witness as the third son of Eunice and Sargent Shriver married his Holy Cross classmate Jeanne Ripp. A native of Old Westbury, Long Island, Jeanne is the daughter of Mrs. William G. Hildebrand of Greenwich, Connecticut, and the late Dr. John A. Ripp Jr. Among the guests were Caroline Kennedy, Joe Kennedy with his mother, Ethel, and Senator Edward Kennedy (who would marry Victoria Reggie in a week's time). It was a late-afternoon candlelight ceremony, followed by a reception for family and friends.

ABOVE Arnold Schwarzenegger gives a thumbs-up to the crowd, who loudly cheered as he and brother-in-law Bobby Shriver arrived early to usher.

MARY COURTNEY KENNEDY AND PAUL MICHAEL HILL

June 26, 1993
Aegean Sea

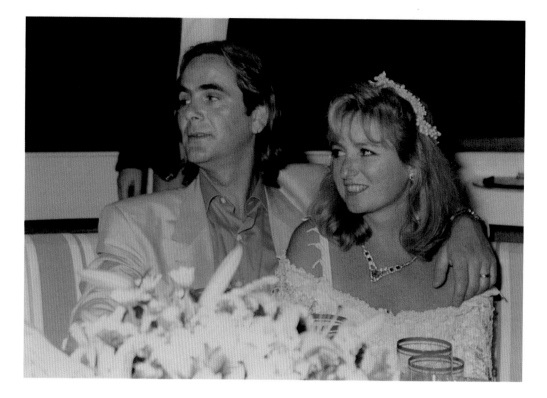

A wedding, the bride a Kennedy woman, aboard a yacht on the Aegean Sea off the coast of Greece. It sounds familiar, yes? But it was the niece of Jacqueline Onassis, Mary Courtney Kennedy, who was the bride at a very private wedding ceremony in which she married Paul Hill, an Irishman whose calamitous personal history was later dramatized in the film *In the Name of the Father.*

Paul Hill was jailed for fifteen years for an Irish Republican Army bombing that an appeals court judged he played no part in. His only "crime" was being a working-class nationalist from Northern Ireland who was living in England during the height of

the IRA's bombing campaign in the early 1970s. Once freed, he became a human-rights activist. He recalled that "I met Courtney in 1990. I had addressed the Congressional Human Rights Caucus in Washington, where her brother Joe was one of the panel. Later, I met her mother, who was at the hearings, and told her I was going to New York. She asked if I would mind seeing her daughter, who had an interest in Northern Ireland but couldn't come to the hearings because she had broken her neck in a skiing accident. . . . My first impression wasn't a good one. Her apartment on Fifth Avenue was like a funeral parlour—there were flowers everywhere and she was still bedridden after twelve

weeks. . . . I asked her out the next day."

Courtney, whose father had always referred to her as "my beautiful Courtney," told how her shipboard nuptials came about: "In June 1993, we were on holiday in Greece, visiting our friends Vardis and Marianna Vardinoyannis. Paul had asked me to marry him a couple of days before we joined them and my mother on their yacht. As soon as we told them about our plans, they suggested we get married onboard. It was a lot easier than inviting guests from two countries and flying them in for a big wedding."

The wedding, so far away, at sea, also avoided a media circus, and they successfully escaped the British tabloid press. A small group of American and European friends attended the ceremony, at which retired *Boston Globe* columnist Bob Healy gave the bride away and an Irish priest offered a blessing. A short while later, the couple had a fifteen-minute private audience with Pope John Paul II, which Courtney found "an extraordinary experience." They spent most of that summer in Ireland's County Clare and could often be found celebrating with friends at McGann's pub in Doolin. "I love her and she loves me" was Hill's response to a reporter's question about married life, and Courtney agreed: "It feels absolutely wonderful, like heaven."

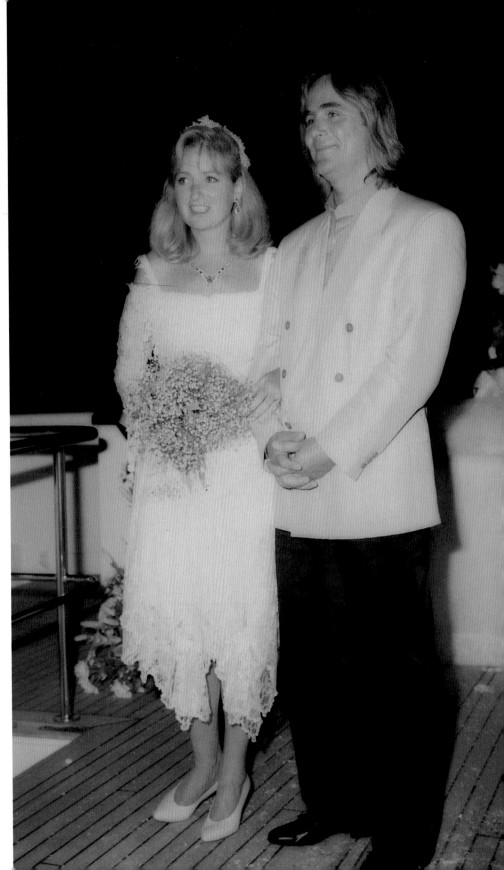

ANTHONY PAUL KENNEDY SHRIVER AND ALINA MOJICA

July 2, 1993
Hyannis Port, Massachusetts

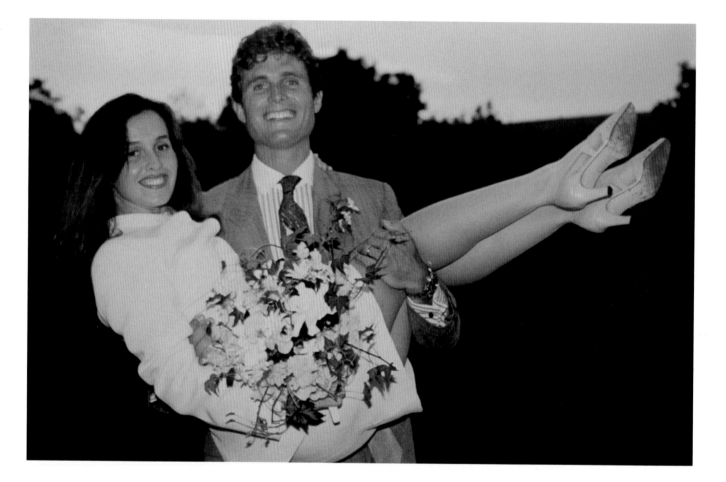

With an exuberant swoop, Anthony Shriver picks up his bride, Alina Mojica, and carries her into his life and into the Kennedy family.

"It was a really small ceremony at the house in Hyannis Port," Shriver told *USA Today* about his wedding on July 2, 1993. "Basically my family and about fifteen very close friends were there." The guest list was "whoever was around," since the wedding was done "very quickly. The people who were at the Cape came, and those who weren't at the Cape for the Fourth didn't come."

The double-ring ceremony was held outdoors, by the sea. As the afternoon sun lowered over Lewis Bay, Eunice Kennedy Shriver, the groom's mother, read a poem as the ceremony began. Alina's four-year-old son, Teddy, served as ring bearer, and

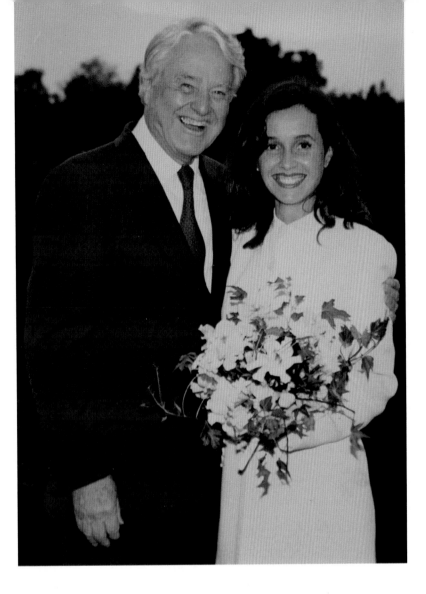

Anthony's nieces Katherine and Christina Schwarzenegger (ages three and two) were flower girls. Their proud parents, Maria Shriver and Arnold Schwarzenegger, did a reading together.

The bride was radiant in a white two-piece suit that featured a short skirt and a three-quarter-length long-sleeved jacket that buttoned down the front. She carried a bouquet of white lilies and Boston ivy. The combination of bright green and pure white is particularly stunning and highlights Alina's dark-haired beauty.

Afterward, a reception and dinner were held at the Shrivers' house close to the Kennedy compound. Though only two days before the Fourth of July, there was no fireworks display. "There were fireworks inside at the party," Anthony boasted with a laugh.

ABOVE Alina Mojica Shriver stands with her new father-in-law outside the family's home in Hyannis Port. Four decades earlier, Sargent Shriver married into the Kennedy family, so he fully understands the daunting prospect of assimilating into the close-knit tribe. As one can clearly see, he's extending a warm welcome to his son's new bride.

The newlyweds dance during the reception in the Shrivers' home. Their gleaming smiles are the clearest indication of just how happy this day turned out for them. Anthony and Alina gathered their closest friends and family around them and married with none of the whoop-de-do that normally surrounds a Kennedy "event." It was meaningful for them to have privacy and quiet; happily, they succeeded.

Anthony, the youngest of the five Shriver children, is especially devoted to his mother's cause of empowering the mentally disabled. He is very close to his aunt Rosemary, and while a junior at Georgetown University, Anthony created Best Buddies, a volunteer program that provides companions to mentally retarded people, for visits and trips to the movies and shopping. Best Buddies is now in forty states and several foreign countries.

The couple today has three children, Teddy, Eunice, and Francesca, and they make their home in Miami, Florida.

EDWARD MOORE KENNEDY JR. AND KATHERINE ANNE GERSHMAN

October 10, 1993
Block Island, Rhode Island

Riding in style to their reception in a red convertible "love sled"—check out the car's vanity plate—the newlyweds are also riding high on a wave of happiness. "This is the most ecstatic day of my life," Kiki exclaimed, "because I'm with the love of my life." Ted echoed her feelings: "I've found the woman I want to spend the rest of my life with."

"There was a time in Ted's life when his family did not know if he would live or die," family spokeswoman Melody Miller said. "For him to find someone as wonderful as Kiki and have this wonderful, happy day is doubly joyful." These sentiments were reinforced during a weekend filled with celebrations, laughter, and love.

Ted Kennedy Jr. and Dr. Katherine "Kiki" Gershman were wed on Block Island, in a small wood-frame church decorated with fragrant cedar garlands. The wedding started on a light-hearted note—as Kiki started to walk down the aisle alone, her impatient groom bounded up the aisle to meet her and bring her to the altar. They chose Robert Frost's poem "A Line-Storm Song," which speaks of love remaining strong through the storms of life, to be read during the ceremony, along with Scripture passages. The wedding, as customary, was a family affair; Ted's brother, Patrick, was best man; his sister, Kara, was a bridesmaid; her husband, Michael, a groomsman. Victoria Reggie Kennedy's children, Caroline and Curran Raclin, carried the rings.

At the rehearsal dinner the night before, Max Kennedy paid heartfelt tribute to his cousin: "Teddy turned out to be the most generous of all cousins, because he shared his father with us."

TOP Flanked by her "main men"—husband Ted and son Curran Raclin—Vicki Reggie Kennedy looks glorious in an azure blue dress designed by Carolina Herrera.

BOTTOM John Kennedy's arrival at his cousin's wedding launched a media feeding frenzy that caused onlookers to shout, "Leave him alone, leave him alone," as he ran a gauntlet of photographers to get into the church.

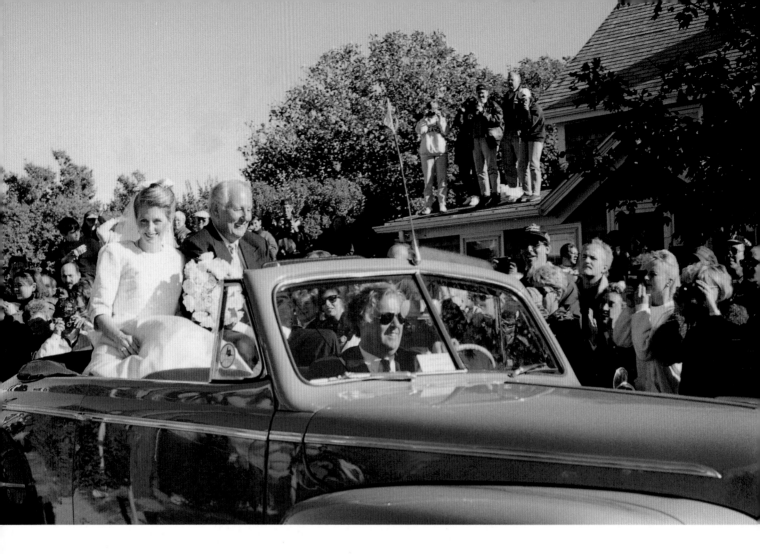

Kiki arrives in glamorous style, escorted by her father, James Gershman, in a 1946 green Ford convertible. She wore a strapless ivory satin gown with a lace bolero jacket and carried a bouquet of cream and pale pink roses.

JOSEPH PATRICK KENNEDY II AND ANNE ELIZABETH KELLY

October 23, 1993
Brighton, Massachusetts

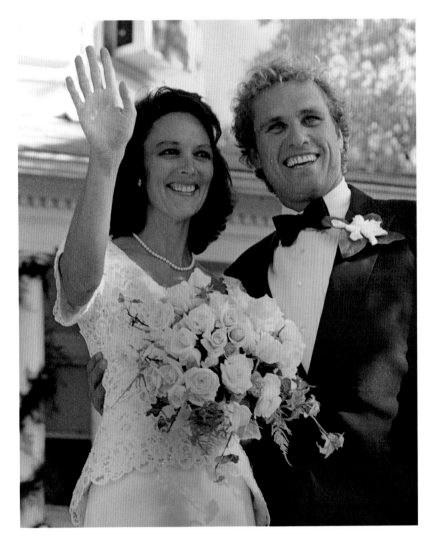

"We've gotten to know Beth over the past few years and are enormously fond of her, and we love Joe
very much. We wish them as much happiness together as we have."

—TED AND VICKI KENNEDY

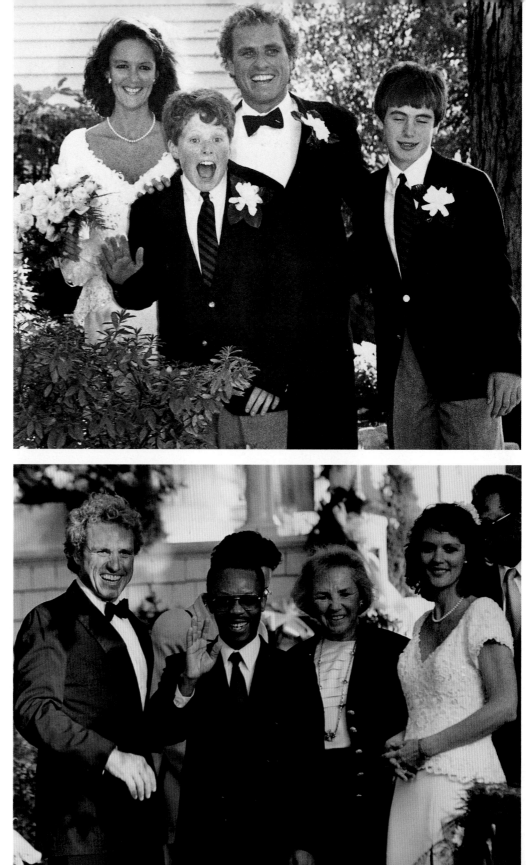

TOP Joe's twin sons, Joe III and Matthew, pose with the newlyweds in their yard, the Kennedy men wearing gardenia boutonnieres in their lapels.

BOTTOM Jean-Bertrand Aristide, the exiled Haitian President, flew up from Washington to attend the wedding of his close friend and political counsel. A priest, he offered a reading from the Book of John during the ceremony. Afterward he posed with Ethel Kennedy, her son, and her new daughter-in-law. Guests included all Joe's brothers and sisters, Patricia Lawford, Ted Kennedy, and cousins Patrick Kennedy and Stephen Smith. Other friends included Senator John Kerry, JKF speechwriter Dick Goodwin and his wife, historian Doris Kearns Goodwin, and the columnist Mike Barnicle.

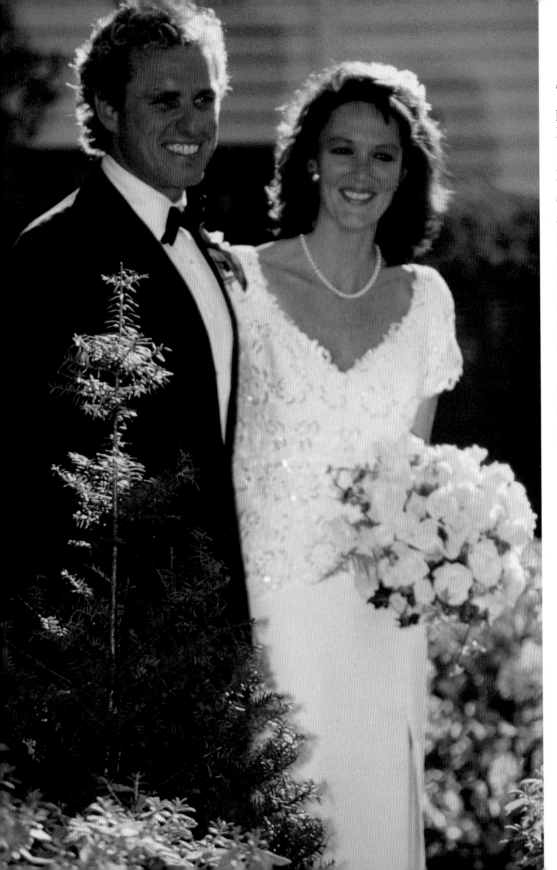

"The happiest day of my life," proclaimed Congressman Joe Kennedy on October 23, 1993. It was a perfect New England fall afternoon, the sun shining and the air crisp like an apple, the day he married Beth Kelly. They married in their rambling Victorian home in the heart of his working-class Congressional district, surrounded by family and friends.

The couple had met over a decade earlier, when she was working at his innovative company, Citizens Energy Corporation. Their relationship developed over time and culminated in a simple but elegant wedding. Thirteen-year-old twins Joe and Matthew were their father's best men. Leo Kelly, Beth's father, gave a reading and Ethel Kennedy read a responsorial Psalm. The vows were followed by a spirited rendition of "When Irish Eyes Are Smiling." Later, when asked how she felt, Beth responded in a voice rich in happiness: "Are you kidding me? I just got married. I feel great."

JOSEPH PATRICK KENNEDY II AND SHEILA BREWSTER RAUCH

February 3, 1979
Gladwyne, Pennsylvania

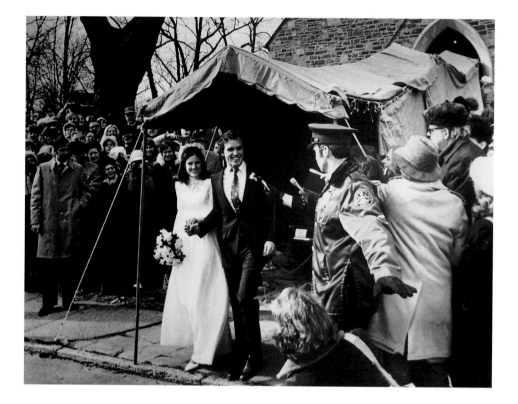

oe had been married previously, in the winter of 1979, to Sheila Brewster Rauch. They had met while she was at Harvard, where she received both her B.A. and master's degrees. Since she was an Episcopalian, there was an interdenominational ceremony, followed by a small family luncheon at the bride's home in Villanova. They became parents of twins Matthew Rauch Kennedy and Joseph P. Kennedy III in 1980 and were divorced in 1990.

ROBERT FRANCIS KENNEDY JR. AND MARY RICHARDSON

April 15, 1994
Stony Point, New York

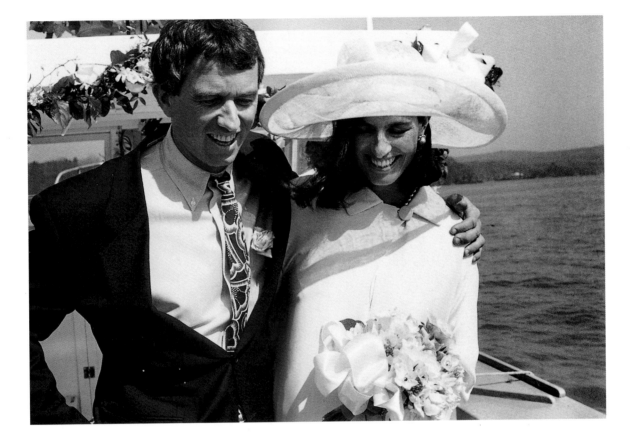

On a quiet spring morning, Robert F. Kennedy Jr. took as his wife his great friend Mary Richardson. They married onboard a boat, surrounded by the vast majesty of the Hudson River. The setting was especially appropriate: Bobby's work with the environmental organization Hudson Riverkeeper had helped reclaim the river, making it safe for wildlife and recreation.

The ceremony, witnessed by Bobby's two children, followed a celebratory Roman Catholic Mass. Afterward there was a picnic lunch for family and friends onboard the *Shannon*, Riverkeeper's research vessel.

Mary Richardson is an architectural designer, and at the time of her wedding was with the firm Parish-Hadley (which had figured so prominently in the Kennedy White House restoration). Today Bobby is a respected activist for the environment; he and Mary live in Westchester County, New York, with their children, Conor, Kyra, and Finbar, and share custody of Robert F. Kennedy III and Kathleen, nicknamed "Kick" after her great-aunt.

ROBERT FRANCIS KENNEDY JR. AND EMILY RUTH BLACK

April 3, 1982
Bloomington, Indiana

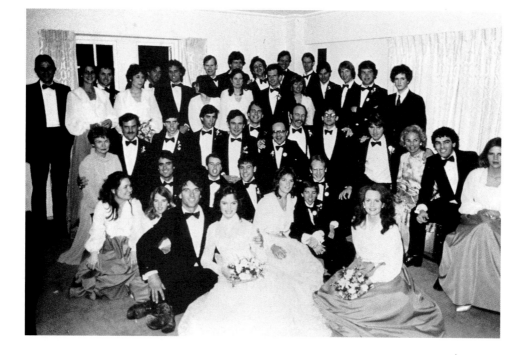

\mathcal{B}obby Kennedy Jr. had been married before, to Emily Black, a fellow student at the University of Virginia Law School. Emily was a native of Bloomington, Indiana, and native Hoosiers came out in force to watch the biggest thing to hit Bloomington since the filming of Academy Award–winning (for Best Original Screenplay) *Breaking Away* in 1979.

The large wedding party included two dozen ushers (who arrived in a double-decker English bus, boisterously singing "Get Me to the Church on Time"), Bobby's six brothers, four sisters, two brothers- and sisters-in-law, and three cousins. Emily's brother, Tom, gave her away, and her sister served as matron of honor.

The couple, who had two children, Robert F. Kennedy III, born in 1984, and Kathleen, born in 1988, did not stay married.

JOHN FITZGERALD KENNEDY JR. AND CAROLYN BESSETTE

September 21, 1996
Cumberland Island, Georgia

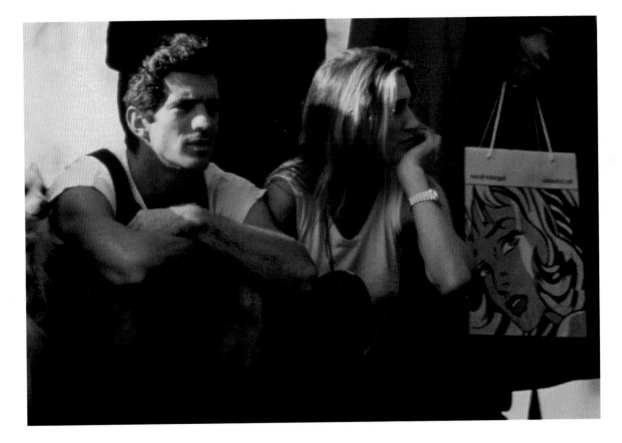

They were private people in a public arena. Carolyn Bessette Kennedy once told Barbara Walters that she would never give an interview and also that she never complained to her husband about the constant media intrusion in her life. Media intrusion came with the territory. And if there was one thing certain in the celebrity-centric environment we find ourselves in, John F. Kennedy Jr.'s wedding would be a media event of gargantuan proportions. The public part of his life had been so public, for so long—really from the moment of his birth.

The entire progression of his life has been looked over, documented, scrutinized, lauded, disparaged, frenzied. Why would his marriage be any different? And who would be his wife?

On a Sunday afternoon in the fall of 1994, John Kennedy was casually sitting on a curb watching the New York City Marathon when noted landscape photographer Peter Guttman took a single picture, motivated by little more than a mild curiosity about the handsome young man who had seamlessly assimilated himself into the daily rhythms of city life. What Mr.

Guttman didn't realize at the time was that he had captured the first public photograph of John with Carolyn Bessette.

Their wedding two years later would both surprise and captivate the world. The calamitous accident that caused their deaths in the summer of 1999 stunned and saddened us all. The threads of tragic irony that weave the story of John and Carolyn Bessette Kennedy are compelling, poignant, and close to unbelievable. En route to Martha's Vineyard, JFK Jr.'s plane went down a few miles west of the area of Gay Head, where Jackie had built a home in the 1980s. The Kennedy family had been gathering in Hyannis Port for the marriage of Robert Kennedy's youngest daughter, Rory (she and her fiancé, Mark Bailey, immediately postponed their wedding), but their celebration turned to a time of prayer and mourning. One recalls a passage from Shakespeare: "Death lies on [them] like an untimely frost upon the sweetest flower of all the field."

OPPOSITE "Even though people may be well known, they hold in their hearts the emotions of a simple person for the moments that are the most important of those we know on earth—birth, marriage, and death. We wish our wedding to be a private moment...with only members of the family present."

These were Jacqueline Kennedy's feelings in October 1968 when she was about to marry Aristotle Onassis, but John Kennedy Jr. easily could have released the same statement twenty-eight years later. Unbeknownst to the world, he and Carolyn Bessette had been engaged for a year before their September 1996 wedding—a secret betrothal made all the more delicious when compared with the voracious and insatiable appetite of the world's celebrity watchers for any bit of news about the handsome couple. Their wedding was planned with such secrecy and discretion that the editor of *The National Enquirer* paid this compliment: "John Kennedy could run the CIA."

Of his wedding, John Kennedy told the world that "it was very important for us to be able to conduct this in a private, prayerful, and meaningful way with the people we love." That the couple was able to achieve that deserves our respect and admiration.

This photograph, taken by Denis Reggie, is one of the most famous pictures in the world—flashed around the globe as news of the wedding ceremony became known after the late-summer weekend was over. The only photograph released to the public after the wedding, it's dashing—filled with sophistication and happiness. Look at Carolyn's face, illuminated with joy, and observe the pride and honor in John's gallant gesture. They didn't know what path their lives together would take, or what fate held in its hands for them. But this sublimely happy moment, frozen forever in time, lovingly illustrates the thought of William Wordsworth: "Bliss was it in that dawn to be alive, but to be young was very heaven!"

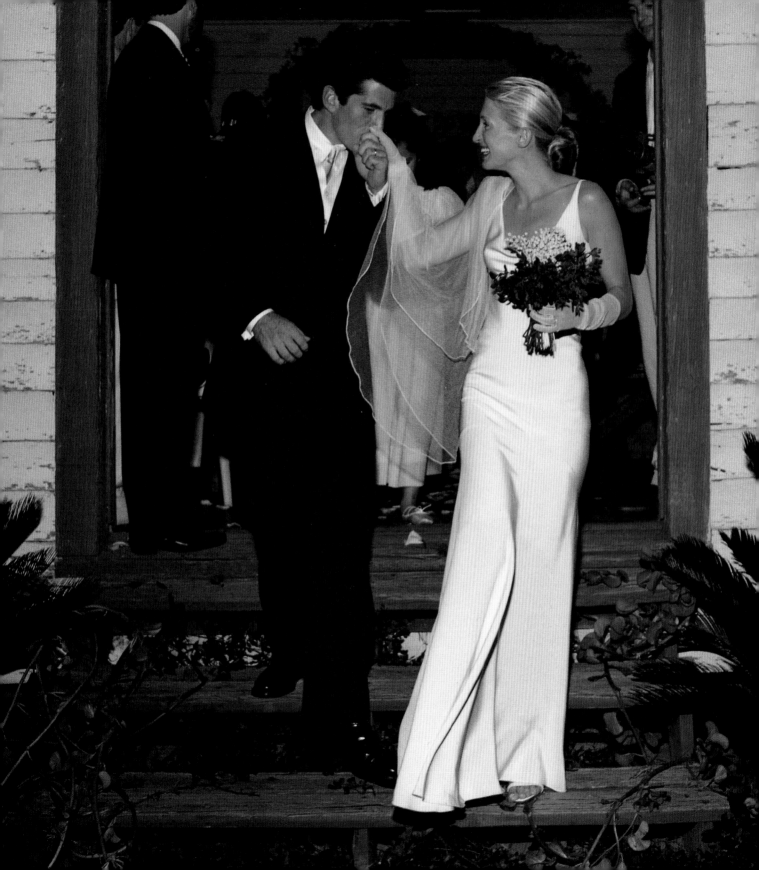

Illuminated by candles and kerosene lamps, the wedding ceremony in a chapel built by former slaves had a lyrical, romantic quality. Small, private, with only a few family members and close friends looking on, the wedding held many similarities to that of the groom's paternal grandparents eighty-two years before.

Again, it was a Kennedy ritual imbued with family—Anthony Radziwill was his cousin's best man, and Caroline Kennedy was the matron of honor. Her daughters, Rose and Tatiana Schlossberg, were flower girls, and her son, Jack, the ring bearer. Carolyn's sister, Lisa Bessette, her brother-in-law, Michael Roman, the groom's cousin Dr. William Smith, the groom's brother-in-law Ed Schlossberg, and Senator Kennedy all read passages from Scriptures.

And the couple relied on the loyalty and discretion of a few close friends.

Carolyn's dress was designed by her friend Narciso Rodriguez, for the house of Cerutti, and was made in Paris. It was fashioned of pearl-colored silk crepe, cut on the bias, with a small train. She wore a veil of silk tulle with a hand-rolled edge and matching tulle gloves. She carried a bouquet of lilies of the valley.

John and Carolyn had visited Cumberland Island many times and were close friends of Gogo Ferguson, who lived there and made the rings for the couple.

Rachel Lambert Mellon, the famous "Bunny" who created the Rose Garden for President Kennedy and helped Jacqueline Onassis with the restoration of the White House, chose the flowers for the bridal party—bouquets of orchids for Caroline Kennedy and Carolyn's mother, Ann Freeman; nosegays of colored blooms for the flower girls; and for the gentlemen in the wedding party, boutonnieres of cornflowers, President Kennedy's favorite flower.

Efigenio Pinhiero, Mrs. Onassis's longtime butler, decorated the nineteenth-century chapel with native wildflowers and island vines.

After the ceremony, a reception was held at the Greyfield Inn on Cumberland Island. There was a traditional three-tier wedding cake decorated with flowers. Mr. and Mrs. John F. Kennedy Jr. danced their first dance to Prince's "Forever in My Life."

Douglas Harriman Kennedy and Molly Stark

August 22, 1998
Nantucket, Massachusetts

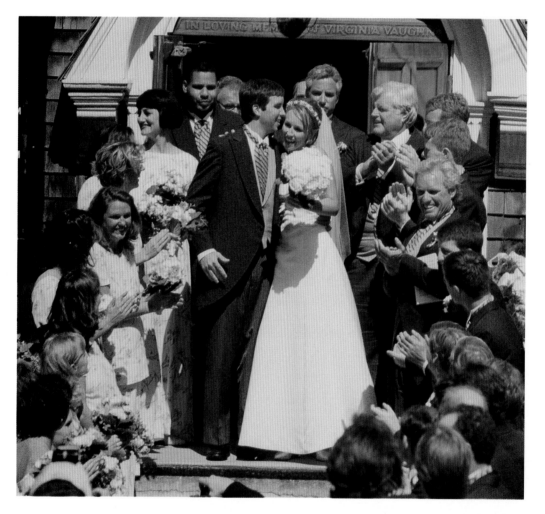

Standing at the top of the stairs outside St. Mary's Church on Nantucket, Douglas Kennedy and his new bride, Molly Stark, bask in the cheers and applause of family and friends after the wedding.

Growing up, the children of Bobby and Ethel Kennedy were surrounded by reporters, many of them family friends. Doug, the youngest son in the family, told *Life* magazine: "Some of my father's best friends—most of them—were journalists. They were my heroes." It's no surprise then that he has become a respected journalist, whose work has spurred legislative reform. Molly is a special-education teacher, working with autistic children.

LEFT Ethel Kennedy arrived at the church with her son-in-law Andrew Cuomo. She wore a pale pink two-piece suit and looked chipper in spite of recently having undergone hip-replacement surgery. Doug was the ninth of her eleven children to marry. He was christened Douglas Harriman Kennedy, in honor of her good friend Averell Harriman (Ethel was a witness at Harriman's wedding to the fabled Pamela Churchill Hayward).

BELOW Bobby Kennedy Jr. arrives at St. Mary's prepared for his dual responsibilities—formal clothes, well suited to his role as usher, and a fold-up baby stroller, perfect for his more important role as father to his infant son Finbar.

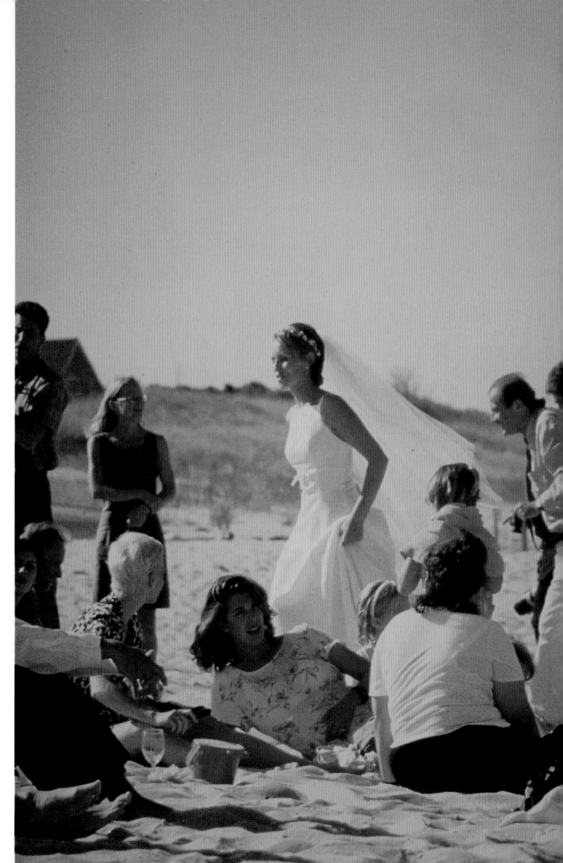

Molly's Vera Wang dress, with its elegant simplicity, doesn't look out of place even on the beach. The reception included a clambake on the dunes near the couple's home. Lobsters, fried oysters, crab cakes, and native corn were on the menu, followed by a more formal dinner that evening and then dancing.

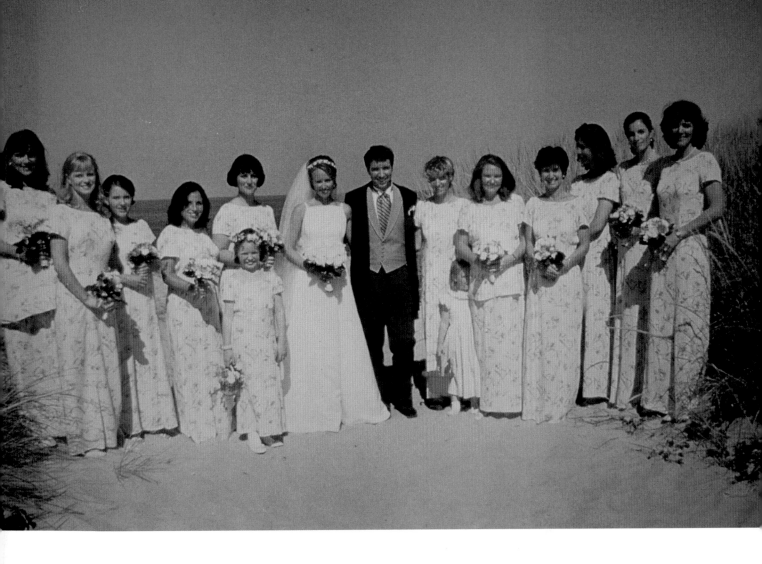

The wedding party included Molly's sister, Michelle Touchette, and best friend, Maret Asaro, as matrons of honor. Doug chose Uncle Ted Kennedy and brothers Chris and Max as his best men. Among the bridesmaids were Doug's sisters Kathleen and Rory and sisters-in-law Beth, Mary, and Sheila. Brothers Joe and Bobby were ushers, along with cousins Anthony Shriver and Ted Kennedy Jr. and nephews Matthew and Joe Kennedy III.

PHOTO CREDITS

AP: viii, 10(l), 20(t), 29, 38, 57, 61(b), 63, 67, 69, 73, 83(l), 99, 102, 105, 108(t), 118, 126, 127, 129, 131, 142, 147, 148, 160, 164(b), 165, 166, 175(t). Courtesy of Yusha Auchincloss: 35. Author's Collection: 12, 18(r), 34(l), 125(t), 153. Bradford Bachrach: 82, 83(r). Courtesy of Harry Benson: 124. *Block Island Times*: 161, 162. *Boston Globe*: xiv, 44(t). *Boston Herald:* 16(l), 24(b), 25, 44(b), 52(b), 71(t), 92, 93, 94, 96, 104, 108(b), 125(b), 132, 133, 134, 136(t), 137, 138, 139, 159, 164(t). Boston Public Library: 4(b). Camera 5: 95. *Cape Cod Times*: i, 98, 100, 101, 113, 114, 115(t), 116(t), 120, 122, 123, 140, 141, 142, 143, 144, 145, 145, 174, 175(b). Corbis/Bettman Archive: 6, 26, 28, 30, 31, 32, 39, 40, 55, 68, 74, 75, 76, 84, 87(r), 89, 110, 111, 119, 121, 135, 136(b), 149, 163. Courtesy of Duke of Devonshire and the Trustees of the Chatsworth Settlement: 8, 13. Peter Guttman: 169. Harcourt Harris: 27, 62, 64, 65, 66, 70, 71(b), 77, 78. Courtesy of Paul and Courtney Kennedy Hill: 154, 155. Courtesy of Senator Edward M. Kennedy: 81. Kennedy Family Collection: 2, 3, 10(r), 11. John F. Kennedy Library: 15, 16(r), 17, 18(l), 19(b), 20(b), 21, 22, 23, 24(t), 34(r), 36, 37(l), 45(t), 58, 59, 60, 61(t). Robert F. Kennedy Memorial: 14. Courtesy of Mrs. Robert F. Kennedy: 154, 155. Courtesy of Robert F. Kennedy Jr.: 19(t). Courtesy of Christopher and Jeannie Lawford: 97. Library of Congress: 33, 41, 42, 43, 45(b), 46, 47, 48, 49, 50, 51, 52(t), 52, 54, 56. Courtesy of Marcia Lippman: 167. National Park Service: 4(u l&r), 5. Photofest: 72, 86, 87(l), 88, 90. Denis Reggie: 79, 91, 103, 106, 109, 128, 146, 151, 152, 171, 172. Courtesy of Anthony and Alina Shriver: 156, 157, 158. SIPA: 150, 176, 177. Courtesy of Mark and Jeanne Shriver: 152. Sygma: 168. Courtesy of Van Cleef and Arpels: 37(r). Courtesy of Lynn Wooten: 115(b), 117.

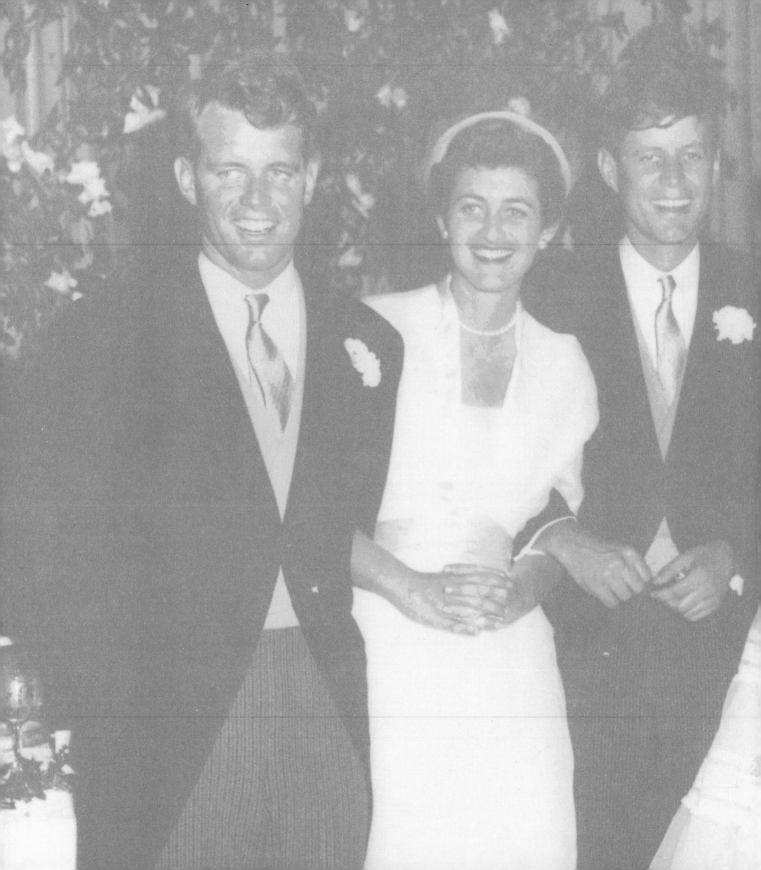